Explore Lightroom® 4: A Roadmap for Photographers

By Gene McCullagh

Course Technology PTR

A part of Cengage Learning

COURSE TECHNOLOGY
CENGAGE Learning·

Australia, Brazil, Japan, Korea, Mexico, Singapore, Spain, United Kingdom, United States

COURSE TECHNOLOGY
CENGAGE Learning·

**Explore Lightroom 4:
A Roadmap for Photographers**

Gene McCullagh

Publisher and General Manager, Course Technology PTR: Stacy L. Hiquet

Associate Director of Marketing: Sarah Panella

Manager of Editorial Services: Heather Talbot

Senior Marketing Manager: Mark Hughes

Acquisitions Editor: Dan Gasparino

Project Editor: Kim Benbow

Technical Reviewer: Peter Schwartz

Copy Editor: Gene Redding

Interior Layout Tech: Judy Littlefield

Cover Designer: Mike Tanamachi

Indexer: Larry Sweazy

Proofreader: Melba Hopper

For product information and technology assistance, contact us at
Cengage Learning Customer & Sales Support Center, 1-800-354-9706

For permission to use material from this text or product,
submit all requests online at **cengage.com/permissions**
Further permissions questions can be emailed to
permissionrequest@cengage.com

Adobe, the Adobe logo, and Lightroom are either registered trademarks or trademarks of Adobe Systems Incorporated in the United States and/or other countries.

All other trademarks are the property of their respective owners.

All images © Cengage Learning unless otherwise noted.

Library of Congress Control Number: 2012939936

ISBN-13: 978-1-4354-6089-8

ISBN-10: 1-4354-6089-8

Course Technology, a part of Cengage Learning
20 Channel Center Street
Boston, MA 02210
USA

Cengage Learning is a leading provider of customized learning solutions with office locations around the globe, including Singapore, the United Kingdom, Australia, Mexico, Brazil, and Japan. Locate your local office at: **international.cengage.com/region**

Cengage Learning products are represented in Canada by Nelson Education, Ltd.

For your lifelong learning solutions, visit **courseptr.com**

Visit our corporate website at **cengage.com**

Printed in the United States of America
1 2 3 4 5 6 7 14 13 12

For my beautiful wife, Juli,
who brings focus to my life
and vibrance to my world.

About the Author

Gene McCullagh is an Adobe Community Professional and an Adobe Certified Expert in Photoshop Lightroom, Photoshop, and InDesign. A freelance photographer based near Dallas, TX, he belongs to the Professional Photographers of America (PPA) and the National Association of Photoshop Professionals (NAPP). Gene is the manager and co-founder of the Dallas Fort Worth Adobe User Group (DFWAUG). He has been involved with Lightroom since the original beta release and enjoys teaching photographers about this versatile tool. In addition to running Lightroom Secrets, Gene also moderates on the Adobe forums and helps users at Adobe's Lightroom Community Help site. He has published several feature articles in *Photoshop User Magazine*.

Acknowledgments

To paraphrase an old Zen adage, "You don't know what goes into a book until you write one!" Boy, is that ever true!

There are so many people who have contributed in one way or another to this project that it is just impossible to list all of them here. Still, there are those who, for me, stand out.

First, I must thank my family who continues to maintain the delusion that I am more talented than I really am. Their unending encouragement helped make this book a reality.

One of the people who continues to inspire me, and to whom I owe a hearty thanks, is Rick Sammon. Rick is such a talented and personable guy. He shares his advice freely and is always open to a quick email conversation. His friendly nature and humorous anecdotes really get you back to the fun of photography.

Of course, no book about Lightroom is complete without thanking Tom Hogarty and the Lightroom team for an excellent application.

My friends, A.J. Wood and J. Schuh, suffer from the same delusion as my family and have been great supporters over the years. These are two talented gents, so I am humbled by their encouragement.

A great source of advice and encouragement comes from four other Lightroom sojourners whom I have never personally met, yet I consider them friends and colleagues after so many years of correspondence and conversation: Anita Dennis, Laura Shoe, Victoria Bampton, and Sean McCormack. They have always been there with an inspiring thought or a great joke.

To my fellow Lightroom Gurus over at lightroomforums.net, thanks for all you do for the Lightroom community and to inspire me.

Last, and certainly not least, are the dedicated editors I have had the joy of working with on this project: Daniel Gasparino, Kim Benbow, and Donna Poehner. Without their talents and dedication to this project, you wouldn't be reading this now.

Contents

Chapter 4: Using the Side Door: Other Import Methods 55

Part 2: Let's Get Organized! 81

Chapter 5: Library—Part One 83

Chapter 6: Library—Part Two 129

Chapter 7: Organizing Your Images—The "Where" 167

Chapter 8: Organizing Your Images—The "What" 217

Chapter 9: Map 247

Chapter 10: The Good, the Bad, and the Ugly 275

Chapter 11: What's Your Preference? 311

Index 331

Note that Parts 3 and 4 of this book can be found online at the Cengage Learning companion website: www.courseptr.com/downloads.

Introduction

A beginning is the time for taking the most delicate care...
—Princess Irulan (from Frank Herbert's *Dune*)

Photography, and the technology that surrounds it, is an ever-changing art. From the earliest pinhole camera, through tintypes and glass plates, and on to film, photography remained chemically based. Hours were spent in a wet darkroom surrounded by chemicals. But in the last decade of the twentieth century, this began to change.

Digital photography arrived on the scene, and the world of photography was changed again. Images could be captured without the need for film. Those early digital cameras posed no threat to film photography. With low resolutions and sluggish capture times, film remained the standard. As with computers, however, digital imaging technology improved and advanced at an amazing rate. In just a few short decades, film has given way to the digital sensor. We stepped out of the wet darkroom and into the digital darkroom.

Adobe Photoshop Lightroom is my digital darkroom. I invite you to explore this unique and powerful program with me. There's a lot to see and do on this journey, and we'll have some fun along the way. At the end of this road lies the beginning of your Lightroom journey. So let's get started.

What Is Lightroom?

If you are new to Lightroom you might be wondering, "What is this all about?" Chances are you've come to the conclusion that the current way of dealing with your images just isn't working. You may be using one program to edit your images and another to tag and organize them. Perhaps your organization method is the hierarchical folder scheme we've all used over the years. When it comes time to put up a Web gallery or share your images on social sites like Flickr and Facebook, you turn to even more applications. It's confusing and at times frustrating. Just keeping track of what application does what and where all your images are is more work than you bargained for. Lightroom to the rescue.

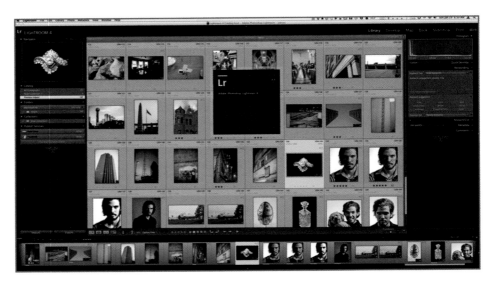

Figure I.1
Lightroom 4 user interface.

Lightroom is a rich and powerful application. It includes the following:

- A digital asset management system
- A keywording application
- An organizational tool
- An image editor
- A Web gallery creation tool
- An interface to social sharing sites
- A geotagging and mapping application
- A publishing system
- A custom print shop
- A slideshow program

And that's just the beginning. All this and more is rolled up into one single application—Lightroom. Not only are all of these features contained within one application, Lightroom has an underlying logic to it that will help you develop an efficient workflow.

Since the old cost restraint of film processing is gone, we just click away. It's easy to generate thousands of images with a digital camera in a very short time. Until now, your hard drive has been the proverbial shoebox of old photos. Take a few hundred

pictures. Dump the card onto the drive. Take a few hundred more. Rinse. Repeat. Well, it's time to pull that shoebox out of the closet and start organizing, enhancing, and sharing. Your images do you no good just sitting there. Let's get them into Lightroom and show the world how great you are.

What Lightroom Is Not

It is also valuable to know what Lightroom is not. You may already have Photoshop and Bridge. Perhaps you are using Photoshop Elements. Lightroom is not a substitute for those applications. However, if you are a photographer, Lightroom is a better choice overall. It is a more comprehensive solution to the problems that photographers face. Adobe built Lightroom from the ground up with photographers in mind.

Having said that, if you already own Photoshop, Photoshop Elements, or some other image editing software, don't erase them from your system. While Lightroom has some very powerful image-editing features, it doesn't do everything those dedicated image applications can do. For example, there are no layers in Lightroom. Compositing is not something you can do in Lightroom, either. To address those particular issues, Lightroom interfaces with external editors and plug-ins extremely well. You can continue to work in Lightroom and "round trip" your images to Photoshop or Photoshop Elements quite easily and efficiently.

By the time we reach the end of our journey, you'll have a much better understanding of what Lightroom is and isn't.

Who Should Read This Book?

If you are a photographer, this book is for you. Whether you are just starting to explore the joy of photography or you are a battle-scarred pro, there is something here you can use.

Nothing can drain the joy out of exploring the world with your camera quite like the nagging burden of a disorganized workflow. It can be frustrating if you can't find those great shots two years from now. If all those images just keep piling up and you don't have any good way to sort through them, find the winners, and enhance them into masterpieces, your camera starts to collect dust so you don't have to deal with the problem. You begin to wonder if woodworking would be a more enjoyable hobby or career.

Stop right there! Lightroom (and this book) can help.

How to Use This Book

You can approach this book in several ways. If you have used Lightroom before, you may just be interested in what's new in Lightroom 4. In that case, start with Chapter 1, "What's New In Lightroom 4?," and then skip to the sections that go into more detail about the new features that interest you.

If you are new to Lightroom, you may want to proceed through the book in order. Part 1, "Getting Started," will walk you through installing Lightroom on your computer. I'll also talk about the underlying logic to Lightroom's workflow and interface. Lastly, we'll look at the overall preferences and settings. I'll explain what they are, what they do, and how to customize Lightroom to your liking.

In Part 2, "Let's Get Organized," you will learn how to get your images into Lightroom. I'll walk you through the Library, getting organized with keywords and collections, and geotagging and mapping features. Rating, ranking, stars, flags, colors, and more will help you find the "keepers" and weed out the rejects.

Once you have a handle on organization, Part 3, "The Art of Lightroom," will let you get your artist hat on. I'll introduce you to Lightroom's rich palette of tools to edit your images. We'll talk about the approach Lightroom takes to image editing. You'll learn how to enhance and polish your work, how to make your images pop with color. We'll explore the rich tones of black and white and make adjustments to your entire image or just a portion. Here is where we will look at the role of external editors and plug-ins. Finally, we'll end with a workflow example so you can start to build your own.

Your vision can enrich the world. Leaving all those images to gather dust doesn't do you (or anyone else) any good. That's why in Part 4, "Sharing Your Work," you will learn to use all of Lightroom's output capabilities: printing, books, emails, slideshows, websites, and more.

This book can also serve as a reference. If you come across a feature you haven't seen before, you can read about it here. Trying to do something but not sure how? Your answer is probably in these pages. Can't keep the studio door open to let in some natural light? Hey, this book makes a great doorstop, too.

However you decide to approach this book, there is no wrong way. So just dive in and have fun.

Conventions Used

Lightroom is a cross-platform application. It is available for both Mac OSX and Windows. Personally, I prefer working on a Mac. (OK—keep it down, Windows

friends.) In Lightroom's case, that's not a problem. There are very few differences between the Mac and Windows interfaces and key combinations. So to save you from reading through double keystrokes, I will be using the Mac keyboard combinations when illustrating shortcuts. In nearly every instance the Mac/Windows key equivalence will be the same:

Mac	Windows
Command	Ctrl
Option	Alt

If you are a Windows user and you see the keyboard shortcut Command+R, you can interpret that as Ctrl+R on your keyboard. For those rare cases where the keyboard shortcuts do differ, I will indicate the combination for each operating system.

Related Tips will appear in the text like this:

TIP

This is a Tip.

I'll warn you about potential problems or dangers with a Caution, like this:

CAUTION

Watch out for this!!

When there is an interesting related bit of information, you'll see a Note:

NOTE

Here is an interesting thing you should know.

Now that we have all of the housekeeping details out of the way, let's get started.

Companion Website Downloads

You may download the companion website files from www.courseptr.com/downloads. Please note that you will be redirected to the Cengage Learning site.

Part 1

Getting Started

The beginning is the most important part of the work.

—Plato

Before you can dive into the inner workings of Lightroom there are a few things that need to be done. Rather than tuck these things away in an appendix, I think it is better to deal with them right up front.

I've talked with many photographers who sooner or later ran into problems working with Lightroom. In most cases the solution is found early on in their relationship with the application. When we talk it over and look under the hood, we find there is a misunderstanding of the underlying logic Lightroom employs, or there is a setting or two that can easily correct the issue at hand. Invariably these users wish they had taken the time in the beginning to build a proper foundation before dumping their images in and running headlong into the fray.

A little patience is in order before we get to the meat of the matter. You could, of course, skip this part of the book. But I believe you will have a better time with Lightroom if you don't. First we'll take a look at what new things Lightroom 4 has. That should whet your appetite enough to get you through the most basic first step—installation.

The opening image for Part 1 (on the facing page) courtesy of Daniel C. McCullagh.

1

What's New In Lightroom 4?

There are always new and interesting features to explore when a new version of Lightroom is released. Lightroom 4 is certainly no exception. In fact, there seem to be more new features in this latest release than I've seen before. The Lightroom team is definitely listening to our suggestions.

The list of new features is long, but five of them are big news. So let's start with the big five, and then we can touch on all of the other enhancements that make Lightroom 4 a great release.

New Process Version

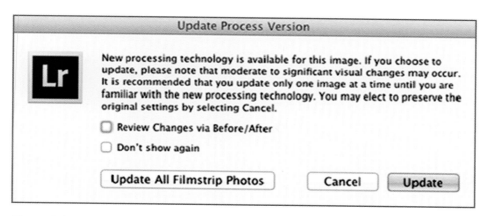

Figure 1.1
The Update Process Version dialog.

That's right. Lightroom 4 brings with it a new Process Version—PV2012. This new Process Version can take your images to a whole new level. If you thought Lightroom 3's PV2010 was groundbreaking, wait until you convert your images with this.

PV2012 fundamentally changes the way Lightroom deals with and interprets your image's underlying data. This opens up new controls for you in the Develop module and the Basics panel in the Library module. Many of the difficulties faced in earlier versions have been addressed here. You can push your images even further than before.

If you experienced issues when adding clarity or trying to wrangle tonal ranges, you will be very pleased. Images that exhibited halos or started to fall apart when applying extreme adjustments will appear much better with this new Process Version.

Of course, as we discovered when making the switch from PV2003 (the original Process Version used in Lightroom 1 and 2) to PV2010, not every image will benefit from the change. So take your time and convert a few images to see how they react. You will need to make a few adjustments after the conversion in most cases. However, I think you will find that PV2012 makes your photos shine.

We'll spend a lot more time with this when we talk about developing your images.

Soft Proofing

Figure 1.2

Lightroom 4's new Soft Proofing interface.

Wow. This one is huge.

If you spend any time creating your own prints you are gonna love this. No longer is it necessary to go out to Photoshop to soft proof your images before committing them to paper. Quality paper is expensive, after all.

With the addition of soft proofing you can examine colors that fall outside your monitor's gamut. Apply the profiles for the printers, papers, and inks you will use, and Lightroom can show you colors that are out of gamut for print. You can easily create proof copies, and Lightroom will automatically name them with the profile the proof is using.

This is definitely a feature that many have asked for since Lightroom 1, and now it is here. Combine this with a new adjustment feature in the Print module, and we can handle many of our print jobs all in Lightroom.

I am really glad to see soft proofing finally in Lightroom. If you haven't tried your hand at making prints, this may be your opportunity. It is a very satisfying part of photography. Go for it.

Maps

Figure 1.3

Geotagging.

Aye, there be dragons here. Get your maps out matey.

Lightroom now does geotagging. Not only that—it does reverse geotagging, too. So if your camera is GPS enabled, your images will automatically appear on the map. If you don't have GPS in your camera, you can still easily tag them with a simple drag and drop.

The new Map module even accommodates GPS loggers. Many photographers wear a small GPS logger on their belt or attached to their camera strap. As they travel around, this logger takes location readings at regular intervals. The log can be brought into Lightroom, and images whose time stamp falls in the logger's ranges will get the coordinates from the log. It sounds more complicated than it is. We'll look at this in more depth when we cover the Map module.

Another neat feature of the Map module is the capability to save frequent locations by name. You can even mark some of these saved locations as private. That way you can see them on the map, but any geolocation data is automatically stripped from the metadata when you export it. So you don't have to be concerned that the paparazzi can find your compound when you post those birthday party pictures to Flickr.

Books

Figure 1.4

Books come to Lightroom 4.

Assembling your master works in a printed book is a marvelous way to share your vision with someone. It is a very tangible expression of your images. Lightroom 4 makes it easy to create books. (And yes, there is the added benefit of not having to hear from Aperture users about Lightroom's lack of book layout features.)

Adobe has partnered with Blurb (www.blurb.com/lightroom) for this feature debut. There are 180 professionally designed page layout templates you can use to design your book. Even if you decide not to print your book, you can export it as a PDF and share it electronically.

To assist you in designing your book, there are helpful guides for layout and page bleeds. Cell padding is available in both image and text cells. Speaking of text, the Book module incorporates some powerful type tools based on the type of technology found in Photoshop and Illustrator.

You can set background colors and include images and graphics book-wide or on a single page or spread.

In addition to designing books, you can save them directly in Lightroom. Automatic page flow is available based on parameters you can set up ahead of time. Images, pages, and spreads are easily rearranged. Every image can be zoomed or panned within the page frames you design.

The new book module is a welcome feature and a great deal of fun. We will spend some time examining its many features and controls in a later chapter.

Video

Video is becoming ubiquitous. It won't be long before every camera on the market has video capabilities. That presents a new challenge to photographers. Where do we store these clips, and how do we keep track of them? Lightroom 3 took some first steps into this arena by allowing us to import video files into our Lightroom catalogs. That was pretty much it. But at least we could keep track of them.

Lightroom 4 ups the ante and adds some more video-specific features. Like Lightroom 3, you can import video into your catalog. But now you can do some basic editing by trimming the start and end points. Even better, many of the Develop module adjustments are now applicable to video clips.

It is now easy to capture individual frames as still images. You can also set the poster frame for a video clip. That's what you'll see in the Library module as the video's preview image. You can scrub through the video right there in the Grid view. Not only that, video plays directly within Lightroom instead of launching an external player. It's certainly not Premiere Pro, but it is a significant step forward for video handling in Lightroom.

Figure 1.5

Lights! Camera! Action! New video tools in Lightroom 4.

Other New Features

The list of new features goes on.

Shadow and Highlight controls are now content aware. This lets you squeeze all the dynamic range you can from a single image. HDR processing is useful but can be time-consuming, especially when all you need is more range boost in a single capture.

Clarity just got better. Go ahead and pump it up. You'll see far less artifacting than before.

Chromatic aberrations can now be auto-corrected with a powerful new algorithm.

You just got more paint for your local adjustment brush. Added to the pallet are these:

- Noise reduction
- White Balance (Temperature and Tint)
- Shadows
- Highlights
- Moiré

The Develop module gets individual RGB curves.

It is now possible to email images directly from Lightroom. You can set up multiple accounts for your native email client, popular online email providers like Gmail and Hotmail, and even accounts hosted on your servers. The new email capability ties into email export presets to control the size and quality of attached images.

DNG gets a significant refresh in Lightroom 4. There is a new option to embed Fast Load Data, which can significantly improve load times in the Develop module. Raw files can eat up your hard drive space quickly, so DNG now offers a lossy compression option. Don't be put off by the term "lossy" just yet. This isn't lossy in the JPEG sense but a compression technology that can dramatically reduce the file size of a DNG with a minimal impact on quality. This is ideal for most of your DNG files. For the five-star masterpieces, you may want to retain the complete DNG raw data, but for most others this can save you a lot of drive space. If you like to shoot raw time-lapse, then this is definitely an option to look at. Metadata and filter options have been added to accommodate these new DNG files.

Video files can now be added to Publish Services collections. This simplifies the sharing process with those sites that support video file uploads. Now you can maintain all your shared data in a Publish Services collection.

There is a new Publish Service for Adobe Revel. (Revel was originally released as Adobe Carousel.)

You have been able to save specialized collections for other modules for a while now. This was a feature that was, frankly, underrated and obscure. Lightroom 4 highlights and improves this feature. Now you will see obvious buttons to save your creations in the Book, Slideshow, Print, and Web modules. This makes it much easier to create variations you can call up again with the click of a mouse.

Two new zoom ratios have been added—1:8 and 1:16.

It is now easier for you to work on your files and folders in the Folders panel. Lightroom 4 adds multiple folder move capabilities. Previously you could only drag one folder at a time.

The sample area you see when using the White Balance tool is now zoom-level dependent. This stabilizes the White Balance tool, especially in noisy images. Until Lightroom 4, the sample window was image-space dependent. That is, one image pixel equaled one White Balance tool pixel. No matter how you zoomed your image, this one-to-one pixel relationship stayed constant. In noisy images this was a problem. Now the sample size is tied to your screen pixels. So one pixel on your screen equals one White Balance tool pixel. Since the size of the pixels on your screen is constant, they can cover more or less of the image pixels, depending on your zoom level. If you have used Adobe Camera Raw, you are already familiar with this distinction.

Previously you had to make sure you were zoomed in on your image to 1:1 or greater to see any effect from noise reduction adjustments. Now noise reduction adjustments are displayed regardless of your zoom level, although I still recommend you zoom in so you can clearly see what is happening. Even so, you can get a sense of the overall impact that noise reduction is having with this new capability.

If you are a tethered shooter, you will be glad to hear that you can now collapse the Tether toolbar down to just the shutter release button. Now you don't have to keep moving the toolbar around because it covers up important details on your screen.

Another new feature for tethered shooters is the Layout Overlay. You can now use a layout template as an overlay during your shoot. For example, if you are shooting for the cover of a magazine, you can bring in a mockup of the cover with open space where the photo will go. This will be overlaid onto the image viewing area so you can get a sense of placement and whether the image will work in the layout. You also have the ability to change the size of the overlay, move it around the screen, and fade out those parts of the image that don't fall within the Layout Overlay.

What's that you say? You never used the Web module? You're tired of seeing it there every time you enter Lightroom? Lightroom 4 now gives you the option to turn individual modules on and off. In the same way you can hide individual panels, you can uncheck those modules you don't want to see, and they will disappear from the module picker.

You'll gain more control over your Publish Services collections. Before, whenever you made an adjustment to an image that was in a Publish Services collection, it was automatically set to republish. Now you can set them to not republish.

There's a new filter option for saved and unsaved metadata.

Develop presets are a wonderful thing, aren't they? But they could get unwieldy as you collect and create more and more of them. Although you could put them in folders in the Presets panel, when you tried to access them in a menu you got a long and seemingly endless scrolling list. Say goodbye to that. Lightroom 4 now honors the folders you've created for your presets and presents them in a hierarchical fashion in menus. Just expand the folder that contains the preset you're looking for and you're all set.

Export now features some additional metadata controls. No longer are you limited to the less than descriptive "Minimize embedded metadata" option. The new controls feature a drop-down, so you can fine-tune what gets included as well as the ability to include or exclude geolocation data.

Users of Windows 64-bit versions can rejoice—disk burning has finally been fixed.

Flag status is now global. Previously, the pick/reject flag status of an image was local to its container. So an image could be flagged as a pick in one collection, a reject in another, and unflagged in yet another. Now the pick/reject status of the flag will be the same no matter what context you view the image in. (Personally, I think this is a mistake. I'll have more to say on this later.)

If you are a big fan of stacks, you'll be glad to know that stacks now work inside of collections. Previously your stacks were confined to images contained in the same folder. There's also an additional benefit here. Within a collection, you can stack images regardless of what folder they live in.

Flash-based galleries are now color-managed.

If you've used Lightroom in previous versions, you are (or should be) familiar with The Five Rules. I am sad to say that these are gone in Lightroom 4. In their place, however, are useful walkthrough tips for each module. The first time you enter a module, these walkthrough tips will appear and highlight different parts of the interface to give you a sense of what's going on in that module. You can dismiss them if you like. If you want to see them again, they can be activated from the Help menu. Even though The Five Rules have ridden off into the sunset, it will always serve you well to remember Rule 5—Enjoy.

2

The Lightroom Way

We see the world in a different way. Vision drives us to look for the shot. Grab a moment in time. Returning from a day of shooting, we have cards full of images. In times gone by it would have been rolls of exposed film (or plates of glass). The technology of photography changes, but the problems remain the same.

How do we process these images and separate the keepers from the rejects? Where do we store them all? How do we find them later? We don't want to deprive the world, so what do we do to share our images? Lightroom addresses all these issues and more.

Before Lightroom, many of us dealt with this part of photography by using different programs to address different issues. Perhaps you used a database of some kind to record file locations, descriptions, captions, or keywords. Maybe you found a program that could write some of this data into the image file. Some used the time-honored system of pen and paper to keep it all under control. It was a lot of work.

Chemicals gave way to pixels. Photoshop and other digital image editors opened new and exciting creative avenues to us. They also added more work. Keeping track of different versions of an image was challenging. In fact, working with different versions chewed up disk space quickly. As cameras yielded more and more megapixels, files only grew larger.

To appreciate what Lightroom brings to the game, it is important that we understand some of the underlying logic and philosophy of the Lightroom Way. No system is perfect, but Lightroom offers an elegant solution for photographers. And that's the first thing to emphasize—a solution for photographers, not designers or professionals or graphic artists. Photographers.

Let's take a look at what makes Lightroom's approach different.

Nondestructive Change

Lightroom is nondestructive. Let me say that again. Lightroom is nondestructive.

This is probably the most significant thing that Lightroom brings to the photographer's workflow. If you are used to using an image-editing application like Photoshop, you know how easily you can destroy your original image file. You start adjusting this and tweaking that. Clone out a few dust spots. Change the color balance. Play with levels and curves. Then you save your work. But what if you come back in a day or two and don't like the result anymore? What if your client says, "That's hideous. Fix it"? If you didn't take extra measures to preserve your original image file, you are out of luck.

Photoshop and other image editors like it are destructive by nature. That doesn't mean you need to put Photoshop in the corner for a time-out until it gets less destructive. It just means that the burden is on you to remember to protect your originals. This means that you either have to make a copy of your file to work on or remember to duplicate the background layer and lock it so you always have the original pixels to go back to. Either way you are going to use more disk space with these extra copies or enlarged files. Disk space may be less expensive today, but that really isn't the issue. How will you keep track of all those additional files? What if you want two, three, four, or more versions of an image? How will you back up all of that in case your drive crashes?

Lightroom saves you from all of this. When you make changes, your original image file remains untouched. It all happens in Lightroom. If you need 27 versions of an image—no problem. Lightroom will let you have as many versions as you want, and still your original file remains untouched. Not only that, you won't have 27 additional files cluttering up your drive. Lightroom manages the versioning and uses virtually no disk space to do it.

Lightroom is nondestructive. However, there are certain actions you can take in Lightroom that will change (and potentially damage) your original image file. I'll point these out as we go along. They are few in number. Certainly there are far fewer opportunities to damage or destroy your files in Lightroom than there are in traditional image editors. But be aware that it is possible.

The Catalog Concept

The way Lightroom deals with your files can be very confusing at first. We're pretty used to the metaphor of files placed in folders placed in other folders as a way of describing how things live on our drives. We are familiar with the way the Finder or Windows Explorer shows us this structure. We point it at a drive and drill down to the folder we want. There we see all of the files that reside in that folder. Unless a file is hidden by the operating system, we see whatever is there. And even the hidden files can be revealed by changing the settings. Lightroom doesn't work that way.

Applications like the Finder, Windows Explorer, and Adobe Bridge are file browsers. Their function is to show you whatever is on the drive or in the folder you point them at. You really don't have to do much more than that. They will dutifully report what they see.

Lightroom is not a file browser. It deals with your files in a different way. Before you will see anything in Lightroom, you must import it into a catalog. The catalog is not the same as the drive. It refers to what's on the drive and keeps track of it.

When talking with photographers about this, I find it useful to employ a few metaphors to help them understand Lightroom's catalog. One way to think about it is that the catalog is like the card catalog at a library. (You remember those don't you?) If you want to find a book on Ansel Adams, you would go to the card catalog and go to the drawer with the photography cards. Dig in and find the photographer cards. Now thumb through the last name until you find Adams. Finally you find a group of cards for Adams, Ansel. Each card describes a book somewhere in the library. The card for *The Camera* (Ansel Adams Photography Book 1) tells you what shelf the book is on. You go to that shelf, and there is the book. The card, however, is not the book. It is just a reference to the book. If you get to the shelf and the book isn't there, then either it has been moved somewhere else or it is gone. The card catalog still has the card, however.

Lightroom's catalog is like that card catalog. When you see a file there, it is only a reference to the physical file somewhere on the drive. If that physical file gets moved or deleted Lightroom will still show it. Its representation of the file is like the card. Even though the book is not there, the card is still in the drawer.

If you prefer a more modern example, think about links. You are trying to find a website about Ansel Adams. So you fire up your browser and head over to your favorite search engine. Type in **Ansel Adams** and get back a list of sites. Each has a link to that site. If you click the link and get a 404—Page Not Found error, then the page is not there. The link is like the card, and the missing page is like the missing book. The link is not the page.

This concept of catalog is fundamental to the way Lightroom works. I've had quite a few conversations with users who didn't yet get this concept. They call or email in a panic. "Where did my images go? I can see them, but Lightroom won't let me work on them." Some continue to duplicate files in order to make different versions of an image. Not understanding the concept of catalog causes them to lose some of the benefits to be gained from Lightroom.

So what is the catalog? It is a database. Just like the card catalog or the search engine results, it is an organized collection of pointers or references to physical files. The moment you understand this, you will avoid a whole host of problems. You will understand why Lightroom behaves the way it does. And you'll be able to fix most problems quickly.

Lightroom Logic—A Modular Approach

Lightroom has an underlying logic and flow to it. It is designed to make your workflow smoother. You may have a workflow now that is comprised of several applications. Each has its own way of doing things. You overlay these applications with certain procedures that tie them together into a workflow that helps you get to a finished product. It works... but it's a lot of work.

Lightroom is a comprehensive application that brings all of the workflow steps a photographer needs into one application (Figure 2.1). Different parts of your workflow are dealt with in different modules. But since Lightroom is a single application, there is continuity between the modules. That's a great benefit because you no longer have to get used to multiple interfaces across a variety of applications.

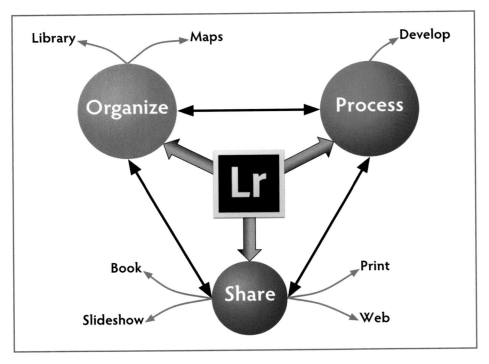

Figure 2.1

Lightroom 4's modules are interrelated and cover the three areas of post-production—Organize, Process, and Share.

Figure 2.1 illustrates how Lightroom handles these different parts of a photographer's workflow. There are basically three stages you deal with when working on your images:

- Organize
- Process
- Share

If you are like me, this isn't a linear process. I spend much of my time bouncing between the Organize and Process stages before I consider the Share stage. Even then, I may return to Process and Share again. So these are all connected in the workflow. Lightroom stands at the middle tying it all together.

Each stage is addressed by one or more of Lightroom's modules:

- Organize
 - The Library module
 - The Map module
- Process
 - The Develop module
- Share
 - The Book module
 - The Slideshow module
 - The Print module
 - The Web module

Even though tasks are contained within certain modules, you shouldn't think that this makes Lightroom rigid or inflexible. Quite the opposite is true. There is a fluidity you will come to know after working with Lightroom for only a short time. Modules are easily changed with keyboard shortcuts or the click of a mouse. The subject of your work follows you throughout the modules. There are even controls in some modules that, while they really belong in a different module, make sense where they appear.

One example of this is the Quick Develop panel in the Library module. Developing tools should be in the Develop module. But these basic adjustments make sense in the Library module. They allow you to perform basic adjustments on images while you are organizing them in the Library module. So if you see an image that's just a bit too dark, bump up the exposure. If it's a little washed out, perhaps some saturation is in order. The idea here is to prevent you from having to switch back and forth between the Library and Develop modules for such small and basic adjustments. That helps you stay focused on the main task at hand in the Library module—Organize.

Go with the Flow

As I've mentioned, there is a flow to how Lightroom works. Take a look at the user interface (Figure 2.2).

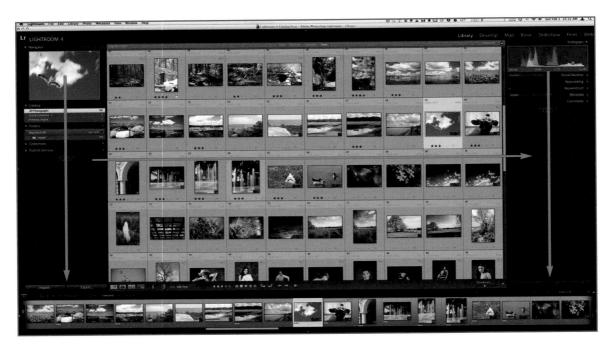

Figure 2.2

There is a logical flow to the user interface.

The basic pattern is to move through the interface from left to right. That's left to right across the modules and left to right within each module. Within a module you work the interface top to bottom as you move left to right. This might seem confusing to you at the moment. But as soon as you get into Lightroom and start working with it, this will make much more sense.

The module picker (Figure 2.3) reinforces this. Refer to the stages discussed earlier in this chapter—Organize, Process, Share. "But those modules aren't in the right order," you say. That is true. The Map module is part of the Organize stage and should be next to the Library module. Instead, the Develop module appears. There is a reason for this slight disruption in the module order.

Library | Develop | Map | Book | Slideshow | Print | Web

Figure 2.3

The Lightroom 4 module picker.

You will spend most of your time between the Library module and the Develop module. There is a constant back and forth between these two (Figure 2.4). Putting them next to each other in the module picker reinforces that and makes it just a little easier for you if you like to switch modules with a mouse.

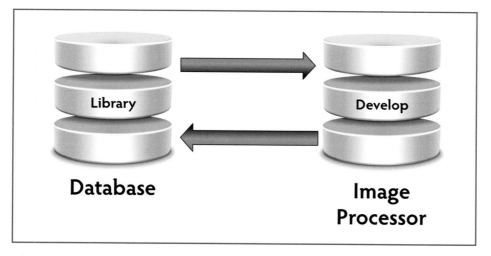

Figure 2.4

There is a strong relationship between the Library module (Database) and the Develop module (Image Processor).

A Quick Walkthrough

Figure 2.5 shows the Lightroom interface for the Library module. Each of the other six modules has the same basic layout. This interface supports and encourages a certain flow. It guides you through the steps you need to take in each module to reach your goals.

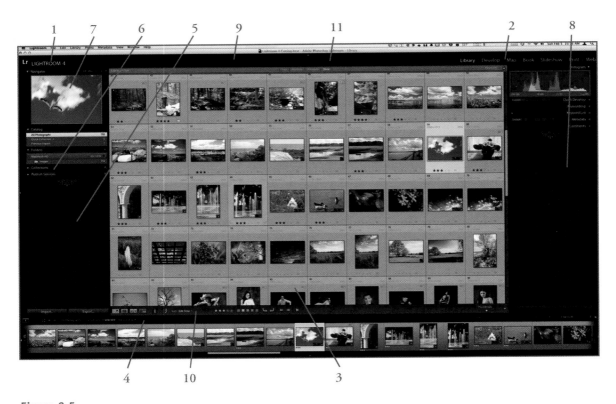

Figure 2.5

There are many parts to the Lightroom 4 user interface.

The top panel contains the Identity Plate (1) and the module picker (2). This top panel appears in all seven modules. It lets you switch easily between modules and, as we will see later, brand your copy of Lightroom.

The bottom panel contains the Filmstrip (3). The Filmstrip also appears in all seven modules and gives you quick access to your images without having to switch back to the Library module. At the top of the Filmstrip, you will notice a toolbar (4). This toolbar appears with the Filmstrip in each of the modules and provides tools to change the selection of images that show in the Filmstrip. There are also tools to control two monitor displays and jump back to the Grid view in the Library module.

The left panel group (5) contains panels that let you deal with your source images, collections, presets, and so on. Of special interest here is the Collections panel (6). This panel appears in all seven modules. Again, this is to minimize the need to bounce between modules by giving you instant access to all your collections. The Navigator (7) (called Preview in some modules) also shows up in each module. But its function is more module-specific and usually serves as a way to preview something before taking an action or to provide a quick way to move around a zoomed-in image.

The right panel group (8) is different in each module. Here is where the panels that contain all the controls for that particular module reside. Adjust your images. Crop them. Set up your books. Annotate your slideshows. All of these controls can be found in the panels in this group.

In the center of the interface is the viewing area (9). Each module presents information here that is relevant to that module. For example, in the Library module you would see all of your images, thumbnails (in Grid mode), or one image will fill this area (in Loupe mode). The Book module uses this area to show your book layout. What will appear on paper is shown here in the Print module. At the bottom of the viewing area is another toolbar (10). These tools change according to what module you are in. Lastly, at the top of the viewing area is one more toolbar (11). This shows up in all modules except the Develop module. It changes function from module to module. For example, in the Library module it houses the filter options. In the Book module it has buttons to save or clear your book layout.

We will explore each corner of this interface before we're done. Consider this an appetizer and an introduction to Lightroom's interface.

Let's Go

Well. We've covered quite a bit of ground so far. This initial conversation is important so that you understand a bit about what's behind the application and why things work the way they do. But I imagine you are anxious to get into Lightroom and see where it takes you.

We'll start at the beginning. When you start Lightroom, you create a blank catalog. Nothing can happen until you get some images into your catalog. In the next chapter we will find out how to do just that. So, if you're ready...let's go.

3

Getting Images into Lightroom

It's been a long day. But what a session you had. Your cards are full of money shots. You can't wait to work your post-production magic. Before any of that magic can happen, you need to get your images into Lightroom.

When you start Lightroom with a new empty catalog, you are greeted with the message "Click the Import button to begin."

Already Lightroom is being helpful. The Import button is the first and most common way to get images into your catalog. And that's where we'll start.

The Import Dialog

You can take Lightroom's advice and click the Import button (Figure 3.1). You will find the Import button at the bottom of the left panel group in the Library module. When you first create a new catalog, Lightroom takes you to the Library module by default. If you are working with a catalog that already has images in it, Lightroom will open to whatever module you were in when you closed Lightroom last. To get to the Library module, click Library in the module picker or use the keyboard shortcut Command+Option+1.

As we will see throughout our Lightroom journey, there is usually more than one way to do anything or get anywhere. Import is no different. Using the menus, click on File > Import Photos and Video (Figure 3.2). There is also a keyboard shortcut for Import— Shift+Command+I.

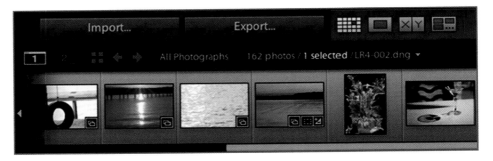

Figure 3.1
The Import button is at the bottom of the left panel group.

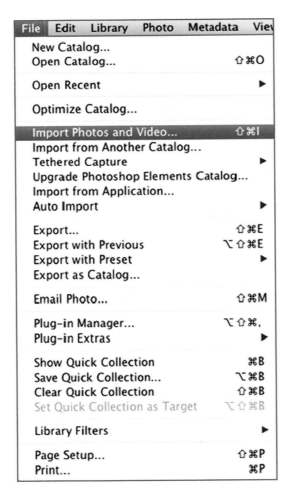

Figure 3.2
Import is available from the File menu.

Whichever method you choose, Lightroom will present you with the Import dialog. If this is the first time you are importing images, the Import dialog will look rather small (Figure 3.3). Don't be deceived by its apparent simplicity. All the power of the expanded version of the Import dialog is contained here. In fact, if you develop an import workflow, this version of the dialog may be what you use regularly.

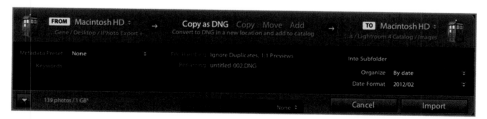

Figure 3.3
The basic or collapsed version of the Import dialog.

The full Import dialog (Figure 3.4) has all of the features of its smaller sibling, so rather than discuss the same features twice, let's start there.

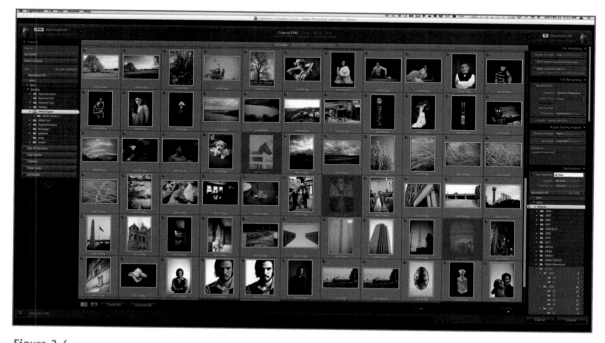

Figure 3.4
The full Import dialog.

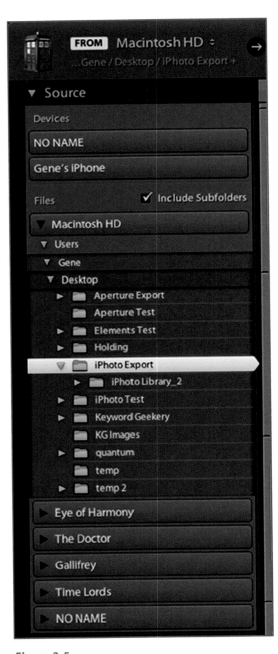

Figure 3.5
The Source panel.

To switch between the collapsed and expanded versions of the Import dialog, click on the small triangle in the lower-left corner of the dialog. The full Import dialog has a lot going on, but remember the discussion earlier about the basic flow in Lightroom—left to right and top to bottom. It's the same here. Where do we get the images? What's the source? How should we import them? Which images do you want? Where will we put them? What's the destination? Should we do anything special to them?

The import process is as easy as answering these questions. In each area we'll move from top to bottom through the panels Lightroom provides in order to guide us.

Source

The possible sources of your image files are listed in the Source panel on the left of the dialog (Figure 3.5). Here you will see two subcategories: Devices and Files.

Devices

The Devices section will list any devices attached to your computer that contain importable images. Some devices you might see here include:

- Your iPhone
- Your iPad
- Your camera
- An internal card slot
- An external card reader

You can select a device as the source of your images by clicking on its name. If it is an ejectable device, such as an SD card, choosing it will add an Eject after Import checkbox (1) next to Devices (Figure 3.6). Checking the box will tell Lightroom to automatically eject the device once the import is complete. This can be handy if you have one card reader and several cards to import. After each import the card is ejected. Then you can swap in the next card and import the images, and that card will be ejected. This is a little more efficient and quicker than having to drop back to your OS to eject each card.

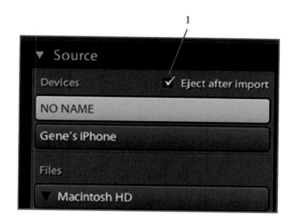

Figure 3.6

Lightroom offers to eject your media for you if you choose.

NOTE

You will receive a warning occasionally. If another application, or the OS itself, is still using the device, it may not eject as expected. When this happens, you will need to manually eject the device.

Files

The Files section presents you with all the volumes or drives on your system. These can come from

- Internal drives
- External drives
- Any attached device with a folder structure (i.e., cards, cameras, etc.)

To the left of each drive is an expansion triangle. Clicking this will expand and collapse the view of that drive's folders. Additionally, every folder that has one or more subfolders will have an expansion triangle to the left of its name. Clicking these performs the same function for that folder—showing or hiding the subfolders contained in that folder.

When you choose a drive with subfolders, Lightroom adds another option at the top of the Files section, Include Subfolders (1) (see Figure 3.7). Checking this box tells Lightroom to present you with images from the chosen folder and all of its subfolders.

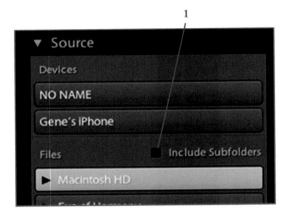

Figure 3.7

Lightroom offers to show you just one folder's images or all images in a folder and its subfolders.

As you might expect, this can get out of hand quickly if you have lots of images in multiple subfolders. In Figure 3.8 I've selected the folder 2006 (1). Since the Include Subfolders box is unchecked, nothing appears. At the bottom of the left panels section you see the size as 0 photos/0 bytes (2). This is because the folder 2006 does not contain any images itself. It contains folders and subfolders that contain images.

If I check the box (1) and tell Lightroom to show me what's in those folders and subfolders, I see everything there (Figure 3.9). Now the size (2) is reported as 38 photos/187MB. I haven't changed my selection (the folder 2006 (3) is still selected), but Lightroom is now showing me everything contained in that folder and all of its subfolders.

However, if I were to choose a folder that is further up in the hierarchy, I might get a size report like 12923 photos/102 GB. In that case, checking the Include Subfolders box may make my task overwhelming. Not only that, Lightroom will slow down considerably as it churns through all those folders and subfolders gathering images to present to you. I recommend you leave this unchecked until you have chosen the appropriate folder. It's up to you in the end, though.

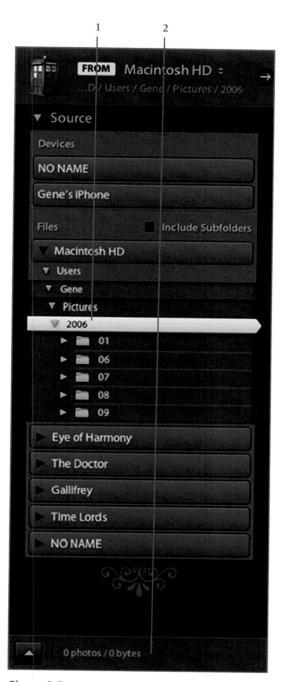

Figure 3.8
Include Subfolders is not selected.

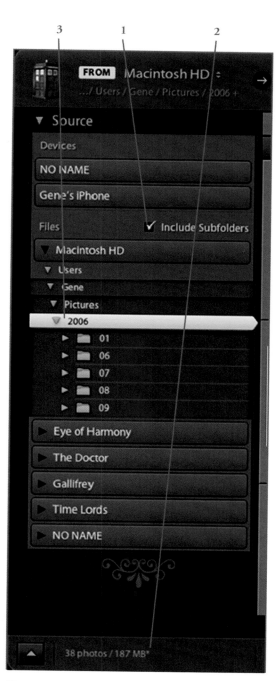

Figure 3.9
Include Subfolders is selected.

TIP

In addition to the checkbox, Lightroom shows you a message in the main viewing area:

No photos found.

Right below that is a button titled Include Subfolders, which performs the same function as the checkbox (Figure 3.10).

Figure 3.10

There is also an Include Subfolders button in the main viewing area.

If you don't like scrolling around to get to your folder, you can dock any folder. Right-click (or Control+click on a Mac with a single-button mouse) on the folder and choose Dock Folder from the contextual menu (Figure 3.11). Doing this will collapse all folders above this one (so you can see the path to the folder) and hide all other folders at the same level in the hierarchy (so you can concentrate on just that folder). See Figure 3.12.

TIP

If you have a single button mouse on a Mac, you can perform a right-click by holding down the Control key and clicking. But here's the real tip: If you are still using a single-button mouse, stop reading now and go buy a different mouse.

Macs are perfectly capable of supporting a mouse with more than one button. You can save yourself a lot of time and easily access contextual menus if you have at least a second button.

So for the remainder of this book, I will only refer to *right-click* and forego the constant reminder to use the Control key with single-button mice.

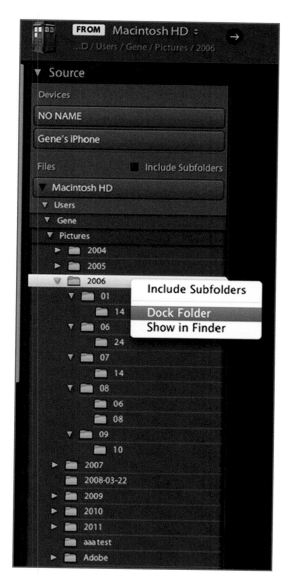

Figure 3.11

Right-click and choose Dock Folder to focus in on a particular folder.

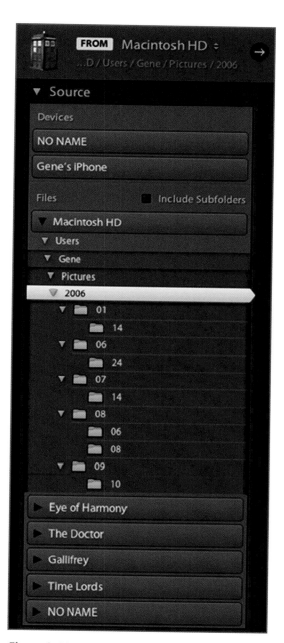

Figure 3.12

Here is the result of docking a folder. It provides a less cluttered interface so you can focus on a particular folder.

If you want to undock the folder, follow the same procedure (right-click on the folder) and uncheck Dock Folder from the contextual menu. Double-clicking on the folder will also dock and undock it.

At the top of the left panel group, you will see an area labeled FROM (Figure 3.13).

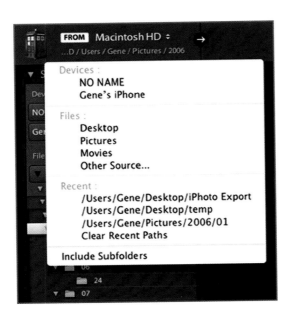

Figure 3.13

The FROM label acts like a button. Clicking it will present different image source options.

In addition to showing you the device or drive chosen, the path to your images, and an icon representing the device or drive, this area is actually a big button (1). Click it to see a contextual menu (2) with the following options:

Devices: Listed here are all the devices currently attached to your computer (iPhone, iPad, card reader, etc.). Click any device to choose it.

Files: Here you will find common image sources listed such as your desktop, pictures folder, movies folder, and so on. Clicking one of these will bring you to those image files. There is also a choice called Other Source available. This option opens a Finder window (an Explorer window on a Windows PC) letting you navigate to images anywhere on your system.

Recent: Several of the paths you recently imported images from will be listed in this section. You can quickly return to one of them by clicking the path here. There is also an option to Clear Recent Paths should you want to erase them from the menu.

Include Subfolders: Yet another way to include images from subfolders. Click it to include them (and a checkmark will appear next to it). Click it again to exclude them (and the checkmark disappears).

You aren't limited to choosing just one folder. You can select multiple folders. To select a group of folders that are contiguous, click the first folder. Hold down the Shift key and click the last folder. This will choose those two folders and all of the folders in between (Figure 3.14). If the folders you want are not contiguous, use the Command key. Click the first folder. Then, while holding down the Command key, click on any other folders to add them to your selection (Figure 3.15).

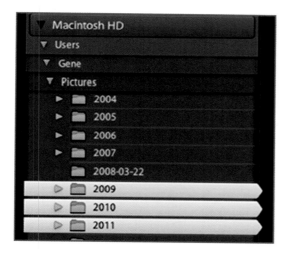

Figure 3.14

Contiguous folders selected using the Shift key.

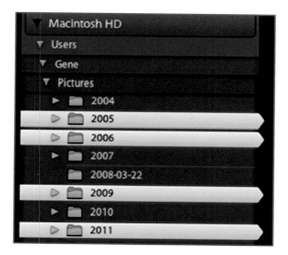

Figure 3.15

Noncontiguous folders selected using the Command key.

Action

Now that we have our sources selected, it's time to move to the right.

Four action choices are presented at the top of the dialog (Figure 3.16). As you select each one, Lightroom provides some helpful information about that action directly below the action list:

- **Copy as DNG:** Convert to DNG in a new location and add to catalog.
- **Copy:** Copy photos to a new location and add to catalog.
- **Move:** Move photos to a new location and add to catalog.
- **Add:** Add photos to catalog without moving them.

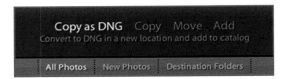

Figure 3.16

Four import actions are available.

These four import actions give you some flexibility when importing your images into the catalog. The first two actions, Copy as DNG and Copy, are, as the names imply, copy functions. Choosing either will leave the original image files on the source device while making copies to your destination. Those images will be added to your catalog. When the operation is complete you will have two copies of every image.

The Move action moves the images from your source device to your destination while adding them to the catalog. Move here is used in the same way your OS uses it— it copies the file to the destination and then deletes it from the source device.

> **CAUTION**
>
> Personally, I never use the Move action, on the off-chance something could happen during the copy stage that might damage the file. That would leave me with a damaged file and no original (since it will already have been erased from the source device). But I do know many photographers who use it regularly. If you are overly cautious like me, then I recommend you skip this action.

The last action, Add, merely adds the images to your catalog and leaves the files where they are. This is a great option if you manage your folder structure yourself or use another application to copy the images from your card to your drives. It saves a lot of time since nothing needs to be copied or moved.

Whenever you are adding images to your catalog that reside on more transient devices such as your iPhone or the card from your camera, Lightroom tries to protect you by only offering the first two copy options to you (Figure 3.17). The Move and Add actions are grayed out (1). Both of these actions are inappropriate when dealing with these source devices. In the Move action, the original files would be erased from your card. If any of the images were corrupted during the import, you would be left without a file to go back to.

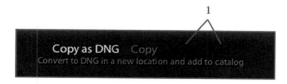

Figure 3.17

Lightroom will try and protect you when importing from devices like CF or SD cards.

Add is also not a good idea for devices like cards because it leaves the image files wherever they are. In this example that would be your card. Once you ejected the card, Lightroom would no longer have access to the original image files.

The Grid and the Loupe

Continuing our journey through the Import dialog, let's move down a bit. At the top of the main viewing area is a small bar with viewing options that let you change what images will appear (Figure 3.18).

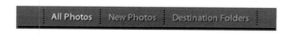

Figure 3.18

Choose what images you want to appear in the main viewing area.

There are three choices:

All Photos: This is not a filter at all but tells Lightroom not to filter the images. It will show you all images from the source device.

New Photos: When the Don't Import Suspected Duplicates option is checked (we'll talk about this in a moment when we get to the Options and Destination panels), Lightroom will only display images that are not already in your catalog. This prevents you from importing duplicate images. If you don't clear your card between imports, you could have older images that you've already imported.

Destination Folders: In this view Lightroom will display the images grouped by their destination folders. This will be more obvious when we discuss the Options and Destination panels.

The Import dialog provides two views of your images: the Grid view and the Loupe view. Figure 3.19 shows the Grid view. Lightroom displays some visual clues to tell you what is going on with the images you are trying to import. Thumbnails that appear grayed out (1) are suspected duplicates. Lightroom sees that these images are already in your catalog and grays them out so you cannot import them a second time.

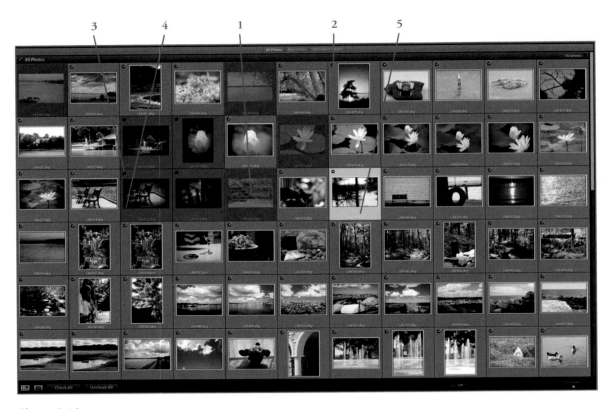

Figure 3.19

The main viewing area of the Import dialog showing all photos in the Grid view.

By default all images (except the suspected duplicates) are selected for import. These images have a checkmark in the upper-left corner (2). Images you have chosen not to import will be unchecked (3). Lightroom will also darken the frame and put a vignette on the thumbnail (4). This all combines to give you a comprehensive visual guide. At a glance, you can see which images are suspected duplicates, which are going to be imported, and which will not be imported.

The thumbnail with the lightest frame is the currently selected image (5). You can change the currently selected image either by clicking on the thumbnail or using the arrow keys on your keyboard. To select or deselect an image, you click in the thumbnail checkbox in the upper-left corner (2). You can also use the spacebar. If the image is currently selected, pressing the spacebar will toggle the checkmark on and off.

TIP

Remember how you selected contiguous and noncontiguous folders in the Source panel? The same rules apply here in the Grid view. To select contiguous thumbnails, click the first thumbnail and then hold down the Shift key and click the last thumbnail. This will select those two and all the thumbnails in between. If you hold down the Command key while clicking on thumbnails, you can select noncontiguous images.

Once you have multiple images selected, clicking on their checkbox or pressing the spacebar will affect all of them at the same time.

Located at the bottom of the main viewing area is the Import dialog toolbar (Figure 3.20). The first icon (1) represents the Grid view, and the second (2) is the Loupe view. Click on these to switch views in the main viewing area.

Figure 3.20

At the bottom of the main viewing area is the Import dialog toolbar.

Next to these are Check All (3) and Uncheck All (4) buttons. As their names imply, they are quick ways to select all or none of the images for import. Continuing to the right is the Sort menu (5) and the Thumbnails size slider (6). The Thumbnails size slider will adjust the size of the thumbnails in the Grid view.

The Sort menu lets you further refine how your thumbnails are displayed in the Grid view (Figure 3.21). It provides five sorting choices:

- **Capture Time** sorts the images by the capture time recorded in the EXIF data.
- **Checked State** will sort all the checked images to the front of the list if you have some checked and some unchecked images.
- **File Name** sorts images by their filenames.
- **Media Type** sorts still images and videos together.
- **Off** is the default state. No sorting is applied to the images.

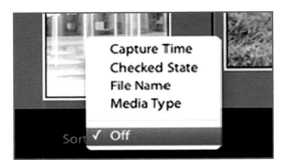

Figure 3.21

The Sort menu.

The Loupe view lets you see a larger view of an individual image (Figure 3.22). Access the Loupe view by clicking the second icon in the toolbar. Note that only one image now appears in the main viewing area. How large an image will depend on your monitor's resolution and the size of the preview image embedded by your camera.

The toolbar changes slightly in Loupe view. The two icons on the left remain, but the Check All, Uncheck All, Sort menu, and Thumbnails size slider are gone. The middle of the toolbar now has the Include in Import checkbox. As you view images in Loupe view, you can include or exclude them via this checkbox (1).

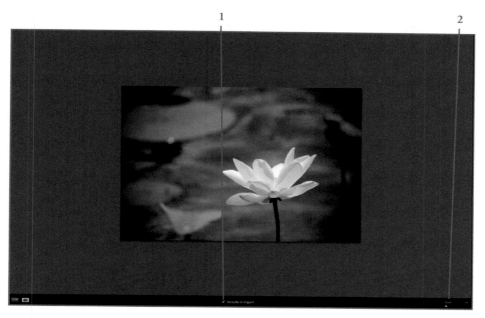

Figure 3.22

The Loupe view.

The Thumbnails size slider replaces the Zoom slider (2). The Zoom slider lets you zoom in and inspect the preview. In Loupe view, pressing the spacebar does not check and uncheck the Include checkbox. Instead, it toggles the zoom between Fit and 1:1. You can zoom in as far as 11:1 by moving the slider all the way to the right. Keep in mind, though, that you are viewing a fairly low-resolution JPEG preview provided by your camera. At 11:1 your image will look more like a mosaic because pixels will be shown as square boxes. Still, it can be useful in deciding whether to import an image or not.

TIP

You can use keyboard shortcuts to switch between the Grid view and the Loupe view. Command+G brings up the Grid view. Command+E switches to the Loupe view.

There are also Grid and Loupe views in the Library module, and these same keyboard shortcuts go to these views in that module, too.

You can remain in Loupe view and move through the list of images using the left and right arrow keys. If you bring up an image that is a suspected duplicate, the Include in Import checkbox will be replaced by the message "This photo is a suspected duplicate."

You can, of course, use your mouse to check and uncheck the Include in Import checkbox. But that will get tiresome if you are using the left and right arrow keys to navigate and you have to leave the keyboard to grab the mouse for every image. Don't worry...there are keyboard shortcuts for that as well.

p will check the box.

x will uncheck the box.

` will toggle back and forth between checked and unchecked. (By the way, that is the accent key. It's usually located to the left of the 1 key and above the Tab key on a standard keyboard.)

TIP

Start getting used to keyboard shortcuts. I'll point them out as we go along.

The more keyboard shortcuts you know, the faster you will get in Lightroom. It may seem daunting at first, but after a while they will become second nature. But only if you make the effort to learn them.

Options and Destination

Our final stop in our journey from left to right across the Import dialog is the Options and Destination panels (Figure 3.23). It is here that we get to make a lot of decisions about where to put the image files we are importing as well as what, if anything, we want to do to them during the import process.

There are some options here I will, of necessity, only touch on briefly. These options are tied to much larger topics that will benefit from a fuller discussion later on. Consequentially, some of these options won't make a lot of sense right now, but by the time you've made your way through the book, it will all come together.

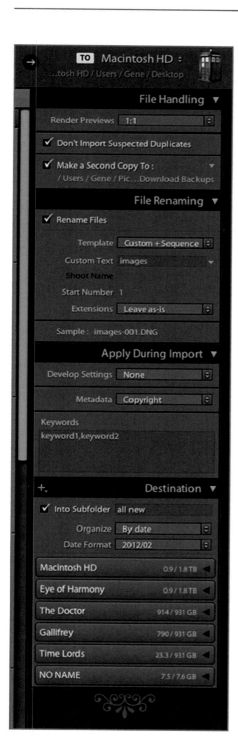

Figure 3.23

The Options and Destination panels.

The area labeled TO (1) at the top of the Options and Destination panels functions like the FROM area does. It's a big button. Click it, and it will present a contextual menu (2) similar to the one you saw with the FROM button (Figure 3.24).

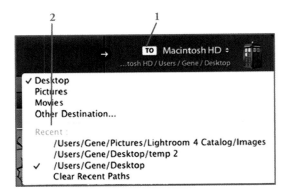

Figure 3.24

The TO contextual menu.

This menu is a little shorter than its FROM counterpart. The top portion lists common destinations along with an Other Destination selection. Clicking Other Destination will open a Finder/Explorer window and let you choose a destination anywhere on your system.

The bottom portion lists recent destinations you have used along with a Clear Recent Paths option. Click this to clear the list.

File Handling

The first selection in the File Handling panel is Render Previews (Figure 3.25). There are four render options available:

Minimal: This uses whatever the smallest preview embedded in the image is. Lightroom will render larger previews later as needed.

Embedded & Sidecar: This option displays the largest preview embedded in the image. Again, Lightroom will render larger previews as needed.

Standard: Lightroom will render a standard-size preview. This is the preview you would see in the Loupe view with the zoom level set to Fit. You can set the size of this preview in Lightroom's preferences.

1:1: This will ask Lightroom to render a 100% pixel-for-pixel preview.

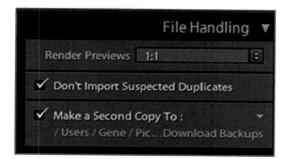

Figure 3.25

The File Handling panel.

A general rule of thumb for making a decision here is the larger the preview the slower the import. However, rendering Standard or 1:1 previews up front can save considerable time later because Lightroom won't have to render them again when they are needed in other modules. As you develop your workflow, you can decide where time is more crucial.

Next is the Don't Import Suspected Duplicates checkbox we mentioned earlier. It's not foolproof, but Lightroom does a pretty good job picking these out. In general, Lightroom compares the original filename, the file size, and the date and time in the EXIF data. If these match, then Lightroom suspects a duplicate.

The final option in the File Handling panel is Make a Second Copy To. This instructs Lightroom to import your images and to make another copy of those files to a second location. It's an easy form of backup. I will touch on backup options throughout the book. Backing up is extremely important. (You are backing up, aren't you?) Images are moments in time never to be captured again. When you lose that file, it is something you cannot replace. Backup. Backup. Backup.

To instruct Lightroom to make that second copy, check the box. You can then choose a backup location from the drop-down menu. You have three choices in the menu. The first is a list of previous backup locations. You can select any of them by clicking on one. The second option is to clear that list. Lastly, you can take the Choose Folder choice to open a Finder/Explorer window where you can pick a folder anywhere on your system. If, instead of bringing up the menu, you click directly on the path shown below the checkbox, you will get the Finder/Explorer window immediately.

CAUTION

Whatever you do, don't select a folder on the same drive as your destination folder. If the drive holding your images fails, you want to have the backup images on another drive. Otherwise, you won't be able to get to the backup either. Don't create a single point of failure. You will regret it when that inevitable dark day comes.

One thing you should know about this easy backup option is that Lightroom will make a second copy to whatever folder you choose. If you rename your files during the import process, it will rename the second copies to match. What this method doesn't do is re-create the folder structure. So if you have images being deposited into a date-based folder hierarchy, your second copies will all be in the one folder you selected. They will not also be in the same date-based folder hierarchy as imported files. However, that doesn't decrease the value of having a second copy of those images available. Whenever anyone asks me if they should check this box, I always say YES.

File Renaming

Many, if not most, cameras today will name your files with such descriptive names as _MG-01225.CR2 or P2D_225x5.RW2. Don't those names bring back memories? No? Fear not. Lightroom will let you rename your files to something that makes more sense to you. There are ample opportunities in Lightroom to rename files if you want to. During import is your first opportunity.

If you would like to rename your files during import, simply check the box next to Rename Files. The File Renaming panel (Figure 3.26) will then come alive, allowing you to choose a renaming template.

Figure 3.26
The File Renaming panel.

We'll cover the remaining templates later, but for now here are some of the standard choices you will see:

Custom Name (x of y): You can choose a custom name, and Lightroom will append a relational sequence pattern, such as wedding (1 of 20), wedding (2 of 20), etc.

Custom Name—Original File Number: Lightroom will add the file's original number to a custom name you choose. So if your original file is _MG-0125.CR2, you would keep the 0125. The result might be birthday-0125.

Custom Name—Sequence: You choose the custom name and the starting number. Lightroom will create filenames from those such as headshot-001, headshot-002, headshot-003, etc.

Custom Name: Lightroom will use a custom name you choose.

Date—Filename: Lightroom will create a filename by adding the capture date to the front of the original filename.

Filename: A puzzling option because it doesn't rename the file. Lightroom will use the original filename.

Shoot Name—Original File Number: You can assign a name for your shoot. Lightroom will create new filenames using the shoot name and the original file number.

Shoot Name—Sequence: You assign a shoot name and choose a starting number. Lightroom will create filenames using the shoot name and sequential numbers.

The file extension used can be changed to uppercase or lowercase or left as is using the Extensions option.

At the bottom of the File Renaming panel, you will see an example filename based on the choices you have made in the panel.

Apply During Import

You can boost your workflow efficiency with the Apply During Import panel (Figure 3.27).

Figure 3.27

The Apply During Import panel.

There are three powerful options in this panel. The first of these is the Develop Settings option. With this option you can apply any Develop preset to all imported images. Develop presets are one of Lightroom's most useful features. They provide a way for you to record a group of settings from one image and then apply those settings to other images. While it sounds like a simple thing, Develop presets are extremely useful. For example, if you find that all of your images look better with a little extra contrast added, you can create a Develop preset and choose it there. Every imported image will have its contrast adjusted on the way into your catalog. We'll see how to create these presets later on.

Lightroom is full of preset opportunities. Another powerful preset is the Metadata preset. The next option in the Apply During Import panel provides a way for you to apply a Metadata preset to all imported images. Information about you, your copyright, contact information, and so on can be set up ahead of time. Adding this data during import will assure you that all of your images contain important information and help protect your work.

You can add keywords common to the images in the current import in the Keywords section of the panel. I know. Keywords? Tags? Do I have to? Well...in a word...yes. Lightroom's keywording capabilities are great, and you will only benefit by applying keywords to your images. Keywords will enable you to find that great shot of the tan puppy in the blue basket next to the bouquet of red roses years after you shot it. If you shoot any stock photography, keywords can make the difference between success and obscurity. Here is a way to make sure you never have an untagged image in your catalog again. Simply enter a few keywords that apply to all of the images in the current import selection. They'll all get tagged, and you'll be better organized for it.

Destination

It's time to let Lightroom know where we want to put these images. The Destination panel (Figure 3.28) is the place we do that. It is also where we can ask Lightroom to organize our file structure as we import.

Figure 3.28

The Destination panel.

There seems to be endless conversation about how to organize files on a drive. Some photographers insist that folders with event or shoot names is how to do it. Others will insist on a strict date format. And still others just dump everything into whatever folder happens to be available. Lightroom can make those problems a thing of the past. You can let it organize your folders for you if you like. Unless you have a folder hierarchy you are really attached to, I recommend letting Lightroom manage this for you. It's one less thing you need to worry about.

TIP

Whatever way you choose to manage your image folder hierarchy, I recommend that everything ultimately reside in one top folder such as Pictures or Images. The reason for this is that it makes Lightroom's task easier should you lose track of a file. When you ask Lightroom to find a missing image file, it will look through a folder hierarchy. If you have your images scattered across several folder hierarchies, Lightroom won't know where to look for them.

The Destination panel looks very much like the Source panel. Just as you chose the device and folder that are the source of the image files, here you choose the device and folder to receive and store your image files under Lightroom's watchful eye.

At the top of the panel is an organizational section. You can choose to have your images placed into a subfolder you create during import. Check the Into Subfolder box and a text field will appear to the right. Enter a folder name here, and Lightroom will create that subfolder in whatever folder you point it to.

CAUTION

The Into Subfolder option creates a new folder with the name you specify. If that folder already exists, it will point Lightroom to the existing folder. Be careful, however, not to specify a name here *and* point to the existing folder in the folder list. This will create a new folder within the existing folder.

For example, suppose I have a folder called My Puppy that is a subfolder of Pictures. If I check the Into Subfolder checkbox, enter My Puppy as the folder name, and point to Pictures in the folder list, Lightroom will see that My Puppy already exists and add the images there. So I wind up with Pictures/My Puppy/new images. However, if I point to the existing My Puppy instead of Pictures, Lightroom will create a new folder inside My Puppy, and I now wind up with Pictures/My Puppy/My Puppy/new images.

The next option, Organize, offers three choices:

- **By original folders:** This tells Lightroom to preserve whatever folder hierarchy is on the source device and import the images into the same structure on the destination.

- **By date:** Here Lightroom will read the date in the file's EXIF data and create folders and subfolders according to the format you choose in the Date Format option.

- **Into one folder:** No matter what folders and subfolders the images reside in on the source device, Lightroom will put them all into one folder on the destination device.

If you choose to organize by date you can specify the format in the Date Format option. Here you have four main groups of date formatting options:

- **Year/month day:** A main folder for each year with a subfolder for the month and day. Examples: *2012/02-12* and *2012/February12*.

- **Year/month:** A main folder for each year and a subfolder for each month. Examples: 2012/02 and 2012/Feb.

- **Year/month/day:** A main folder for each year, a subfolder for each month, and another subfolder for each day. Examples: 2012/12/02 and 2012/February/02.

- **Year month day:** A single folder with a name contracted from the year, month, and day. Examples: 2012 Feb 02 and 20120212.

The drop-down menu here will present you with several variations in each of these main groups.

The same docking features we looked at in the Source panel are also available here in the Destination panel. There is one other focusing feature here. In the title bar for this panel, you can see a + icon to the left of Destination. Clicking the + will bring up a contextual menu. In addition to offering another way to create a new folder on your destination device, there are two choices offered in the View section: All Folders and Affected Folders Only. With All Folders selected, the Destination panel's folder list displays all the folders on the destination device. If you choose Affected Folders Only, then only the folders receiving images will appear, letting you focus on what will happen.

When you look at the folder list in the Destination panel (Figure 3.29), it will show you exactly what will happen during import.

Italicized folders (1) do not yet exist on the destination device and will be created by Lightroom. Non-italicized folders (2) already exist and will have things added to them as indicated. To the right of each folder you will see a number and a checkbox (3). The number indicates how many images will be placed in that folder. The checkbox allows you to further select/deselect images for import. So if you have chosen a group of images and decide that you don't want the images from July 2007 to be imported, simply uncheck the box next to that folder (4). The number will change from 10 to 0/10 (10 in this example is the number of July 2007 images), letting you know that 10 images (5) are being excluded. If the images are in a subfolder, the parent folder's number changes from 27 to 17/27 (6), indicating that only 17 of the possible 27 images will be imported. Also note that the excluded folder will be grayed out (7).

In addition to excluding folders via the checkbox, you may see other folders grayed out (8). These are folders that would have received images that Lightroom considers to be suspected duplicates.

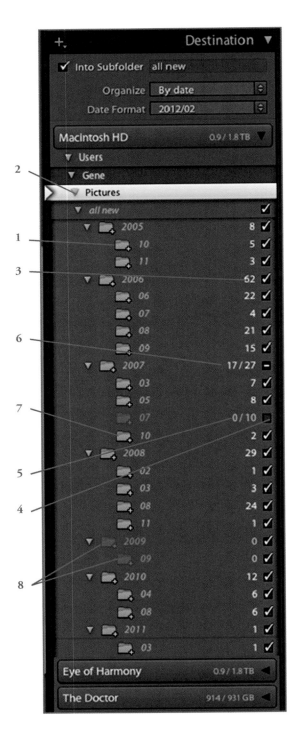

Figure 3.29

The Destination panel will also show you the folders that will be created during the import.

Import Presets

You're all set to import now, so click on the Import button, and Lightroom will start the process.

Before you do that, let's look at our last stop in the Import dialog: Import Preset (Figure 3.30).

Figure 3.30

Presets are available for import options.

I warned you that Lightroom would try to help you be efficient. Here is yet another preset opportunity. Import presets let you store all of the settings you made during an import session so you don't have to do them all again the next time you import.

To create a preset click on the drop-down menu to the right of Import Preset, in the menu, click Save Current Settings as New Preset (Figure 3.31).

Figure 3.31

Create a new import preset.

The New Preset dialog pops ups (Figure 3.32), where you can name the preset and click Create.

Figure 3.32

The New Preset dialog.

A Word about File Formats

If you try to import files and wonder why some files do not show up, remember that Lightroom is a tool for photographers. Certain file formats are not supported in Lightroom. Lightroom supports and will import the following file formats:

- Most proprietary raw formats. (Lightroom can read most camera manufacturers' proprietary raw formats. However, as new cameras come out, there is usually a short time before Lightroom will recognize files from those new cameras. Adobe needs to create the conversion files first before Lightroom knows what they are. In rare cases a manufacturer will not share the raw format with Adobe, and those files will not be supported.)
- DNG.
- TIFF, TIF.
- JPEG, JPG.
- PSD.
- CMYK-based files (any adjustments or output from Lightroom will be in RGB and not CMYK).
- Video files: AVI, MOV, MP4, and other popular video formats created by digital still cameras.

The Import dialog is the most common way to get images into your catalog. It is not the only way, however. In the next chapter I'll show you several other methods to gather your images under the Lightroom umbrella.

4

Using the Side Door: Other Import Methods

Import is the grand entrance to Lightroom, but it isn't the only way in. It's true that most of your images will come from the cards in your camera, but there are other image sources you may have. Lightroom is flexible. One thing to remember as you learn your way around Lightroom is that there is usually more than one way to accomplish any task.

In this chapter, we'll examine other ways to get images into Lightroom. These "side doors" help complete and round out your workflow and can be useful to have in your bag of tricks.

Drag and Drop

Let's start with the easiest method first—drag and drop. You can drag a single image, any selection of multiple images, or even a folder of images and drop it on the Lightroom icon (Figure 4.1).

Figure 4.1

You can drag and drop images and folders to the Lightroom icon to import them into the catalog.

If Lightroom isn't open when you release the mouse and drop the images on the icon, it will open and present you with the Import dialog we've come to know and love from Chapter 4. If Lightroom is already open, then the Import dialog will simply open (Figure 4.2).

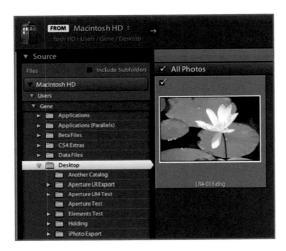

Figure 4.2

Lightroom will present you with the Import dialog when you drag and drop images.

The Import dialog shows the images you just dropped on the icon. All of the remaining options you already know are available, and you can import the images into your catalog.

Drag and drop offers a simple way to get images into Lightroom quickly.

Auto Import

Here's a real powerhouse of a feature. Lightroom can import images for you automatically. With Auto Import, Lightroom gives you a way to streamline certain workflows and set up all of the Import dialog options ahead of time. Lightroom will then perform its import magic with no further guidance from you. Hold on, though. Don't run out to dinner and a movie and expect everything to be done by the time you get home. Sorry. You'll still have to be involved in the process.

The best way to explain Auto Import is to walk through an example workflow. Suppose you have some old prints you want to scan and add to your catalog. You could scan them all and collect the resulting images into a folder. At that point you'd use the Import dialog as you would for any other straight import. Why not let Lightroom help you out a little? Even though Lightroom does not support scanners directly, Auto Import can be used for a seamless scanning workflow.

To start the Auto Import process, you need to be in the Library module. Now go to
File > Auto Import > Auto Import Settings (Figure 4.3).

Figure 4.3

Auto Import starts in the File menu.

This will bring up the Auto Import Settings dialog (Figure 4.4).

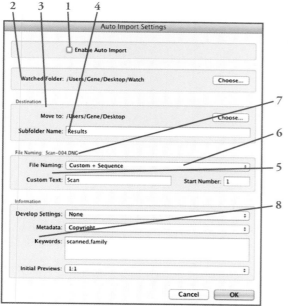

Figure 4.4

The Auto Import Settings dialog.

At the top of the dialog is the Enable Auto Import checkbox (1). Checking this box will alert Lightroom to begin auto importing. You can also do this from the File > Auto Import > Enable Auto Import menu. When Auto Import is enabled you will see a checkmark next to Enable Auto Import.

Auto Import works on the principle of a watched folder. Simply put, you tell Lightroom to watch a folder. Whenever something appears in that folder, Lightroom will spring into action and perform the tasks you set up in this dialog. That's what is next in the dialog. Tell Lightroom which folder to watch (2). Press the Choose button and choose an existing folder or create a new one. This watched folder is merely a temporary holding area. Lightroom will clean it out as it processes the images it finds.

Now that we've told Lightroom where to look for incoming images, we need to tell it where to put them. That brings us to the Destination section of the dialog (3). Here is another Choose button to let you pick the destination folder. If you would like Lightroom to create a new subfolder here, enter its name in the Subfolder Name field (4).

Next, in the File Naming section (5), we can tell Lightroom how we want to rename any files it finds in the watched folder. The File Naming drop-down (6) will show you all of the naming templates or presets you have set up in Lightroom (as well as the standard set of templates that come with Lightroom).

NOTE

Throughout Lightroom you will have opportunities to use templates. In nearly all cases, you have the ability to edit existing templates and create new ones. At the end of every list of existing templates you will find an option to edit. This gives you a lot of flexibility to tweak template settings to fit whatever you are doing at that time. It's just another example of how fluid and flexible Lightroom is. We will look at templates in greater detail in a later chapter.

The fields that appear next in this section are dependent upon which template you've chosen. In Figure 4.4, we see a field for Custom Text and one for Start Number because the template chosen is Custom+Sequence. When you enter values in those fields you can see a representative version of your new filename right after the name of the section (7). This gives you a good idea of how your new filenames will look and lets you make any changes before you start applying the template.

The last section in this dialog, Information, is where you can get a head start on organizing and processing your new images (8). We touched on Develop Setting and Metadata presets in Chapter 3. We have the same options here to apply any of these presets to images passing through the watched folder. We can also assign some initial keywords to these images as well as have Lightroom build initial previews. You can also set the initial preview that Lightroom builds for these images. (We will cover the preview choices when we get to the Library module.)

TIP

Start adding keywords to your images as early in the process as you can. If you have never keyworded your images before, you are in for a pleasant surprise. Keywording makes your images easy to find, and Lightroom's powerful organizational tools leverage your keywording efforts tremendously. You may know where that image of the adorable puppy on the red pillow in the wicker basket next to the fireplace is right now, but how will you find it in five years? If you added keywords like *puppy, pillow, basket, wicker, red, fireplace,* and *adorable,* then you will find it in milliseconds. Without keywords you will have to plow through thousands of images to find it or overheat your brain trying to remember where or when you took the shot.

Take every opportunity Lightroom gives you to keyword your images. You really won't regret it.

Once you have all of your choices made, click OK. If you didn't check Enable Auto Import, you can enable it now from the File menu. Select File > Auto Import > Enable Auto Import, and you're ready to go.

Fire up your scanner software and tell it to save the scans to the folder you selected as the watched folder in the Auto Import Settings dialog. Some scanning software can save scans in a variety of file formats. Be sure that you have chosen a format compatible with Lightroom. TIF and JPEG are excellent choices. More advanced scanning software such as VueScan (www.hamrick.com) will allow you to set bit depth and color space information as well.

Back in Lightroom, go to the Loupe view in the Library module by pressing E (Figure 4.5).

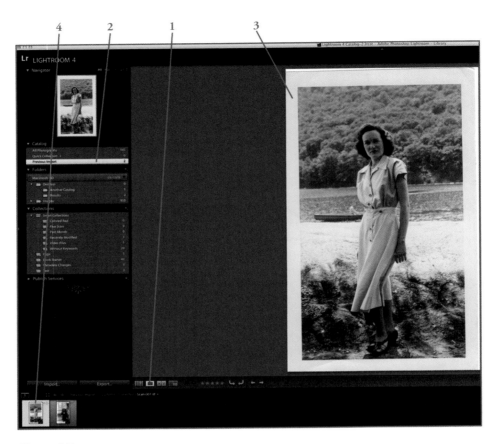

Figure 4.5

The Library module's Loupe view.

If you are already in the Library module you can click the second icon on the toolbar (1). Choose Previous Import from the Catalog panel (in the left panel group) (2). Start scanning your photos. As Lightroom sees the new scan file appear in the watched folder, it will import it per your settings. The new image will appear in the main viewing area (3) so you can see the quality of the scan. It will also be added to the filmstrip at the bottom (4).

Now you don't have any more excuses for not scanning in all those old family photos.

Another common use for Auto Import is tethered shooting. A little later in this chapter, we'll take a look at Lightroom's extensive tethered shooting capabilities. But if your camera is not one of the models supported in the tethered shooting feature, Auto Import may be an alternative.

The process is similar to the scanning example we just looked at. In this case, however, you would need to have a utility that can interact with your camera when it is connected to you computer. Usually your camera manufacturer has a tethering utility. Third-party software developers also sell tethering utilities. (For example, onOne's DSLR Camera Remote application at www.ononesoftware.com/products/dslr-camera-remote/ offers not only tethering but also remote control capabilities for tethered shoots.)

Set up Auto Import in the same way we did for the scanner. Tell your tethering utility to drop the images into the watched folder. Whenever you press the shutter release, a new image is saved to the watched folder, and Lightroom springs into action. Not bad, huh?

If you shoot with an Eye-Fi card (www.eye.fi), tell the Eye-Fi software to drop the images into your watched folder, and Lightroom will process them as they come from your camera wirelessly.

Auto Import is a little-known and underutilized feature. I am sure you can find many creative ways to make it part of certain workflows.

Importing from Another Catalog

There is a constant debate in the Lightroom community about whether you should use many catalogs or only one catalog. We'll examine the merits of both sides later on. For now let's look at another way to get images into your catalog—Import from Another Catalog.

Whatever the reason, you may have another catalog (and there are a few valid reasons). This feature makes it easy to consolidate it into your main catalog.

In the Library module choose File > Import from Another Catalog. This will bring up your Finder (Explorer) window where you can navigate and choose the other catalog (Figure 4.6).

Figure 4.6

Choose the other catalog you want to import.

Once you choose the other catalog, Lightroom presents the Import from Catalog dialog (Figure 4.7).

If you have been using Lightroom for a while, this dialog may look very familiar to you. Prior to version 3, this is how the Import dialog looked. If your Import from Catalog looks like Figure 4.7, then the first thing you should do is check the Show Preview checkbox in the lower-left corner. This will expand the dialog to include previews of the images in the catalog you are about to import (Figure 4.8).

There are a number of options available. The Catalog Contents section (1) shows all of the available folders. Check the box to the left of the folder name to include it in the import or uncheck it to exclude that folder.

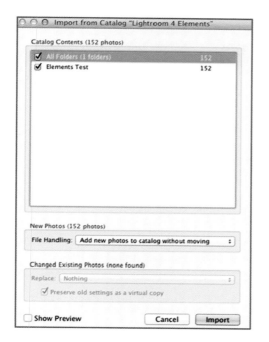

Figure 4.7

The Import from Catalog dialog.

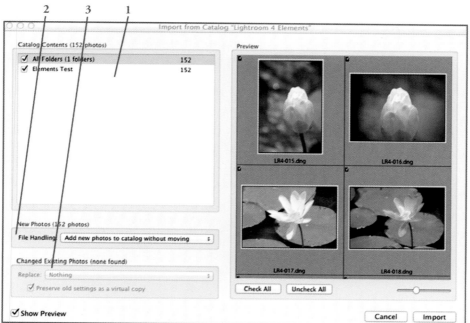

Figure 4.8

With the image previews showing, you can further refine what you import from the other catalog.

File Handling (2) in the New Photos section provides three options.

- **Add new photos to catalog without moving:** This option will leave the image files where they are on your drive and merely add the images to your catalog. If the files are already located where you want them, this is the option you want.

- **Copy new photos to a new location and import:** If you want to move the original image files to another location on your drive, choose this option. A Choose button will appear under the option so you can point Lightroom to the location you want the files stored in.

- **Don't import new photos:** Although this option appears to be a contradiction to importing, it becomes useful if some of the images are already in your main catalog. If all you need to do is import changes for those images and you do not want to add any new images, this option will do just that.

The Changed Existing Photos (3) section is active whenever images exist in both the source and destination catalogs and have been changed in either catalog before importing. Here you can tell Lightroom what to do about these changed images. The Replace option has three choices:

- **Nothing:** If you have both new and changed images in the other catalog, this option will ignore the changed images and let you deal with only the new ones.

- **Metadata and develop settings only:** Only the metadata and any develop settings will be imported into your main catalog.

- **Metadata, develop settings, and negative files:** This does the same thing as the second option but adds the image file to the import as well.

The additional options in this section fine-tune what will happen to the images and their files after the import.

Preserve Old Settings as a Virtual Copy—When this box is checked, a virtual copy (more on this later) will be created using the existing settings before the new settings are applied to the file on import. This lets you retain both versions of the image without duplicating the image file itself and wasting disk space.

Replace Non-raw Files Only (TIFF, PSD, JPEG)—If you have chosen to include the file in the import, then Lightroom would normally replace the existing file with the imported file. You can preserve the existing raw file by checking this box. DNG and any proprietary raw formats (CR2, NEF, etc.) will not be replaced by the incoming image file.

Let's see this in action. Figure 4.9 shows the other catalog I want to import into my main catalog. To make this example simple, it contains only one image—a fancy egg. But let me point out a few things about this image and its catalog. First, there is a Smart collection called Eggs (1), which includes any image tagged with the keyword "egg." The image has three keywords assigned: Another Catalog, egg, and Product Shot (2).

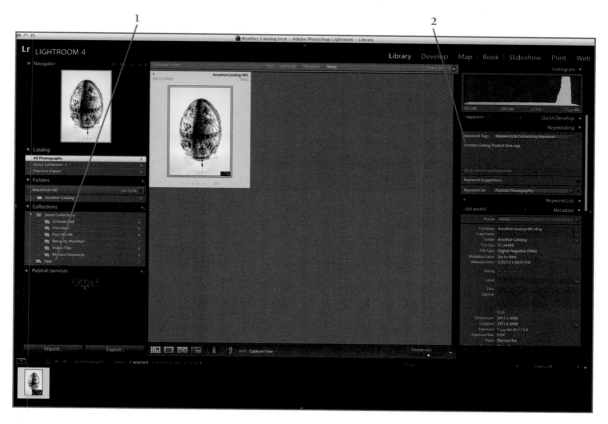

Figure 4.9

The other catalog.

If we take a peek in the Develop module (Figure 4.10), we can see a Develop preset called egg preset (1) in the Presets panel and a number of steps in the History panel (2).

Back in the Library module, I select File > Import from Another Catalog from the menu (Figure 4.11).

Figure 4.10

The Presets and History panels for the egg image.

Figure 4.11

Import from Another Catalog menu selection.

In the resulting Finder window, I navigate to the other catalog, highlight it, and click Choose (Figure 4.12).

Figure 4.12

Choose the catalog to be imported.

I check the Show Previews box in the lower-left corner of the Import from Catalog dialog (Figure 4.13) so I can see the images from the other catalog. There's my fancy egg. I like where the files currently live, so I've selected the Add New Photos to the Catalog Without Moving option in the New Photos section (1). Since there are no changed images from this catalog already existing in my main catalog, the Changed Existing Photos section (2) is grayed out. Everything looks the way I want it, so I click Import.

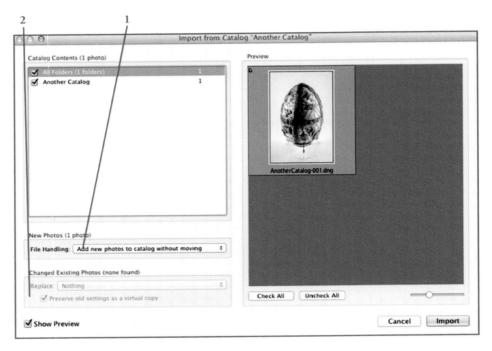

Figure 4.13

The Import from Catalog dialog with the Show Preview option checked.

Luckily Lightroom didn't drop the egg during import, so here it is in my main catalog (Figure 4.14), but it has brought along more than just the image. The Collections panel now has the Eggs Smart collection (1) (remember this collects all images that have the keyword "egg" applied) and the keywords Another Catalog, egg, and Product Shot (2) applied.

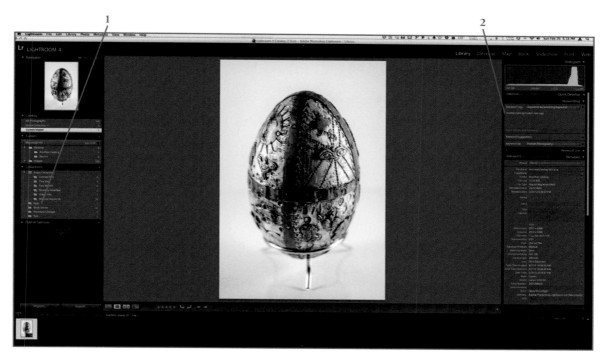

Figure 4.14

The egg has made it to my catalog without a single crack.

Press D to sneak over to the Develop module (Figure 4.15), and I see the Develop preset egg preset (1) in the Presets panel, and all of the history for this image is safely stored in the History panel (2).

The ability to import from another catalog has some very interesting and useful features. Since Lightroom knows everything about what's going on inside a catalog, it can import everything you need to keep your relationship with an image intact after the import is done. This will be a useful aspect of Import from Another Catalog that we'll play on when we discuss the multiple catalog issue.

Figure 4.15

Let's take a peak in the Develop module.

Shooting Tethered

The last side door we'll look at in this chapter has really become popular in recent years. Since it was introduced in Lightroom 3, many photographers are now shooting tethered. What does it mean to shoot tethered? Simple. You attach your camera to your computer, usually with a USB cable. Then you tell Lightroom what you're doing, and it will monitor shots coming in and add them to the catalog.

There are two big advantages to tethered shooting in Lightroom:

- The import is already done. If you are tethered, Lightroom adds the images to your catalog as they are taken. You don't have to import them from your card afterwards.

- You get to see your shots on a much bigger screen. The LCD on the back of your camera is fine to see if you captured anything when you pressed the shutter release. It may even be useful to view the histogram and determine if your exposure is OK. But you can't see critical focus issues on that tiny screen. If you have an art director breathing down your neck, it gets difficult to keep showing him the back of the camera. With tethered shooting you (and that pesky art director) can stand at a reasonable distance and see the shot on a much bigger screen.

Attach your camera to your computer. Consult your owner's manual for the proper way to do this for your camera. In the Library module choose File > Tethered Capture > Start Tethered Capture to begin your session.

The first thing you are presented with is the Tethered Capture Settings dialog (Figure 4.16). Here is where you tell Lightroom all about the tethered session you are about to create.

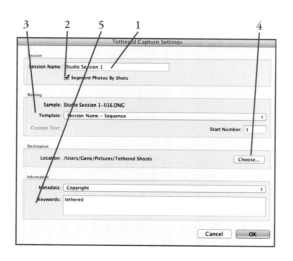

Figure 4.16

The Tethered Capture Settings dialog.

Name your session (1). This will become a folder where your tethered shots will be placed. The checkbox right below the Session Name field gives you the option to have Lightroom segment your session by shoots (2). The option reads Segment Photos by Shots, but this is a small error you'll see in a few dialog boxes during tethered shooting. A shot is a single image, while a shoot is a group of images. You may want to segment by shoot if you will be doing separate shoots during a session. For example, we'll be doing a session with two oranges and a mouse. I know that seems strange, but, hey, they're willing to pay for the session. When this box is checked, each shoot will be a separate subfolder within your session subfolder.

In the Naming section (3) you can set up the name template for the incoming shots. In this example, I've chosen the session name plus a sequence number. In the Destination section press the Choose button (4) and select the folder you want the session to be placed into.

The Information section (5) is another of those many organization opportunities I mentioned earlier. Lightroom tries to get you to be organized from the first press of the shutter release, so take the opportunity. I've chosen to apply my copyright metadata template and to attach the keyword *tethered* to all of the shots. Press OK to proceed.

Since I've chosen to segment my session by shoot, Lightroom presents me with the Initial Shoot Name dialog (Figure 4.17). The oranges arrived first, so they're the first shoot for this session. Enter the name and press OK.

Figure 4.17

The Initial Shoot Name dialog.

The session has begun (Figure 4.18).

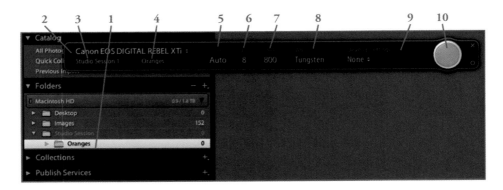

Figure 4.18

When the tethered session starts, we see the tethered shoot toolbar.

The first thing to notice is that Lightroom has created the folder structure we set up in the previous two dialogs (1). There is the Oranges folder inside the Studio Session 1 folder as expected. Turning our attention to the toolbar, we can see it contains quite a bit of information:

- The name of the tethered camera is shown. Notice that it is a drop-down menu. If you have more than one camera tethered to your computer, you can switch between them using this menu.

- Underneath the camera name is the session name.

- If you have chosen to segment the session by shoot, the shoot name will appear to the right of the session name.

- Next is the current shutter speed. If your camera is set to calculate this speed, you will see the word *Auto*.

- Here you can read your current aperture or f-stop. As with shutter speed, you will see the word *Auto* if the camera is setting this for you.

- Your current ISO.

- Your current white balance setting.

- The toolbar gives you access to all of your Develop presets. You can choose one to apply to images as they are taken.

- This is the onscreen shutter release button.

The toolbar only reports your current shutter speed, f-stop, ISO, and white balance. You cannot change these settings remotely in Lightroom. You can, however, fire the shutter from Lightroom by clicking on the Shutter Release button (10). The oranges are ready, so let's take the first shot. Either click the Shutter Release button on the toolbar or press the shutter release on the camera.

Success (Figure 4.19). We can see that there is now one image in the Oranges folder (1). The lovely oranges are showing in the main viewing area (2), and we can see the first shot down in the Filmstrip (3). But wait, something is just a little off with our white balance. We can fix that quite easily so that we don't have to see out-of-balance images in every shot. This is a small appetizer for our exploration of the Develop module later on.

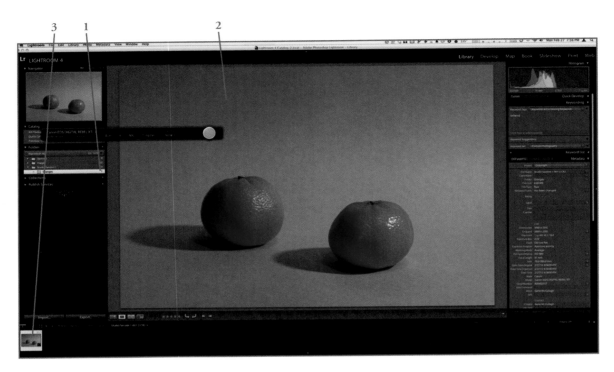

Figure 4.19

The lovely orange supermodels.

First, press W. This will bring up the White Balance eyedropper (Figure 4.20 (1)]. Move the eyedropper around the image and look at the preview that shows up in the Navigator window (2). This gives you an idea of the white balance correction that would be applied if you clicked where the eyedropper currently is. When you see a reasonable correction, click once. Now press E to return to the Loupe view. The image should look much better now.

Figure 4.20

Changing the white balance in midshoot.

That fixes the initial shot. But we want this same correction to be applied to the subsequent shots (Figure 4.21). To do this we need to select a develop setting on the toolbar. Go to the Develop Settings drop-down (1) and choose Same as Previous. As the name implies, Lightroom will apply the same settings as it did to the previous shot.

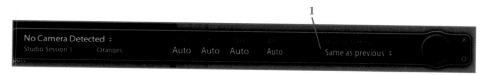

Figure 4.21

To make this work for subsequent shots, we need to pick a develop setting on the toolbar.

Now that we've taken care of the white balance we can continue the shoot (Figure 4.22). Looking at the Filmstrip, we can see that all of the shots have the correct white balance applied. Depending on the speed of your computer, your camera, and the connection, this can be fun to watch. You take the shot, and it appears with the incorrect white balance. Then Lightroom jumps in and applies the correction and the image changes to the proper white balance. Pretty neat.

Figure 4.22

More oranges.

There are two additional controls on the end of the toolbar (Figure 4.23). The first is a small x (1), which has a few functions. Click the x and it will end your tethered shooting session. This is the same as choosing File > Tethered Capture > Stop Tethered Capture.

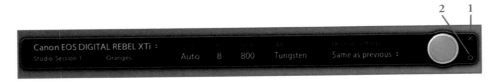

Figure 4.23

Additional toolbar controls.

Below the x is a small gear icon (2). Click this, and you will bring up another Tethered Capture Settings dialog (refer to Figure 4.16). You can then set new parameters and start a new session. This has the effect first of ending the current session. The new folders and options will then take effect, and you are on to your next session.

Remember that small x (1)? There's a hidden feature there. If you are tethered to a laptop with a smaller screen, you may find that the toolbar, while quite informative, is in the way. No matter where you drag it, it seems to be blocking something you want to see. If you hold down the Option key, the x turns into a -. Click the - and the toolbar shrinks down to just the Shutter Release button (Figure 4.24).

Figure 4.24

Get that toolbar out of the way.

Much better. We can move that small button out of the way and see all of our screen real estate. If you want the full toolbar back, hold down the Option key and the x turns into a plus sign (+). Click the + and you have your full toolbar back. If you don't want to see the toolbar at all, you can toggle it on and off using Command+T.

All right. The lovely oranges are done, and Madame Mouse has been waiting patiently. To start the second shoot for this session, all you need to do is click on the shoot name in the toolbar [Figure 4.25 (1)]. Alternatively, you could press Shift+Command+T or choose File > Tethered Capture > New Shot. (Yes, it should say New Shoot, and hopefully Adobe will correct the shoot/shot problem soon.) This will bring up the Shoot Name dialog (2).

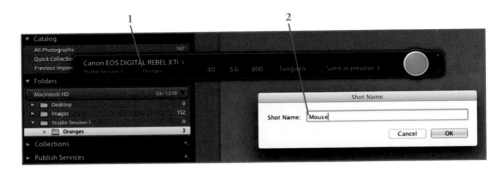

Figure 4.25

Time for your shoot, Madame Mouse!

Enter the new shoot name (here I've entered Mouse) and click OK. This resets the stage and creates another folder, Mouse, in the Studio Session 1 folder we started at the beginning (Figure 4.26).

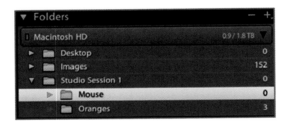

Figure 4.26

Same session—new shoot.

Since we are in the same session, the Same as Previous Develop setting is still at work and will correct the white balance for our mouse shots as well.

It looks like all is going well (Figure 4.27). Madame Mouse's shots are lining up in the Filmstrip. Wait—it looks like one of the orange models is trying to upstage her. Dealing with subject temperaments is beyond the scope of this book, so I'll leave that solution to you.

Figure 4.27
Our second shoot for this session is going well.

I think you will agree that Lightroom provides more than enough ways for you to get your images into the catalog, so get those images in, and we can start organizing them. There's a whole lot in store in Part 2, "Let's Get Organized," so take a break and get ready to have some fun. (There will be a little work, too.)

Part 2

Let's Get Organized!

Out of clutter, find Simplicity. From discord, find Harmony.
In the middle of difficulty lies opportunity.

—Albert Einstein

We photographers are curious creatures. There is a reason you picked up a camera. You found a passion for capturing light and creating images. Before you know it you have thousands of digital image files. After all, your passion knows no bounds, right? But what do you do with all of those files? How do you find that one money shot among all those other money shots? You need to get organized.

Back in the days of film it was filing cabinets, index cards, colored stickers, bound catalogs, and even the occasional shoebox. Today we use keywords, databases, stars, and a host of other methods to keep track of all those image files. Lightroom has some powerful features to help you organize, rate, and find your images when you want them. Say goodbye to endless searching through folders wondering where you saved the shot.

Back in Chapter 3, we talked about the underlying workflow logic in Lightroom: organize, process, share. In this part, we'll take a detailed look at the organize step in that workflow. After that we will take a short off-road trip and look at how to customize Lightroom's interface.

So put the lens cap on and take a break from shooting. Let's get organized.

5

Library—Part One

Welcome to the Library. Don't worry. There aren't any "Please Be Quiet!" signs in this library. Make all the creative noise you want in here.

The Library module is the first of Lightroom's seven modules. Keeping with the general workflow logic, this makes sense. It is to the Library module that you import your images. This is the module where your organizational and filtering tools live. Whenever you need to find something, it's off to the Library module.

In this chapter we will take an extensive look at the Library module. By examining the different parts of the interface, we will expose all of the tools at your disposal. This will also lay the foundation for later chapters, because each of the modules has the same overall interface but with different sets of tools. When you look at the modules in this way, it becomes quickly apparent that Lightroom has a subtle and elegant structure.

The Library module is the window to your catalog. So it is best to start there and talk about what a catalog is and how many you should have.

Where Do I Put My Catalogs?

In a previous chapter we briefly touched on the concept of a catalog. Underneath it all, your catalog is nothing more than a database. You don't really have to worry about that, though. Lightroom will handle it all behind the scenes. This lets you concentrate on the important task—your photography.

As I mentioned previously, you create a blank catalog the first time you start Lightroom. Unfortunately, if you've never used Lightroom before you may not have thought about where that catalog should live on your drive or what you should name it. We've already talked about the importance of deciding where to store your image files, but your catalog is a separate (and very different) animal.

You can store your catalog wherever you like, with one exception. Lightroom will not allow you to keep a catalog on a network drive. Your images can live on a network drive, but not your catalog. Lightroom is a single-user system. Having your catalog on a network drive exposes it to the possibility that more than one user would open it at the same time and corrupt the database. A multiuser version of Lightroom is a highly requested feature, and the team at Adobe, I'm sure, has it on their to-do list. For now just pick a non-networked drive.

Whatever you decide, be consistent. Should you decide to take the multiple catalog route, keeping them in a consistent location will make your life much easier.

Interface Overview

The initial approach I will take each time we look at a new module is to walk through the entire interface in detail. This serves two purposes. First, it gives you an in-depth look at every feature available to you in that particular module. That helps you find what you're looking for when you are working on your images. Second, it is a logical way to explain each feature. Remember the flow we talked about earlier—left to right, top to bottom. That's generally the way you'll approach a module's interface to get your work done. It's not a strict rule but merely a framework for your workflow. You will frequently bounce around the interface, depending on the task at hand, but it's a good place to start when you aren't sure how to proceed. As we meet more modules, you will be comfortable with how the interface works, and we can concentrate on the more important elements.

I'll introduce features as we tour the interface for the Library module. In the subsequent chapters we can look at them in depth and see some examples of how you can put these features to use. We'll finish up this part of the book by looking at how to make Lightroom look the way you like and remember things you'll use often.

One more thing. We will cover the Library module interface in two chapters. Since this is our first look into one of Lightroom's modules and since there is a lot going on in the Library module, we will look at all of the panels that deal with things about your images first. The next chapter will continue the tour with the parts of the interface where your images actually appear. As I said earlier, this first look will lay the foundation for other modules. Once we've discovered how the map is laid out, we will be able to navigate the other modules' interfaces in a single chapter.

Ready? Great. Then let's start all the way to the left and up at the top.

Top Panel

At the top of the Lightroom window is the top panel (Figure 5.1). This panel remains the same regardless of what module you are working in.

Figure 5.1
The top panel.

There are only two parts to this panel:

1. The Identity Plate
2. The module picker

If you don't change it, Lightroom displays the default Identity Plate (Figure 5.2). This is where Lightroom gives you feedback on the progress of tasks you've asked it to perform. The Identity Plate is temporarily replaced by one or more progress bars (Figure 5.3).

Figure 5.2
The default Identity Plate.

Figure 5.3
Progress bars in the Identity Plate.

At the end of each progress bar is a small x, which you click on to cancel a task.

But that's not all you can do here. Lightroom allows you to customize the Identity Plate so you can *brand* your copy. This is great if you want to present a professional branded experience to clients who may be looking over your shoulder as you choose images or present a slideshow example. Even if your clients never see Lightroom in action, you may prefer to look at your own brand while working.

There are two different ways to customize the Identity Plate. We will go into the details on how to do this in a later chapter. Figure 5.4 shows the styled-text Identity Plate. You can customize the identity plate using different fonts and colors available on your system.

Figure 5.4

The styled-text Identity Plate.

The other customization option is to use a graphic to replace the default Identity Plate (Figure 5.5). This lets you include your logo or other graphic elements.

Figure 5.5

The graphical Identity Plate.

On the right side of the top panel is the module picker (Figure 5.6). As the name implies, you pick which module you want to work in by clicking on its name. The currently active module is highlighted. Like the Identity Plate, you can customize this as well (Figure 5.7).

Figure 5.6

The module picker.

Figure 5.7

Customize your module picker.

There is no graphical option for customizing the module picker, but you can choose any font you like and even change the colors for the active and inactive modules.

Right-click on the module picker, and Lightroom presents a menu that lets you hide modules or show previously hidden modules (Figure 5.8). Simply check a module to show it and uncheck a module to hide it. There is also a Show All choice to turn all modules back on. Hiding a module only removes it from the module picker. Any hidden module is still available from the menu or via keyboard shortcuts.

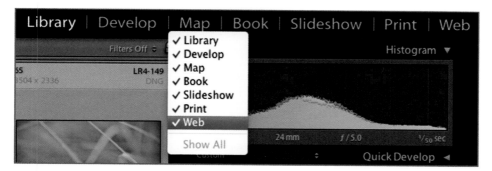

Figure 5.8
You can hide and show individual modules in the module picker.

You can choose a module from the Window > Modules menu. Each module also has an easy to remember keyboard shortcut.

- Library Option+Command+1
- Develop Option+Command+2
- Map Option+Command+3
- Book Option+Command+4
- Slideshow Option+Command+5
- Print Option+Command+6
- Web Option+Command+7
- Go back to the previous module Option+Command+Up Arrow

There are other keyboard shortcuts to help you navigate through the modules, but these are the easiest to remember. We'll see the others as we go along.

CAUTION

Lightroom is flexible enough to let you hide modules. You can even hide individual panels, as we will see shortly. However, this is a mixed blessing. A good portion of the questions I receive from photographers boil down to a hidden module or panel. They'll contact me after wrangling with an issue for some time only to find the module or panel they are looking for is hidden. They thought, early on, "I never use that thing, so I might as well get it out of my way." Time goes by, and they forget they did it.

The moral of the story is—go ahead and hide what you don't use, but try to remember you did.

Left Panel Group

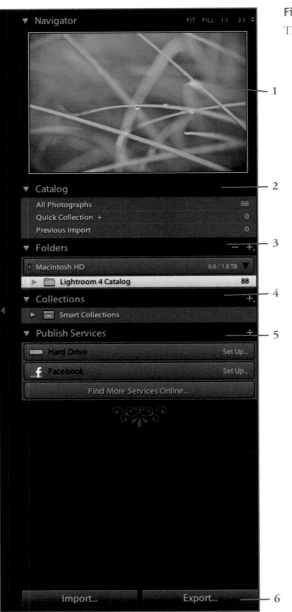

Figure 5.9
The Library module left panel group.

The left panel group in the Library module is where you will find the tools to manage the files and folders in your catalog (Figure 5.9). From the top down we have these panels:

- Navigator panel
- Catalog panel
- Folders panel
- Collections panel
- Publish Services panel
- Import and Export buttons

You can adjust the width of the left panels to increase the area for the main display area (Figure 5.10). Place your cursor on the edge of the panel group until you see it change to a bar with opposing arrows (1). Click and drag to adjust the width. On the other side of the panel group is a small triangle (2). Right-click the outside edge of this triangle to bring up a menu to control the behavior of the panel group. You have the following options:

Auto Hide & Show—This option automatically hides the panel group when your cursor moves away from it. Moving your cursor over the edge of the triangle will automatically show the panel group. In this mode, the panel group is semitransparent and appears over the main display area.

Auto Hide—This acts like the first option and will hide the panel group when your cursor moves away. You need to click the edge manually to show the panel group again.

Manual—This turns off any automatic hide or show behavior.

Sync with Opposite panel—This option will apply whatever behavior you chose from the first three options to the right pane group.

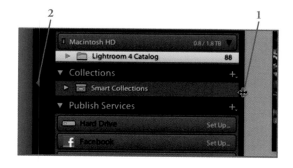

Figure 5.10

You have the ability to change the way the panel group looks and behaves.

TIP

A quick way to tell whether auto or manual mode is active is to look at the triangle. A solid triangle indicates manual mode. If the triangle is comprised of small dots (not solid), you are in auto mode.

This ability to change the behavior of the left panel group applies to all the panel groups in Lightroom. So whether you access this menu from the top panel, left panel group, right panel group, or the Filmstrip, you have the same controls.

There are also some controls for how panels behave. Clicking on the panel header will expand or collapse a panel. Hold down the Command key and click on any panel header to expand or collapse all panels at the same time. Right-click on a panel header, and you will be able to hide and show any of your panels. The same warning I gave you about hiding modules applies here. It's OK to hide a module. Just remember you did so if you seem to be missing something or having a problem.

Some users don't like to scroll or prefer to have only one panel at a time expanded. Click the panel header to expand. Do some work. Click the header again to collapse. Then repeat with the next panel. That's a lot of effort. Just right-click on a panel header and choose Solo mode from the context menu. Solo mode automatically collapses all of the panels in a panel group when you expand any one of them. So if Solo mode is active and I expand the Folders panel, the Catalog, Collections, and Publish Services panels automatically collapse. Some panels are exempt from Solo mode because of the integral part they play in the workflow. The Navigator and Histogram panels are two examples.

Navigator

The first panel in the left panel group is the Navigator panel (Figure 5.11). To expand and collapse the panel, click on the panel header (1). On the right side of the panel header are the zoom controls (2). The bulk of this panel is taken up by the window that shows the currently selected image (3). This window's display changes as you hover your cursor over different panels in the group. It gives you a quick way to view the first image in a folder, collection, or publish service so you can determine if you are choosing the right one.

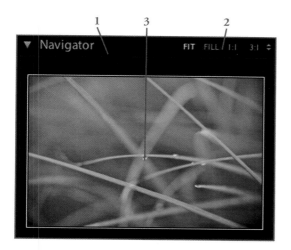

Figure 5.11
The Navigator panel.

The first two choices, FIT and FILL, determine the unzoomed state of the image when shown in the main display area in either Loupe or Compare view. FIT ensures that the entire image is shown (Figure 5.12). FILL will take up the entire area available for viewing the image even if that requires that some of the image is not shown (Figure 5.13).

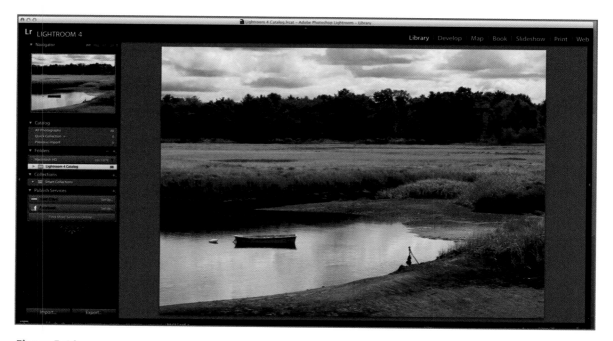

Figure 5.12
Using the FIT option.

Figure 5.13
Using the FILL option.

When you really want to get up close and personal with your images, you can take advantage of the zoom levels Lightroom provides in the Navigator panel [refer to Figure 5.11 (2)]. The default zoom level is 1:1 and will zoom into your image at 100%. Next to that option is a drop-down menu with several zoom levels to choose from (1:16, 1:8, 1:4, 1:2, 2:1, 3:1, 4:1, 8:1, and 11:1).

The first four choices (1:16 through 1:2) are zoom-out levels. The remaining choices (2:1 through 11:1) zoom in.

You can move between FIT, FILL, 1:1, and your chosen zoom level by pressing Command+- to move left and Command+= to move right.

When you are zoomed in on an image, you can change what portion of the image shows in the main viewing area (Figure 5.14). The rectangle that appears in the Navigator panel represents what is being shown (1). You reposition this by dragging the cursor (2), which will move the rectangle with it. Clicking anywhere in the Navigator panel's image will jump the rectangle to that location.

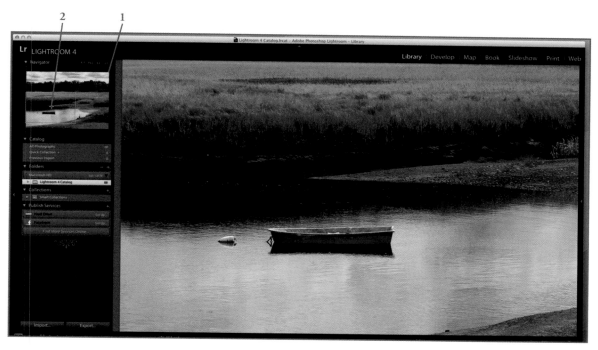

Figure 5.14

Using the Navigator when zoomed in.

> **NOTE**
>
> If the cursor is over one of the edges of the rectangle, it will change from a cross to a small hand. This is merely a cosmetic change and does not give you any additional functionality, so don't be concerned that you have to grab the edge of the rectangle to move it.

Lightroom remembers which normal (unzoomed) level you used last as well as which zoom level you used last. Zooming in and out will alternate between these settings. Click directly on the zoom options you want. You can temporarily zoom in and out with the spacebar. Press and hold the spacebar to zoom in. Release it to zoom back out. If you tap and release the spacebar, you will remain zoomed in. Tap and release again to zoom back out.

This same functionality is available with the cursor.

When your cursor is positioned over the image in either FIT or FILL mode, it will appear as a magnifying glass (Figure 5.15). To zoom in temporarily, press and hold the left mouse button. The image will zoom, and the cursor changes to a closed hand (Figure 5.16). Moving the mouse at this point lets you pan around the image. If you simply click the mouse, the image will zoom, and the cursor will change to an open hand (Figure 5.17). Click again to zoom out. Click and drag to pan.

Figure 5.15
The magnifying glass cursor indicates you can zoom in.

Figure 5.16
A closed hand cursor indicates you are zoomed in temporarily. Releasing the mouse button will zoom back out.

Figure 5.17

An open hand cursor indicates you can click to zoom back in.

That's a lot of functionality in a small panel. Lightroom is full of these power-packed panels.

Catalog

The Catalog panel (Figure 5.18) provides instant access to your images.

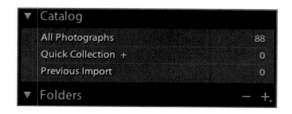

Figure 5.18

The Catalog panel.

You can easily display all the images in your catalog. Most of the time you will see three entries in this panel.

All Photographs—Click this to display all of the images in your catalog in the main display area. The total number of images in the catalog appears on the right side of this entry.

Quick Collection—Click here to see all of the images you have gathered together in your quick collection. We will see this in action when we discuss collections.

Previous Import—Clicking this displays all the images that came into the catalog during your last import.

Another entry you may see here from time to time is Previous Export as Catalog. Clicking that will show the last set of images you exported as a new catalog.

As we have seen with other areas of Lightroom, there is additional functionality hidden in the Catalog panel. Right-click on All Photographs and choose Import Photos and Videos or Import from Another Catalog from the contextual menu.

A different menu appears when you right-click on Quick Collection. That gives you the choice to Save Quick Collection, Clear Quick Collection, or Set as Target Collection. This will become useful when we work with collections later.

Folders

The Folders panel (Figure 5.19) is Lightroom's version of the Finder (Mac) or Explorer (Windows). But it is much more selective in what it shows you. The only items that appear in the Folders panel are those that have been added to your catalog. This removes the usual clutter and allows you to concentrate on what is important—the assets currently in your catalog.

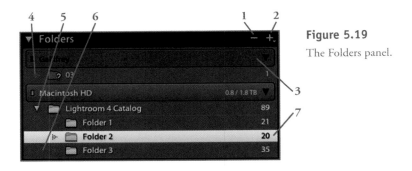

Figure 5.19

The Folders panel.

On the right side of the panel header are two buttons. The – is the Remove button and will appear only if a folder is selected in the Folders panel (1). Click this to remove the selected folder from the catalog. If the folder is empty, it will simply be removed from the panel. However, if the folder contains images, you will be given a chance to change your mind. A dialog box will appear, warning you that the folder you are removing contains images (Figure 5.20).

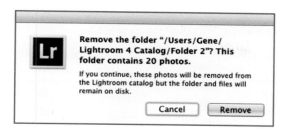

Figure 5.20

Lightroom warns you if you are about to remove a folder that contains images.

Even if you ignore the warning and click Remove, the folder and image files remain on your disk. They are only removed from the catalog.

Next to the – is the + or Add/Display button [refer to Figure 5.19 (2)]. This will show you a contextual menu with several options. The first two are concerned with adding to your catalog.

> **Add Subfolder**—This creates a subfolder within the currently selected folder. The Create Folder dialog (Figure 5.21) provides a place to name the subfolder. If images are selected, check the Include Selected Photos checkbox and those images will be moved to the new folder. This new folder and any contents will also appear in the Finder (Mac) or Explorer (Windows).

> **Add Folder**—This will bring up a Finder window where you can navigate to the folder you want to add. Once you select the folder, the Import dialog will open with that folder's contents ready for import. However, only the Add option is available because you will not be copying or moving the images in this case.

Figure 5.21

The Create Folder dialog.

The next three options are under the heading Root Folder Display and determine what information is displayed to indicate the folder.

Folder Name Only—Displays just the folder name (Lightroom 4 Catalog).

Path From Volume—Displays the path from the volume to the folder (Users/Gene/Lightroom 4 Catalog). This path is only shown on the parent folder.

Folder And Path—This is a combination of the prior two choices and, again, only affects the parent folder (Lightroom 4 Catalog – Users/Gene/Lightroom 4 Catalog).

The last option, Show Photos in Subfolders, determines what will be shown at higher folder levels. When this option is checked, selecting a parent folder will show all the images within that parent folder and all of its subfolders. It will also cause the image count that appears on the right side of the folder name to include a count for the parent folder and all subfolders. Unchecking this option tells Lightroom to show and count only the images that are in that folder. Lightroom will ignore any images in subfolders.

The Volume browser [refer to Figure 5.19 (3)] is the next tool in the Folders panel. Each volume that contains images in your catalog will appear. The Volume browser shows the status of the volume, its name, and additional information that you choose. To the left of the volume name is a small LED indicator that by default shows one of five states:

- **Green**—10GB or more is available on the drive.
- **Yellow**—Less than 10GB is available.
- **Orange**—Less than 5GB is available.
- **Red**—Less than 1GB is available. You will get additional warnings in the form of tooltips as the drive approaches maximum capacity.
- **Gray**—The volume is offline. The name will also be darkened for an offline volume.

You can change this to only report whether a drive is online or offline by right-clicking on the LED and choosing Show Status. If you want to switch back to reporting the remaining space as well, right-click on the LED and choose Show Status and Free Space.

You can change the information reported for the volume on the right side of the Volume browser by right-clicking on the Volume browser (anywhere but the LED) and choosing from:

Disk Space—Reports the space on the drive in the form available/total so you will see something like 0.8/1.8TB, indicating that 0.8TB out of 1.8TB is available.

Photo Count—Shows the number of images on the drive that are in the catalog.

Status—Indicates either online or offline.

None—No additional information is shown on the right side of the Volume browser.

Two other options are available when you right-click on the Volume browser. Show in Finder (or Show in Explorer on Windows) will open the Finder to that volume. Get Info (Mac) or Properties (Windows) will open the info/properties window for the volume.

Below each Volume browser, the folders and subfolders for that volume will appear. When a folder is offline or otherwise missing, a question mark (?) will appear on its folder icon [refer to Figure 5.19 (4)]. Right-click on the missing folder and either remove it or choose Find Missing Folder. You can also see parent folders (5) and subfolders (6). Selected folders are indicated by a light gray background (7). If you right-click on a folder you will get a context menu with quite a few choices:

Move Selected Photos to This Folder—If you have images selected then this option will appear. Choosing it will move the selected images to the folder. This happens both in Lightroom and on your drive.

Create Folder Inside <*folder name*>—Click this to create a subfolder.

Rename—Rename a folder.

Remove—Remove the folder. If it is empty it will be removed. If it contains images, you will be warned before it and its images are removed from the catalog.

Hide This Parent—If the folder you have chosen has subfolders and no visible parent folder, you may choose to hide it and promote its subfolders. If there are images in the chosen parent folder, they will be removed from the catalog.

Show Parent Folder—Every folder, with the exception of the root folder, has a parent folder. You can choose to have Lightroom show this parent folder in the Folders panel with this option. If you keep selecting this option on every parent folder that appears until you reach the root folder, the Folders panel will directly mirror your operating system's folder structure. Some users prefer to work this way.

Save Metadata—Information about the image and any changes made are stored in the catalog. Choosing this option will write that metadata out to the image file. In the case of proprietary raw files, an XMP sidecar file is created with the same filename as the raw file.

Synchronize Folder—Over time you may find that the contents of the folder on the drive don't match the contents of the folder in Lightroom. Choose this option to import any missing images and bring the folders into synch.

Update Folder Location—Occasionally you may find that you have two copies of a folder showing in the Folders panel. The catalog is a database, and this can happen. Select this option to point to the correct location for the folder. Do this for each of the copies, and you will eliminate the copies in the Folders panel.

Import to This Folder—Another quick way to get images into Lightroom. Choosing this opens the Import dialog with the folder as the destination.

Export This Folder as a Catalog—This is a quick way to create a new catalog from the contents of a folder.

Show in Finder—Opens the Finder at this folder. This will appear as Show in Explorer in Windows.

Get Info—Displays the Info window for the folder. In Windows this will appear as Properties.

Everything you need to do with files and folders can be done in the Folders panel. You can select one or more folders and drag and drop them on another and Lightroom will move everything there. You can also select images in the main display area and drag and drop them on a folder. Lightroom will take care of moving them for you. What happens in the Folders panel is reflected on your drive, so there is no need to redo any of this in the Finder.

Collections

Continuing our journey down the left panel group we come to the Collections panel (Figure 5.22). This panel is somewhat special in Lightroom. It is one of the few panels that will appear in each and every module. So no matter which module you are working in, you will have your collections right at your fingertips.

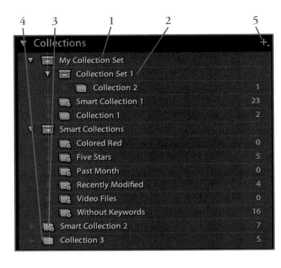

Figure 5.22

The Collections panel.

Collections is a very deep topic, and we will be coming back to it throughout this book. In the next chapter we will explore what collections are and how to use them effectively. For now let's look at how we can control collections in the Collections panel.

Collections come in two main flavors—collections and smart collections. So what's the difference? Collections are static. That is, you create a collection and add images to it. Images don't get added or deleted automatically. You need to take some direct action to add and remove images from a collection.

Smart collections, on the other hand, are always on the lookout for images to add and remove. When you create a smart collection, you give it a set of rules. The smart collection keeps comparing its rules to your catalog and adds any images that meet those rules. If an image stops meeting the rules, a smart collection kicks it out, no questions asked. Lightroom installs a few sample smart collections from the beginning to give you an example. One of them is called Five Stars. It has one simple rule—if the star rating on an image is five stars, add it to the collection.

There is a third major type of collection, but it doesn't collect images. It collects collections. This is called a collection set and is a way to organize your collections.

The Collections panel looks very similar to the Folders panel. Collection sets (1) appear like parent folders. Collection sets can contain other collections sets (2) as well as collections and smart collections. Its icon looks like a filing box. A smart collection is represented by a stack of images with a small gear in the lower-right corner. Collections have the same stack icon but without the gear.

The now familiar + icon appears on the right side of the panel header (5). As with the Folders panel, the - icon will also appear if a collection is selected. Click the + to gain access to the three create options—Create Collection, Create Smart Collection, and Create Collection Set. Two sorting options are also available—Sort by Name and Sort by Kind.

Creating a collection from the + menu is simple. Choose Create Collection, and you'll be greeted by the Create Collection dialog (Figure 5.23). Type the name of your collection in the Name field.

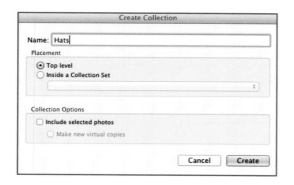

Figure 5.23

The Create Collection dialog.

There are two choices in the Placement section. You can place your collection either at the top level or in a collection set. If you want to put it in a collection set, choose which one in the drop-down menu. Finally, in the Collection Options section you can include any selected photos in the new collection when it is created. If you choose this, the Make New Virtual Copies option becomes available.

NOTE

Virtual copies are a powerful feature of Lightroom. You can have many independent versions of an image without using up any appreciable disk space. We'll look at these in depth in the chapters on the Develop module.

Creating a smart collection is similar to creating a collection. When you choose Create Smart Collection, you get the Create Smart Collection dialog (Figure 5.24).

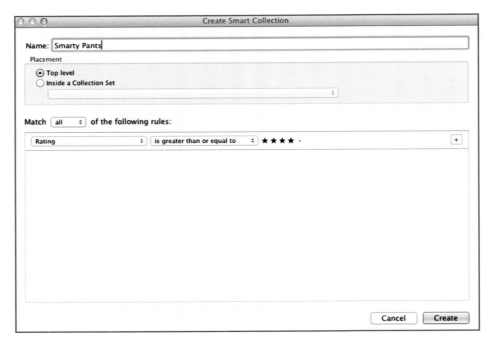

Figure 5.24

The Create Smart Collection dialog.

The first two sections are the same. Give the smart collection a name and whether it should be at the top level or placed in a collection set. It is the next section that is different. You don't decide what images get included. Instead, you will set up a list of rules. You can decide to match all, any, or none of the rules you place in the dialog. What kind of information can you test against? Quite a few data points are available (Figure 5.25).

✓ Rating
Pick Flag
Label Color
Label Text
Folder
Collection
Publish Collection
Published Via
Any Searchable Text
Filename
Copy Name
File Type
Is DNG With Fast Load Data
Any Searchable Metadata
Title
Caption
Keywords
Searchable IPTC
Searchable EXIF
Any Searchable Plug-in Metadata
Metadata Status
Capture Date
Edit Date
Camera
Camera Serial Number
Lens
Focal Length
Shutter Speed
Aperture
ISO Speed Rating
Flash State
GPS Data
Country
State / Province
City
Location
Creator
Job
Copyright Status
Has Adjustments
Is Proof
Develop Preset
Treatment
Cropped
Aspect Ratio

Figure 5.25

Choose from a long list of data points to set up your smart collection rules.

The Create Collection Set dialog that appears when you choose Create Collection Set is the simplest of the three dialogs (Figure 5.26). Just give the collection set a name and decide whether you want it at the top level or within another collection set.

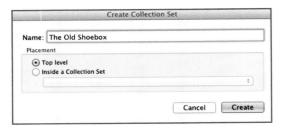

Figure 5.26

The Create Collection Set dialog.

A slightly different dialog comes up if you create a collection set by right-clicking an existing collection set and choosing Create Collection Set (Figure 5.27).

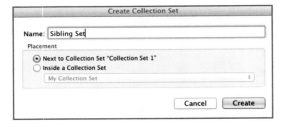

Figure 5.27

A slightly different Create Collection Set dialog.

The top level option is replaced by Next to Collection Set *<collection set name>* (1). The collection set name shown will be the one you right-clicked on. This option creates a "sibling" collection set. That is, it is created at the same level as the collection set you right-clicked. So if Collection Set 1 is inside another collection set, the new collection set with this option selected will appear within the same collection set as Collection Set 1. (OK. I think we have a new record for the use of the words *set* and *collection* in one paragraph.)

Double-clicking a smart collection in the Collections panel will open the Edit Smart Collection dialog, where you can rename the smart collection and change its rules. Smart collections can also be shared easily among users. Two of the options available when you right-click on a smart collection are these:

> **Export Smart Collection Setting**—This lets you save the rules set you configured to an .lrsmcol file that can be emailed to another user or shared on your network.

Import Smart Collection Settings—This is the other side of the transaction. Choose this and select the .lrsmcol file to import.

Collections and smart collections, like folders, can be exported as catalogs. Right-click and choose Export This Collection as a Catalog.

We will come back to collections and explore the many uses they have. Next we'll take a short stop in the Publish Services panel.

Publish Services

Remember the overall OPS workflow (organize—process—share) we talked about earlier? The Publish Services panel (Figure 5.28) lives in both the Organize and Share spheres. Publish Services are another type of collection, but they are collections that interact with the outside world. That might be as close as your hard drive or as distant as the Internet.

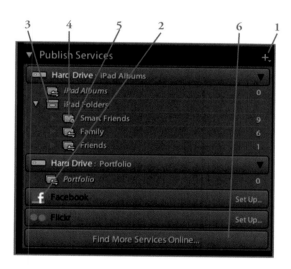

Figure 5.28

The Publish Services panel.

Lightroom installs with four Publish Services options: Hard Drive, Adobe Revel, Facebook, and Flickr. This should give you some insight into what Publish Services does. To the left of each Publish Service is an icon (2). You can turn those off if you like by clicking the + (1) in the panel header and unchecking Show Publish Service Icons. You aren't limited to only one connection per Publish Service.

We have similar options to those in the Collections panel. Instead of collections, we call them *folders* in Publish Services. So we have published folder sets (3), published smart folders (4), and published folders (5) that act just like their Collections panel counterparts.

If you need additional Publish Services, click the Find More Services Online button (6), and your browser will open to Adobe's exchange site where you can find them. I would also heartily recommend you check out Jeffrey Friedl's site (http://regex.info/blog/lightroom-goodies). Jeffrey is probably the most prolific Lightroom plug-in developer out there, and his plug-ins are excellent. He provides his plug-ins as donationware and will send you a license for whatever you can donate. The minimum is one cent. I think you should dig a little deeper, though. Jeffrey is very generous, and the community should be generous in return. He currently has Publish Services available for Zenfolio, SmugMug, Flickr, Picasa Web, and Facebook.

The Flickr and Facebook Publish Services Jeffrey provides are more comprehensive than those that come with Lightroom. If you plan on publishing to either of those services, you definitely should check these out. When we discuss how to use Publish Services later on, I will use the default Publish Services since that is what everyone with Lightroom has.

Import and Export

At the bottom of the left panel group are the Import and Export buttons. Pressing the Import button will bring up the Import dialog. (We covered the Import dialog in detail in Chapter 4.) Pressing the Export button brings up—you guessed it—the Export dialog.

TIP

If you hold down the Option key (remember, that's the Alt key in Windows) Import and Export change to Import Catalog and Export Catalog (Figure 5.29).

Figure 5.29
The Option key changes to Import and Export.

But here's the real tip—your Option key is like the "show me some cool features" key. While you are exploring the panels and menus in Lightroom, press the Option key to see what changes. There are many places where new options and features will appear. I'll point out some of them along the way, but there are too many for me to cover, so explore with your Option key.

The Export dialog (Figure 5.30) is one of the more feature-rich dialogs in Lightroom.

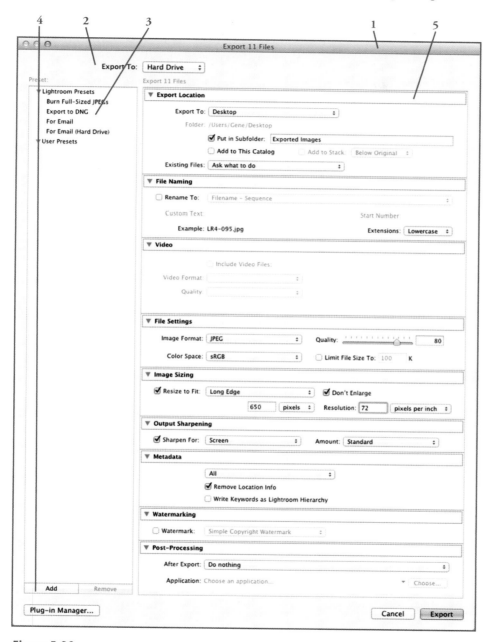

Figure 5.30

The Export dialog.

The name of the dialog will change to remind you of how many files you are about to export (1). There are several export modes to choose from (2) that change the options you can set for the export:

- Email
- Hard Drive
- CD/DVD

On the left side of the Export dialog are the export presets. There are the Lightroom presets that ship with Lightroom and a section for user presets that you create (3). At the bottom are the Add and Remove buttons (4). The bulk of the dialog is taken up with the settings panels (5), where you choose the options that will apply to your export. The settings panels will change, depending on what mode and/or preset you choose. The Hard Drive mode is the most common, and the settings panels available in this mode are these:

Export Location—These settings deal with where to put the exported files, whether to add the new files back into your catalog, and how to handle duplicate filenames.

File Naming—You have the ability to rename the files created during the export. If you do nothing, the new files will have the same filename and whatever file extension is applicable (based on other settings you choose).

Video—You can include or exclude video files during the export. If you choose to include video files, you can set the format and quality here.

File Settings—You can choose what format you want the exported files in. The options are JPEG, PSD, TIFF, DNG, and Original. Original will keep the exported file in the same format as the original. You can also set other parameters applicable to each format type. For example, for JPEG files you can set the quality. You can also choose from several color spaces where applicable. The three main color spaces available are sRGB, AdobeRGB (1998), and ProPhoto RGB. There is also an Other choice with which you can select a color profile from your drive.

Image Sizing—You may want the exported files to be a different size or resolution than the original files. You can have Lightroom set the size via Width & Height, Dimensions, Long Edge, Short Edge, or Megapixels. Resolution is set by entering a number in the Resolution field.

Output Sharpening—Different media require different degrees of sharpening. This can be set with precision in the Develop module. But sometimes you only need a little alteration for exported files. You can sharpen for screen, matte paper, or glossy paper. There are three levels available: Low, Standard, and High.

Metadata—Here you can decide how much metadata to embed in your exported file or to exclude embedded metadata altogether. This is extremely useful, for example, if you want to export images for use on the Web but don't want to include the location information in the file. No need to help the paparazzi find you.

Watermarking—Watermarking can be automatically applied to exported images.

Post-Processing—This is a neat settings panel. It can make Lightroom part of a longer automated workflow. When you install Lightroom, it creates an Export Actions folder. You can place any application or utility that can accept incoming files in this folder. That application can begin to work on the exported files as part of your extended workflow. Lightroom will trigger the indicated action after the export is done. It can be a really significant boost to your productivity.

Fiddle around with these settings and see what suits you. You can save any combination of options in a preset (we'll see how to do that in Chapter 12) for easy use later.

That's it for the left panel group. Remember, we are taking a very detailed tour in the Library module, so you can get a sense of where everything is and what it does. In subsequent modules, we won't need to be as thorough, since many of these principles will be the same. This is one of the things that makes Lightroom quicker to learn—a consistent interface from module to module.

Right Panel Group

The right panel group (Figure 5.31) of the Library module is all about information. While the left panel group helps you deal with where all your files and folders are, the right panel group will help you organize your images and perform some basic adjustments.

Continuing our top to bottom tour the panels in the right panel group are these:

- Histogram
- Quick Develop panel
- Keywording panel
- Keyword List panel
- Metadata panel
- Comments panel
- Sync Metadata and Sync Settings buttons

You have the same control over the appearance and behavior of the right panel group and its panels as you have over the left panel group.

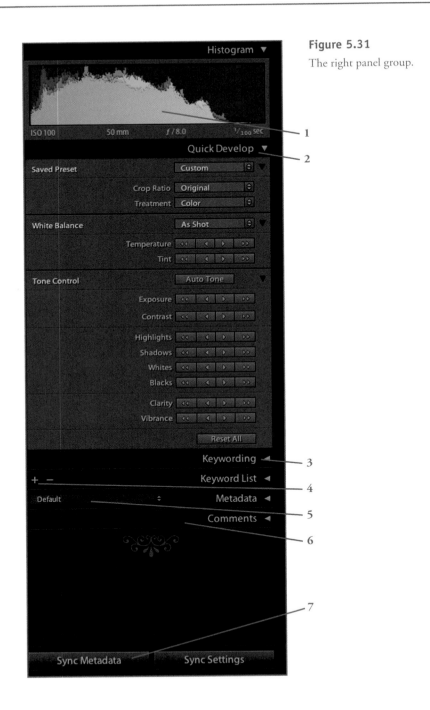

Figure 5.31

The right panel group.

Histogram

The Histogram (Figure 5.32) tells you a lot about your selected image. There is nothing you can adjust or control in this panel. It is informational only. It is also a non-scrolling panel like the Navigator panel in the left panel group. That is, if you scroll in the right panel group, the other panels will scroll beneath the Histogram so that it remains visible at all times. (You can, however, collapse the panel by clicking on the panel header.)

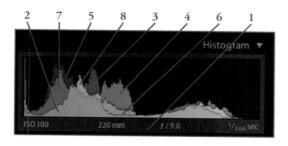

Figure 5.32

The Histogram.

At the bottom of the Histogram is an information bar (1), which displays the four key elements of the selected image.

- ISO
- Focal Length
- Aperture or f/stop
- Shutter Speed

If you are unfamiliar with histograms, you should investigate them further. Most modern DSLRs have a setting to show you the histogram on the rear display. It can be an excellent guide to how well your image is exposed. A histogram is fundamentally a bar chart. Luminance levels progress from left (darkest) to right (lightest). The number of pixels in the image at each luminance level is represented by a bar. The bars are so close together you can't really tell it's a bar chart. A quick glance at a histogram will tell you the overall brightness and whether you might be losing information on the darkest and brightest ends of the range. Histograms that are bunched to the left have lots of dark pixels and few light ones. If the histogram is bunched up to the right side, you have a lot of bright pixels and few dark ones. If you see a spike at either end of your histogram, you are losing data at that end of the tonal range. This is called *clipping*. In the field you can quickly spot these problems and take another shot right then.

Lightroom's histogram is more robust than what you'll find on the back of your DSLR. It not only reports luminance values but also will tell you where pixels fall in each of the individual RGB channels—Red (3), Green (4), and Blue (5). When all three channels overlap you will see gray (2). Cyan, Magenta, and Yellow are shown when only two of the three RGB channels overlap. Green and Blue show up as Cyan (6). Red and Blue show up as Magenta (7). Red and Green show up as Yellow (8).

Lightroom has a second, more interactive, histogram in the Develop module.

Quick Develop

The Quick Develop panel (Figure 5.33) provides a way for you to make preliminary adjustments to your images without leaving the Library module and going to the Develop module. There are three sections to the panel.

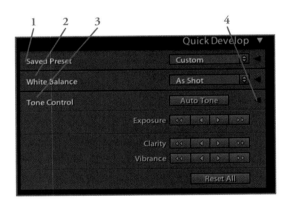

Figure 5.33

The Quick Develop panel.

- ■ Saved Preset
- ■ White Balance
- ■ Tone Control

Each section can be expanded and collapsed by clicking on the small disclosure triangle to the right of the section header (4). Figure 5.34 shows a fully expanded Quick Develop panel.

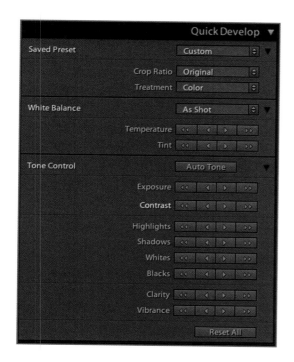

Figure 5.34

The Quick Develop panel with all sections expanded.

The first drop-down in the Saved Presets section gives you access to all of the Develop presets you have saved in Lightroom. The Crop Ratio drop-down lets you quickly apply a crop to the selected images. You can switch between Color and Black & White using the Treatment drop-down.

The White Balance section provides a way to adjust the Temperature and Tint for images. Simply click the buttons to increase or decrease each. The drop-down in the section header will show you different choices, depending on the type of file selected. For non-raw files, your choices will be these:

- As Shot
- Auto
- Custom

For raw files, the choices mirror those available on your DSLR:

- As Shot
- Auto
- Daylight
- Cloudy
- Shade
- Tungsten
- Fluorescent
- Flash
- Custom

You can quickly reset Temperature and Tint back to As Shot by clicking on their names.

The Tone Control section is where you can make finer adjustments to a variety of tonal controls. At the top is an Auto Tone button. Click this to let Lightroom adjust the image automatically. If you don't like the results, you can tweak it with the individual controls. The individual tonal controls available here are these:

- Exposure
- Contrast
- Highlights
- Shadows
- Whites
- Blacks
- Clarity
- Vibrance

You can set any of these back to 0 by clicking its name. There are two more tonal controls available here. Can you see them? No? Remember what I said about the Option key. It can show you hidden options and features. Press the Option key, and Clarity becomes Sharpening, and Vibrance becomes Saturation.

At the bottom is the Reset All button. Press this to remove the adjustments.

We haven't really talked much about Process Version. Lightroom 4 has a new Process Version called PV2012. The Process Version is the way Lightroom interprets raw files. If you have been using Lightroom for a while, you may have images in your catalog using previous Process Versions (PV2010 and PV2003). If so, the controls available in the Tone Control section will be different. Figure 5.35 shows the Tone Control section for a non-PV2012 image.

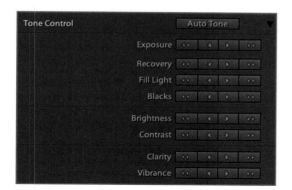

Figure 5.35

The Tone Control section for an image using a previous Process Version.

The controls here are not as fine as in the Develop module. The inner buttons move in small increments and the outer buttons in larger increments. For example, the Exposure buttons move +/– 1/3 of a stop for the inner buttons and +/– one full stop for the outer buttons. So this panel is useful for quick and minor adjustments. Personally, I rarely use the Quick Develop panel (with one major exception) and much prefer the finer controls of the Develop module. But it is useful to have this access right in the Library module.

So what's the exception I hinted at? It lies in the fact that these adjustments are relative. That's a pretty powerful thing. Let's say I have two images and I think they both look great, just a little dark. The first is at –1 stop and the second at –1/2 stop. I'd like to add 1 stop of exposure to both images. I could take them into the Develop module and adjust them individually. But I couldn't use the synchronization features in the Develop module. That would result in both images being at the same exposure stop. Quick Develop panel to the rescue.

If I select both images and increase the Exposure one full stop by clicking the outside button next to Exposure, I will add one stop to each selected image. It won't make each image's exposure equal +1 stop. It just adds one stop to wherever they are. In the example we're looking at, one image would go from –1 stop to 0 stop and the other from –1/2 stop to +1/2 stop. For me, that's the best use of the Quick Develop panel.

Keywording

Keywords are the heart of organizing your images. Too many photographers avoid adding keywords to their images. As a result, they expend enormous amounts of energy to either come up with an alternative way of organizing their images or find them later on. If they only directed a portion of that energy to applying even a few basic keywords, they'd have a much better time of things. Please don't be one of those photographers. Take every opportunity Lightroom gives you to add keywords.

We've already seen that you can add keywords during an import. That's a great start. But for more extensive keyword work we turn to the Keywording panel (Figure 5.36).

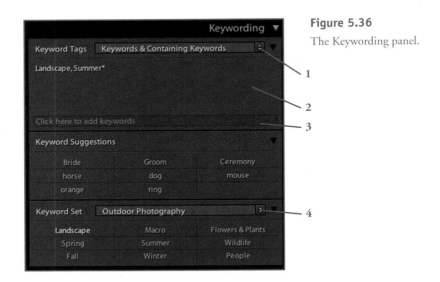

Figure 5.36

The Keywording panel.

This panel is divided into three collapsible sections:

- Keyword Tags
- Keyword Suggestions
- Keyword Set

In the Keyword Tags section, the drop-down in the section header (1) determines what will show in the window immediately below the section header (2). There are three choices:

Enter Keywords—Allows you to enter keywords directly into the window.

Keywords & Containing Keywords—This will show all the keywords and keywords higher up in the hierarchy for the selected images.

Will Export—All of the keywords for the selected images that will be embedded during an export will appear in the window.

The bottom of this section includes a field with the words Click Here to Add Keywords (3). No matter which option you've chosen in the drop-down, you can enter new keywords here. Anything you enter will be applied to the selected images.

NOTE

Keywords can be pretty much anything you want. There are a few rules, however.

- They can't start or end with a space.
- They can't start or end with a tab character.
- They can't end with an asterisk (*).
- Characters that are used to separate keywords can't be part of a keyword. These include commas (,), semicolons (;), pipes (|), and the greater-than symbol (>).

When you select multiple images, all of the keywords associated with the selected images will appear in the window below the Keyword Tags section header. Whenever a keyword has not been applied to all of the selected images, an asterisk (*) will appear after its name.

The Keyword Suggestions section presents a grid of nine suggested keywords. Simply click on one to add it to the selected images. Lightroom uses a number of things to come up with this list, such as recently used keywords, keywords in the current selection of images, and keywords applied to images taken at around the same time as the selected images.

Keyword Set, the last section in this panel, also provides a grid of nine keywords. The difference here is that you can predefine keyword sets for use in this section. Lightroom comes with a few keyword sets to get you started: Outdoor Photography, Portrait Photography, and Wedding Photography.

If any of the keywords in the set have been applied to all of the selected images, they will be highlighted. You can change keyword sets from the drop-down in the section header (4). From there you can also edit existing keyword sets or create new ones. Choose Edit Set from the drop-down, and you will get the Edit Keyword Set dialog (Figure 5.37).

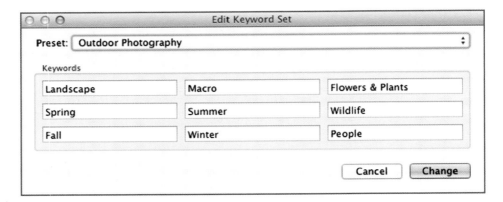

Figure 5.37

The Edit Keyword Set dialog.

The current keyword set will be showing. To create a new set, change the keywords in the nine boxes and then choose Save Current Settings as New Preset from the Preset drop-down at the top of the dialog. The New Preset dialog pops up so you can name your preset. Enter a name and click Create (Figure 5.38).

Figure 5.38

Creating a new keyword set.

If you are just making changes to an existing keyword set, change the keywords you want. As soon as you make a change, the name of the preset will have (edited) added to the end to remind you it has been changed but not yet saved. When your changes are done, select Update Preset *<keyword set name>* to save your modified keyword set.

You can also switch between keyword sets by pressing Option+0 (that's the number zero, not the letter O). Wait a minute. Did you see that? Something else changed when you pressed the Option key. (I really meant it when I told you to snoop around with that key for buried treasure in Lightroom.)

When you hold down the Option key, little numbers appear to the left of each keyword in a keyword set (Figure 5.39).

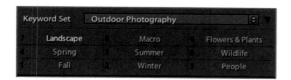

Figure 5.39

The Keyword Set section with the Option key pressed.

If you have a keyboard with a number pad on the right, this configuration of numbers will look very familiar. The grid matches the number pad layout. Holding down the Option key and pressing a number on the number keypad will apply the corresponding keyword from the keyword set grid. This can make keywording go quickly if you are a keyboard shortcut kind of person. Flip through your keywords sets with Option+0 and assign keywords from the active set using Option+1 through Option+9.

I'll have more to say about keywords in the next chapter. For now, on to the Keyword List panel.

Keyword List

The Keyword List panel (Figure 5.40) is where you will find a list of all keywords you have created. It's more than just a list, however. It provides information about your keywords as well as a way to get to images tagged with a particular keyword.

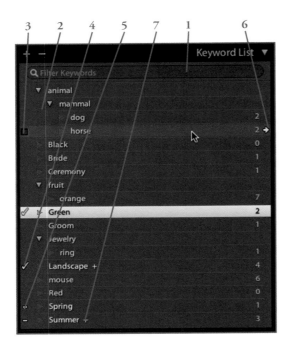

Figure 5.40

The Keyword List panel.

At the top of the panel is a search box (1) with the words Filter Keywords. As you enter information here, the list will show the results of your search. For example, type **an**, and your list will show any keyword with that pattern (*an*imal, L*an*dscape, or*an*ge, etc.) and any keywords higher in the hierarchy for a keyword. You can separate multiple search patterns with a space.

Keywords can be organized into hierarchies (2), and that is reflected in the Keyword List. Each level has a disclosure triangle to its left to allow you to expand and collapse the list. A solid disclosure triangle is an indication that the keyword has other keywords in its hierarchy (children).

When you hover your cursor over the list, a small checkbox will appear to the left of the keyword (3). Click this to assign that keyword to any selected images. When a keyword is applied to all of the selected images, a check appears to the left of that keyword (4). If only some of the selected images have a keyword applied, a dash appears to the left (5).

At the right side of the keyword line Lightroom reports the number of images in your catalog that the keyword has been applied to. When you hover over a keyword, a small arrow appears to the right of that number (6). If you click this arrow, Lightroom will show you only the images that have that keyword applied.

A plus (+) to the right of a keyword indicates that it is part of the current Keyword Shortcut (7). A Keyword Shortcut is a quick way to apply or delete one or more keywords from an image. To set a Keyword Shortcut, right-click a keyword and choose Use This as Keyword Shortcut from the context menu. This method allows you to set only one keyword as the Keyword Shortcut. If you would prefer several keywords in your Keyword Shortcut, select Metadata > Set Keyword Shortcut or press Shift+Option+Command+K to bring up the Set Keyword Shortcut dialog (Figure 5.41).

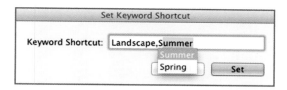

Figure 5.41

The Set Keyword Shortcut dialog.

Enter the desired keywords in the dialog, separated by a comma. As you type keywords, Lightroom will suggest some from your list. Press the Enter key to accept the suggestion. Click Set when you are done. To use this Keyword Shortcut, select one or more images and press Shift+K. All keywords in the set will be applied to the images. If the images already have all of the keywords applied, pressing Shift+K will remove them. Keyword Shortcut is also useful when using the Painter tool, which we will meet later on.

Don't worry. We will be talking about keywords in depth in the next chapter. For now it's on to the Metadata panel.

Metadata

A picture may be worth a thousand words, but sometimes you want more information than that picture alone can convey. That's where metadata comes in. Metadata is data about data, and the Metadata panel is where you store that information in Lightroom (Figure 5.42). There are essentially two kinds of data here: the kind that's baked in (such as the shutter speed or aperture) and the kind you add later (such as a title or caption).

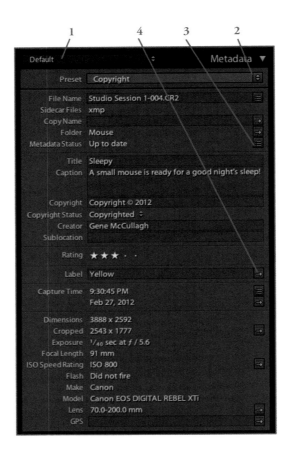

Figure 5.42

The Metadata panel.

There is so much data you can store about an image that the Metadata panel has several different views to accommodate it all. You access these views front the drop-down in the panel header (1). The views provided by Lightroom are as follows:

- **Default**—A basic sampling of data from different groups. Here you can see such items as filename, title, caption, rating, exposure, lens, etc.

- **All Plug-in Metadata**—Lightroom can accept plug-ins, and those plug-ins can create new metadata fields. Those fields can be seen with this view. If you don't have any metadata fields created by a plug-in, this view will show you filename, copy name, and folder.

- **EXIF**—Nearly all modern digital cameras use EXIF (EXchangeable Image File) format data to record data about an image. Data about exposure, focal length, aperture, GPS coordinates, and so on are recorded by your camera and stored in the EXIF data for the image.

- **EXIF and IPTC**—This shows data from the previous view (EXIF), along with a subset of International Press Telecommunications Council (IPTC) data, a standard set of data fields used in journalism and stock photography. However, they are extremely useful data points for any photographer. You can read more about the standards at the IPTC site at http://iptc.cms.apa.at/cms/site/index.html?channel=CH0099.

- **IPTC**—Just the basic IPTC data is shown.

- **IPTC Extension**—Extended IPTC data for model and property releases as well as other licensing rights data are shown.

- **Large Caption**—Copyright data and a large box for entering captions are shown in this view.

- **Location**—This view shows location and GPS fields.

- **Minimal**—Just a few basic fields (ratings, caption, copyright, etc.) are shown here.

- **Quick Describe**—This is a compact view with essential image data and fields such as title, caption, and rating. It is great for quickly moving through your catalog and entering descriptive information.

- **Video**—Metadata important to video, such as camera angles, tape names, speaker placements, is shown in this view.

Choose a view that fits your task. I find the Quick Describe and Large Caption views extremely useful when going through my top shots and filling in the missing data points.

Just below the panel header you will find the metadata Preset drop-down menu (2). This is an easy way to blast data into your Metadata panel. You can define any number of metadata presets and instantly have those applied to one or more images. As we discussed earlier, metadata presets are very useful during the import process.

As you look down the list of fields in the Metadata panel, you will notice some icons to the right of different fields. One looks like a small list or menu (3) and will open a dialog related to the field it is next to. For example, clicking the menu icon to the right of the File Name field will open the Batch Rename dialog. The same icon next to the Capture Time field will open the Edit Capture Time dialog. These little menu icons are a quick way to make adjustments and changes to one or more images.

The other icon that appears is a small right-pointing arrow (4). This does different things for different fields. For fields such as Label or Lens, it creates a filter and shows you all images that match what is in the field. For the Folder field, it switches from whatever location you are viewing to the folder where that image resides. If you click this icon next to the Cropped field, you wind up in the Develop module with your Crop tool active.

The Metadata panel is both informational and functional. Lightroom doesn't like to waste screen real estate, and this panel is another example of the nexus of information and function.

Comments

Our last panel in the right panel group is the Comments panel (Figure 5.43). It is a small and unobtrusive panel, but it creates another connection to the outside world. When we discuss Publish Services in more depth later, we'll see exactly how this panel operates.

Figure 5.43

The Comments panel.

Sync Metadata and Sync Settings

We come, at last, to the end of the right panel group, where we find the Sync Metadata and Sync Settings buttons. These buttons will be grayed out if you have only one image selected because it makes no sense to sync something with itself. When you elect more than one image, they will be active and look like the buttons in Figure 5.44.

Figure 5.44

The Sync Metadata and Sync Settings buttons.

Lightroom is all about making your workflow quicker and more efficient. If you have spent some time entering a lot of information in the metadata fields for one image, and the same information applies to other images, you can select them all and have Lightroom copy all of that metadata to the other images. (We will discuss how to select images a little later in this chapter.) After you select your images, click the Sync Metadata button, and the Synchronize Metadata dialog will open (Figure 5.45). This dialog has a long scrolling list of all the metadata you can possibly add to your image. Metadata from your main image in the selection will populate all fields for which you have entered data. This is the data that you can apply to all the other images you have selected.

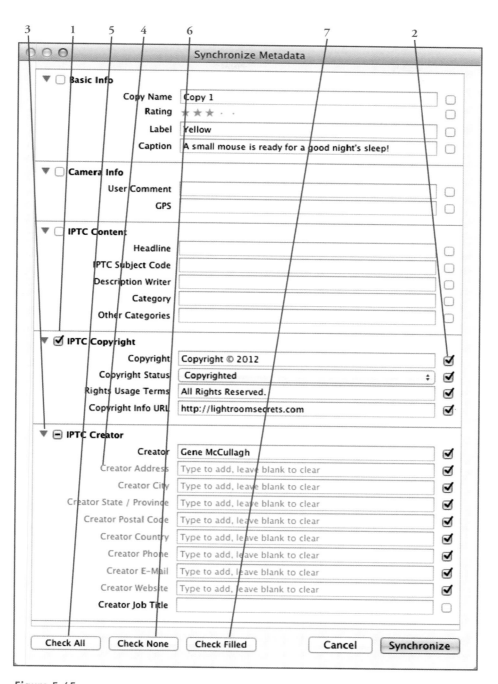

Figure 5.45

The Synchronize Metadata dialog.

Each category of metadata appears in its own section. You can apply all of the fields within a section by checking that section (1). You can select (and deselect) individual metadata fields by checking their individual checkboxes (2). If you have selected an entire section and then deselect individual fields in that section, you'll see a – in place of a checkmark for that section (3) to let you know not all of the fields for that section will be included. When you select a field that has no data, Lightroom reminds you by coloring the field name in red and putting the message Type to Add, Leave Blank to Clear in the field (4). Selecting a field and choosing to leave it blank has the effect of clearing out that field in all of the selected images.

At the bottom of the dialog are three useful buttons:

- **Check All**—Click this to select all metadata fields.
- **Check None**—Click this to deselect all metadata fields.
- **Check Filled**—Click this to select only fields that already have data entered.

When you are ready, click the Synchronize button to apply all that juicy metadata to your selected images.

The full list of metadata fields available is shown in Figure 5.46.

The Sync Settings buttons does the same thing for image settings. Click this and the Synchronize Settings dialog (Figure 5.47) presents itself.

Just as we saw in the Synchronize Metadata dialog, items are in groups. Each group has a selection checkbox (1), and so does each individual setting (2). You can select all of the settings in a group by clicking its checkbox. When all items are selected, a checkmark appears (3). If only some of the settings in a group are chosen, a minus sign (–) appears in place of a checkmark (4).

We've touched on the new Process Version that Lightroom 4 uses. Process Versions are an important part of how your images are interpreted, and we will cover this in depth in the Develop module. However, different Process Versions have different settings available. If you choose to apply the settings from one Process Version to an image using a different Process Version, Lightroom warns you in the Synchronize Settings dialog (5) with the message Settings That Do Not Specify a Process Version May Produce Different Visual Results when They Are Transferred to Photos with a Different Process Version Applied. Just be aware that the results may be different from what you expect.

Figure 5.46

You couldn't ask for more metadata! Here is the full list available in Lightroom.

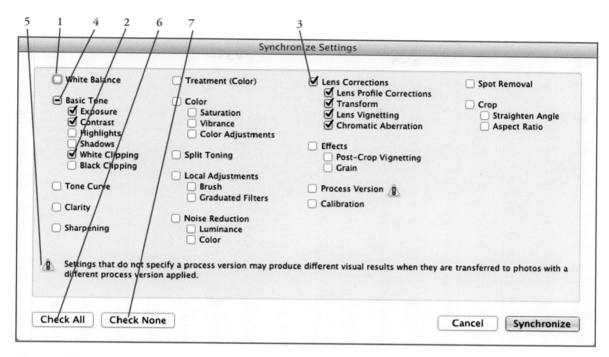

Figure 5.47
The Synchronize Settings dialog.

The Check All (6) and Check None (7) buttons are also available and do the same things as in the Synchronize Metadata dialog.

I won't go into great detail about all these settings until we get to the Develop module. All of these play into creating Develop Presets, and we will have a chance to get our hands dirty then.

That about wraps it up for part one of our Library tour. We've now seen everything in the Library module that isn't your images. In the next chapter, we'll finish up the Library module tour and see where your images are. Take a brief break, and then we'll press on.

6

Library—Part Two

Welcome back. I hope you enjoyed your break and are refreshed and ready to go.

We have only two more areas of the Library module interface to visit, but these are the areas where you can actually see your images. Many of the topics we will cover apply throughout Lightroom, so I've separated them into this chapter so we can spend some time with those areas and their controls:

- The Filmstrip
- The main display area

The Filmstrip

At the bottom of the Library module is the Filmstrip (Figure 6.1). I think you can see where it gets its name. It's a horizontal strip of images that you can scroll back and forth in either direction. If you remember film, you can see the relationship.

Figure 6.1

The Filmstrip.

The Filmstrip is a special panel. Like the Collections panel, the Filmstrip is a constant companion. It appears in all seven Lightroom modules, so you have ready access to your images without having to return to the Library module.

Like the other panels, you can activate manual or auto-hide/auto-show behavior. You can also change the height of the Filmstrip by grabbing the top and moving it up or down. As you do, the size of the images you see will grow or shrink. So it can be as large as you see in Figure 6.1 or as tiny as in Figure 6.2.

Figure 6.2

A teeny tiny Filmstrip.

For now let's make the Filmstrip bigger and take a look at what's there (Figure 6.3).

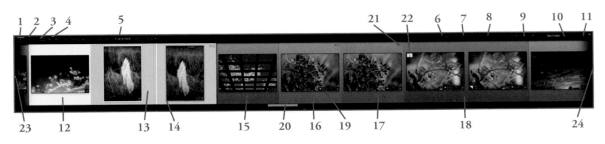

Figure 6.3

Let's see what we have in the Filmstrip.

First I'll simply list what's going on here in the Filmstrip. After that, we can look a little deeper into each topic.

1. Main window options
2. Secondary window options
3. Return to Grid
4. Previous/Next navigation buttons
5. Quick Locator
6. Quick Filter
7. Flag Filter
8. Star Filter
9. Color Label Filter
10. Filter Presets drop-down
11. Filter on/off switch
12. Target image
13. Selected image
14. Selected image with blue color label applied
15. Unselected image
16. Unselected image with yellow color label applied
17. Unselected image with red color label applied
18. Expanded image stack
19. Thumbnail badges
20. Scroll bar
21. File Alert icon
22. Stack badge
23. Scroll Filmstrip to the left
24. Scroll Filmstrip to the right

Main Window

At the top left of the Filmstrip is the Main Window button [Figure 6.3 (1)], which offers some controls over what you see on your primary monitor. Click this and it brings up a small context menu (Figure 6.4).

Figure 6.4
The Main Window menu.

The top section lets you choose one of the four display formats for the main display area—Grid, Loupe, Compare, or Survey. We'll cover these later on in this chapter.

The bottom section offers three screen modes:

Normal Screen Mode—This is your normal view, with Lightroom running in a window on your main monitor.

Full Screen with Menubar—Just as the name implies, Lightroom will occupy your entire monitor and have the menu bar at the top.

Full Screen—This is the same as the previous choice but without the menu bar. This mode is especially useful when clients or art directors are looking over your shoulder. It lets you fill your monitor with Lightroom and removes any distractions.

You can always return to Normal Screen mode by pressing Option+Command+F. You can cycle through all three screen modes by pressing F.

Secondary Window

Lightroom has the capability to use two monitors. If you don't have two monitors, you can still take advantage of the Secondary Window features since your secondary window can be a smaller window on your single monitor setup. Click the Secondary Window button [refer to Figure 6.3 (2)] to display the window. To see the context menu (Figure 6.5), right-click.

This menu is also divided into two sections. The top section controls the visibility and size of the secondary window. When you click the button to activate the secondary window, it will open in full screen on your second monitor. If you don't have a second monitor, it will open as another window on your main monitor (Figure 6.6).

Secondary Window :

✓ Show ⌘F11
 Full Screen ⇧⌘F11
 Show Second Monitor Preview

 Grid ⇧G
✓ Loupe – Normal ⇧E
 Loupe – Live
 Loupe – Locked ⇧⌘↵
 Compare ⇧C
 Survey ⇧N

Figure 6.5

The Secondary Window menu.

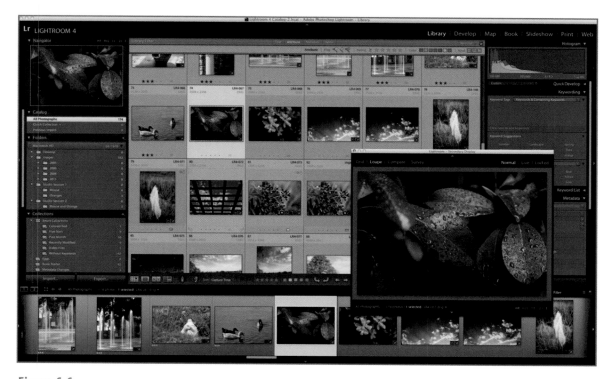

Figure 6.6

The secondary window on your main monitor.

When not in Full Screen mode, you can change the size of the secondary window just as you would any other window. If you are displaying your secondary window on a second monitor, the third option, Show Second Monitor Preview, becomes available. This turns on a small preview window showing you what's on your second monitor (Figure 6.7).

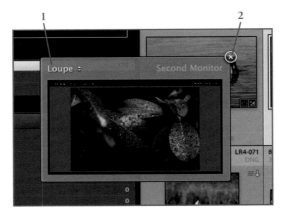

Figure 6.7

The second monitor preview window.

What's this about? I'm looking right at my second monitor, so what good is this little window? Let me paint a scene and show you how clever this is.

You may have a second monitor, but you might not be able to see it. Suppose you have your second monitor facing the client instead of you. This little window not only lets you see what is showing on a second monitor you can't see, it also lets you change what is being shown on that monitor. In the upper-left is a small drop-down (1) that gives you access to the viewing modes on that second monitor. You can also run a slideshow on the second monitor and control the playback from the preview window. Pretty neat, eh? If you want to close the preview, just click on the X (2).

The bottom of the Secondary Window menu (refer to Figure 6.5) lists the four viewing modes available for the secondary window. However, for the Loupe mode you will see three options:

Loupe - Normal—This displays the target or most selected image.

Loupe - Live—This displays whatever image is under the cursor on the main window.

Loupe - Locked—You can lock an image to the secondary window, and it will continue to be shown even if you select a different image in the main window. You can lock an image by right-clicking on it in the main window and choosing Lock to Second Monitor from the context menu. Alternatively, you can select the image and press Shift+Command+Return.

> **TIP**
>
> Are you tired of that frantic art director hovering over your shoulder during a shoot? You added a second monitor for him, but that cable just isn't long enough to keep him at a distance. If you have an iPad or other tablet, find an app that turns your tablet into a second monitor (such as Air Display from Avatron Software (http://itunes.apple.com/us/app/air-display/id368158927?mt=8). Most of these apps will function when your computer and tablet are on the same Wi-Fi network. Put your secondary window on the tablet as a second monitor and hand that to the art director. He can sit a comfortable distance away from you and look at his own personal display to see what you are shooting. Using the preview window capability, you can even change what is displayed on the tablet.

Navigation Controls

The next three items in the Filmstrip are navigation controls:

- Return to Grid [Figure 6.3 (3)]
- Previous/Next navigation buttons [Figure 6.3 (4)]
- Quick Locator [Figure 6.3 (5)]

The Return to Grid button is particularly useful when you are in a different module and need to return to the Grid view of the Library module. Simply click the button, and Lightroom will take you back to the Library module and activate the Grid view. Of course, you can always press **G** to return to the Grid view.

As you move though various modules, you can easily get back to a previous module by clicking the Previous (left arrow) button. Once you have gone back, you can return by pressing the Next (right arrow) button.

The Quick Locator displays information about where you are and what's going on. For example, if you see All Photographs 174 photos/3 selected/import-003.dng, you know that you are displaying images from the group All Photographs, that there are 174 photos in the group, you have three selected, and your target (or most selected) image is import-003.dng. But wait, there's more.

You may have noticed the small display triangle to the right of the text in the Quick Locator. That indicates there is a drop-down available. Click anywhere on the Quick Locator to display the menu (Figure 6.8).

✓ **All Photographs**
Quick Collection
Previous Import

Favorite Sources :
Folder : Images

Recent Sources :
Smart Collection : Eggs
Collection : Metadata Changes
Folder : Studio Session 1
Folder : Mouse and Orange
Folder : Mouse
Folder : 2008
Folder : 2005

Clear Recent Sources

Figure 6.8
The Quick Locator drop-down.

This menu changes according to where you've been and what you have chosen in the menu. At the top Lightroom provides three default locations: All Photographs, Quick Collection, and Previous Import. You have the capability to make sources favorites. These appear in the next section. If you choose something in your Favorite Sources section, a Remove from Favorites option will appear at the bottom of the menu. You can create a favorite from locations in the next section, Recent Sources. When a recent source is selected, the Add to Favorites option will appear at the bottom of the menu.

Recent Sources is a list of the last few locations you've been to. You can see from the example that it keeps track of folders, smart collections, and collections you've visited. This lets you easily return to a previous location. If you want to clear this list, click the Clear Recent Sources option at the end of the menu.

There are also three navigational controls along the edges of the Filmstrip. At the bottom is the scroll bar [refer to Figure 6.3 (20)]. Grab this and move it left or right to scroll the images. Clicking the scroll left triangle [Figure 6.3 (23)] or scroll right triangle [Figure 6.3 (24)] will accomplish the same thing.

Quick Filter

Moving to the right side at the top of the Filmstrip we find the Quick Filter [refer to Figure 6.3 (6)]. The main components of the Quick Filter are as follows:

- Quick Filter Hide/Show button [Figure 6.3 (6)]—Click this to hide or show the Quick Filter.
- Flag filter [Figure 6.3 (7)]—Filter images based on their flag status.
- Star filter [Figure 6.3 (8)]—Filter images based on their star rating.
- Color Label Filter [Figure 6.3 (9)]—Filter based on the label color applied.
- Filter Presets drop-down [Figure 6.3 (10)]—This gives you access to any filter presets you've defined without the need to return to the Library module. You can also create and update filter presets directly from this menu.
- Filter on/off switch [Figure 6.3 (11)]—Quickly toggle the filter on and off using this switch.

We will be discussing selections and filters in greater detail in a later chapter.

Visual Feedback Features

In addition to showing your images, the Filmstrip offers a wealth of visual feedback about your images. These visual cues are also available in the main display area.

Around each image thumbnail is a border (reminiscent of the paper border around slides). The color of this border gives you some idea regarding the status of your image. Let's look at some of the examples shown in Figure 6.3.

12. If the border is white (or very bright gray), this is the target (or most selected) image. The target image is the one that will be the focus of most actions you take. For example, the target image will be the one displayed when you switch to the Develop module.

13. When the border is light gray, it indicates that the image is selected but not the target image.

14. If you see a small colored frame around the thumbnail of a selected image, that tells you that a color label has been applied. In the example shown, the image is selected and has a blue color label applied to it.

15. Dark gray indicates that an image is unselected.

16. A border that is fully colored indicates that a color label has been applied, but the image is not selected. In this example the yellow color label was applied.

17. This shows the red color label.

18. The darkest gray indicates that the images are part of a stack of images.

In addition to colors and shades of gray, the Filmstrip offers some icons for more feedback:

19. Badges. We'll come back to these in a minute because they need a more detailed discussion.

21. In the upper-right corner of the thumbnail border, Lightroom will display File Alert icons when something needs your attention. In this example we see three lines next to a downward arrow. This icon indicates that there have been changes to the metadata for this image in the catalog that haven't been written out to the file yet. There are other File Alert icons, and we will go over them in the main display area.

22. The small rectangle with a number that appears in the upper-left corner of the thumbnail indicates that this image is part of a stack and is the top image in the stack. The number tells you how many images are in the stack. As you hover over any image in the stack, the icon will change to *x of y*, where *x* is the place this image holds in the stack, and *y* is the total number of images in that stack. In this example, if we put the cursor over the image, the 2 will change to 1 of 2. Finally, a single rectangle as we see here tells us that the stack is expanded. If the icon resembles a small stack of three rectangles, it tells us that the stack is collapsed, and we are looking at the top image only.

You can turn badges off, but I recommend you don't because they not only tell you something about the image, they are also interactive (Figure 6.9).

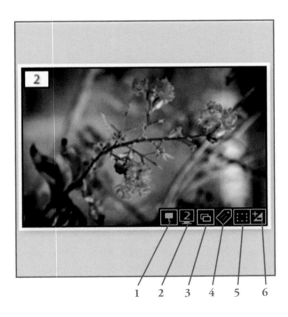

Figure 6.9

Badges.

1. The first icon here, which looks like a pin, indicates that this image has location data and has been pinned in the Map module. Clicking this badge switches to the Map module and shows the location of this image.

2. If I have locked this image to my secondary window, I will see this small monitor with the number 2. Click this to unlock the image from the secondary window.

3. Next is an icon that looks like a rectangle with a shadow. This indicates that the image is part of at least one collection. To see what collections, click the badge and you will see a list. Click any collection in the list to change to that collection. Notice that smart collections are not part of this list.

4. The next badge looks like a small tag. Some users I've talked to see a short stubby pencil instead of a tag. Either way it tells me that keywords have been applied to this image. If I click this badge, Lightroom will transport me back to the Library module and expand the Keywording panel so I can see what keywords have been applied and add some new ones if I like.

5. The small rectangle with dots at each corner and dots in the middle of each side indicate that the image I am looking at has been cropped. Click the badge and you will find yourself in the Develop module with the Crop tool active. From there you can adjust or reset the crop.

6. Finally, the black and white rectangle with a plus sign (+) and a colon (:) in it indicates that adjustments have been made to the image. Click this badge to go to the Develop module and resume your adjustments.

There are four more cues available in the Filmstrip (Figure 6.10).

1. Images that have been "picked" will have a small white flag in the upper-left corner of the thumbnail border. We will cover how to use flags later. For now,

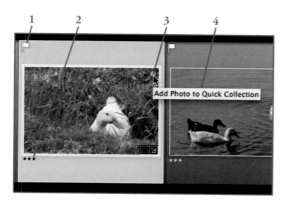

Figure 6.10

Additional visual feedback elements in the Filmstrip.

though, you should know that you can turn this flag on and off by clicking in the upper-left corner of the thumbnail border.

2. Images can be rated with zero to five stars. At zero stars you won't see anything. With one through five stars, you will see the star rating just below the lower-left corner of the thumbnail. Unused stars are shown as dots. So a three-star image will show star, star, star, dot, dot. This reminds you that the maximum number is five.

3. When you move your cursor over a thumbnail, a small dot appears in the upper-right corner of the thumbnail. Click this to add the image to your Quick Collection. Once added, the dot turns dark and remains there even after your cursor moves on.

4. Lightroom offers to help you out in many areas. If you hover your cursor over different parts of the interface, you will get tool tips, hints about what that thing does. Here we see the tool tip telling us that the dot will Add Photo to Quick Collection. If you aren't sure what something does, hover a second and see if Lightroom gives you a hint.

If you decide that you don't want to see one or more of these visual cues, you can turn them off.

CAUTION

If you don't see your badges or stars or flags and you haven't turned them off, check the size of your Filmstrip. When you shrink the Filmstrip down, Lightroom turns these visual feedback cues off to prevent clutter and let you see the thumbnails. Make the filmstrip larger to bring these cues back.

To turn visual cues in the Filmstrip on or off, right-click on any thumbnail. At the bottom of the context menu that appears (Figure 6.11), you will see view Options. Uncheck any of the options you want to turn off by clicking that item. Clicking an unchecked item will turn it on.

Allright, we've now been all the way around the Library module interface, and it's time to move to the center and discover the main display area.

✓ Show Ratings and Picks
✓ Show Badges
✓ Show Stack Counts
✓ Show Image Info Tooltips
✓ Show Photos in Navigator on Mouse-Over

Figure 6.11
You can change the view options for the Filmstrip.

Main Display Area

In the center of the Library module, we find the main display area (Figure 6.12).

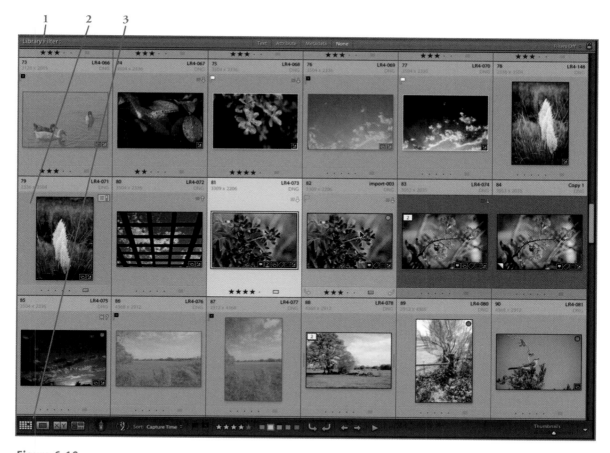

Figure 6.12
The main display area of the Library module.

There are three main sections to the main display area:

- Filter Bar
- Image display area
- Toolbar

This is the real star of the Library module. The other panels we've looked at so far are the supporting players for what lies in the main display area. Here is where we find our images and can start to bring the power of the Library module to bear.

Filter Bar

At the top of the main display area is the Filter Bar (Figure 6.13). You can hide or show the filter bar by pressing the backslash (\) key or selecting View > Show Filter Bar. The Filter Bar is a more robust version of the Filmstrip's Quick Filter.

Figure 6.13

The Filter Bar.

In the middle of the Filter Bar are four filtering choices:

1. Text—Use this method to search for text in different fields.
2. Attribute—This method lets you search by flags, starts, colors, etc.
3. Metadata—Remember all of that rich metadata Lightroom will let you gather and store? This method opens it up for filtering.
4. None—Not technically a method. This disables any filtering.

On the right side of the Filter Bar is the Filter Preset drop-down (5), which you use to recall saved filters, to create new filters, to delete filter presets, and to update existing filter presets. Further to the right is a small lock (6).

If you create a filter while you are in All Photographs and then you switch your source to the collection called My Favorite Collection, the filter will be cleared if the icon is unlocked. If you want to retain the filter settings you've set up when changing sources, click the icon to lock it before you change sources.

When you choose Text, the Filter Bar expands to show you the options for this method. (Figure 6.14). There is a drop-down to select what text field to search (1) and one to choose how inclusive the search is (2). You can access all of the options from both of these fields, however, by clicking on the small magnifying glass icon (3) at the beginning of the text entry field (4).

Figure 6.14

The text filter.

Next up is the Attribute filter (Figure 6.15).

Figure 6.15

The Attribute filter.

Choosing Attribute again expands the Filter Bar, showing the attributes available for filtering. You can filter on these attributes:

- Flags
- Stars
- Colors
- Kind

Each attribute is like a small on and off switch. The effects are cumulative. For example, if I click two stars, Red, and Blue, I am filtering for all images with two or more stars that have either a Red or Blue color label.

The Metadata filter (Figure 6.16) is a filtering paradise. Click Metadata in the Filter Bar, and you are greeted with four columns. Each column represents a metadata field (1) whose name is shown in the column header.

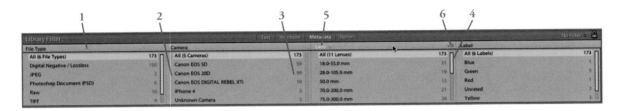

Figure 6.16

The Metadata filter.

Below the column header is a list that begins with All (# type), showing you the number of different entries in that metadata field. Looking at the Camera column in the example we see All (5 Cameras), indicating there are five different cameras in this selection. Below that you can see the individual entries (2) and how many images meet that criterion (3). If there are more entries than will fit in the list, a scroll bar will appear (4) so you can scroll to see the other entries.

If you move your cursor over the column header, the name of the field will show up and down disclosure triangles (5) to indicate there is a drop-down menu. Click the field name and you can switch to a different metadata field for that column. To the right in the column header is another drop-down menu indicator (6). Click this to remove that column or add another column. You can have up to eight columns of metadata in the filter.

To see how the logic of this filter works, take a look at Figure 6.17.

Figure 6.17

This is how the logic of the Metadata filter works.

In this case, I want to find all of my images that

- Are Lossless DNG file types AND
- Shot with a Canon 5D AND
- Shot with a 70–200mm lens AND
- Shot with an aperture of f/16

As I select an entry in the first column, Digital Negative/Lossless, the number shown is 150. The next column then changes to a maximum of 150 images (i.e., the cameras that shot DNG files). I choose Canon EOS 5D, which shows a total of 55. Those 55 become the starting point for the Lens column. The 70.0-200.0 mm entry has 8. Therefore, my Aperture column starts with 8, and I finally arrive at the f /16 entry, showing 4. When I look at my images now, only four of them appear, and I know each of them meets the criteria of my filter.

Don't worry. We'll come back to filtering because there is more to say on this topic.

Image Display Area

Right below the Filter Bar is the image display area (Figure 6.18). This is the stage where your images perform.

Figure 6.18

The image display area in Grid view.

Figure 6.18 shows one of the four views you can have in the image display area, Grid view. The four views are these:

- Grid view
- Loupe view
- Compare view
- Survey view

Let's look at each of these views.

Grid

The Grid view (Figure 6.19) is the most complicated of the four views. But once you learn to read and work with it, this view can provide a wealth of information at a glance. I've already covered many of the visual cues you see here when we discussed the Filmstrip, so I won't repeat that information. There is more in the Grid view to look at.

The easiest way to activate the Grid view is by pressing the G key. G for Grid—easy to remember and a key you will probably wear out on your keyboard.

Each image thumbnail is contained within a cell. We can customize how those cells look, and we will look at that in a moment. For now, this format of the Grid has a head at the top of each cell (1) that provides some basic information about the image. In this example we see the image number, filename, pixel dimensions, and file type in the cell header.

At the bottom of the cell are star ratings (2) and color labels (3). You can apply either by clicking directly on them. The flags appear in the upper-left corner of the thumbnail border. Images flagged as a "pick" get a white flag (4). Also notice that "picked" images get a small white border around their thumbnail. Images flagged as a "reject" receive a black flag with an X or, as some call it, a pirate flag (5). Lightroom provides a more visible cue for rejected images by graying out the thumbnail slightly (6).

For stacked images, the small rectangle is in the upper-left corner of the thumbnail (7). It appears as a single rectangle for expanded stacks. For collapsed stacks, the icon changes to a small stack of rectangles (8). Clicking this icon will expand or collapse the stack. Another indication that you are dealing with a stack is the small grooves on either side of the thumbnail (9). Clicking either of these will also expand or collapse the stack.

Moving your cursor over a thumbnail will cause additional controls to appear. In addition to the Quick Collection circle and the flag we talked about in the Filmstrip, rotate left (counterclockwise) and rotate right (clockwise) will appear (10). Click these to rotate the image in either direction.

Images that have been added to the Quick Collection will have the dark circle icon in the upper-right corner of their thumbnail (11).

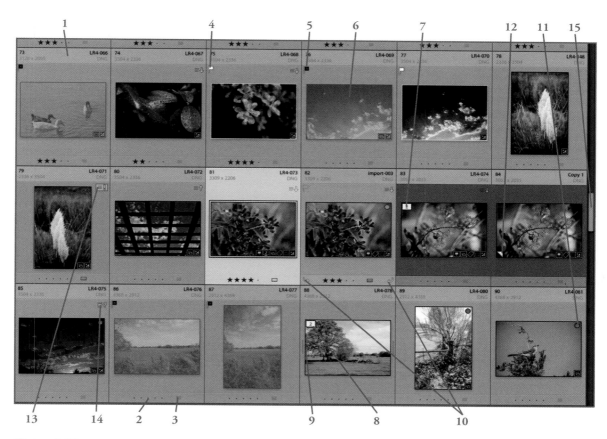

Figure 6.19

The Grid view.

If the thumbnail represents a Virtual Copy, the lower-left corner will look curled up (12). Virtual copies are a really powerful feature of Lightroom. You're gonna love them if you haven't run into them before.

We talked a little about File Alert icons in the Filmstrip. If you recall, we saw the icon that resembled three lines with a downward-pointing arrow. This means there is a change to the metadata for the image that had not yet been saved to the file. You'll also notice in Figure 6.19 a similar three-line icon with an upward-pointing arrow. This one means that the metadata for the file was changed by another program and hasn't been uploaded to the catalog yet. Two more import File Alert icons are three lines with an exclamation point (13), which indicates a conflict. What this is telling you is that the metadata for the image was changed in Lightroom and changed by another program, and the two don't match. To resolve this conflict, click on the icon. Lightroom will bring up a dialog to explain the problem (Figure 6.20) and offer you a choice.

Figure 6.20

Resolving a metadata conflict.

If you choose Import Settings from Disk, you will bring the metadata settings from the file into the catalog. Choosing Overwrite Settings will take the metadata from the catalog and save it to the file. There is also Cancel, but that really isn't a choice is it? If you aren't sure what the conflict really is and need to investigate further, go ahead and choose Cancel and come back to this conflict when you're ready.

The other File Alert that plagues many users is the File Missing icon [refer to Figure 6.19 (14)], which looks like a piece of film with a question mark. This often happens when you move or rename a file using your operating system rather than the Folders panel or renaming tools in Lightroom. When you do this, Lightroom loses track of the file. To resolve this, click the icon. Again Lightroom serves up a dialog telling you what the problem is (Figure 6.21).

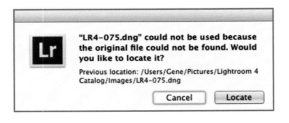

Figure 6.21

Locating a missing file.

Lightroom tells you the original file can't be found and asks if you'd like to locate it. To help you out, it reports the last known location. Choose Locate to proceed.

The next dialog you will see is called Locate *<filename>* (Figure 6.22). In this example, we're looking for LR4-075.dng, so the dialog name is Locate "LR4-075.dng," which is a handy reminder of what we're looking for. Find the file and select it (2). At the bottom of the dialog is a checkbox labeled Find Nearby Missing Photos (3). If you moved a folder or two full of files, checking this will tell Lightroom to look around in case it sees the other missing files and update their locations in the catalog. Click Select, and the File Alert icon should disappear.

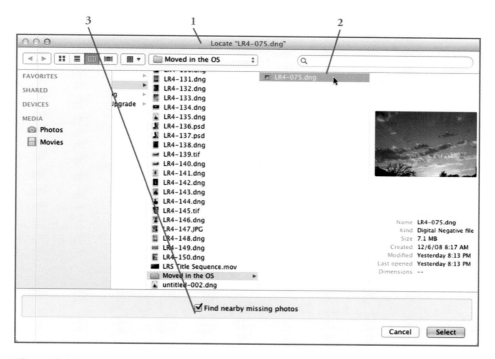

Figure 6.22

Navigate to where the missing file is now located.

You probably have more images in your catalog than will fit on one screen (if not, put the book down and go shoot). In that case, you will see a scroll bar on the right [refer to Figure 6.19 (15)], so you can easily move through your images in Grid view.

Adjusting the View

Lightroom has a myriad of options for displaying information in each cell. This can tell you quite a bit about the image without having to consult any of the panels or modules. Let's take a look at what we can do with view options.

To bring up the View Options dialog, you can use the keyboard shortcut Command+J or go to View > View Options. This will bring up the Library View Options dialog (Figure 6.23).

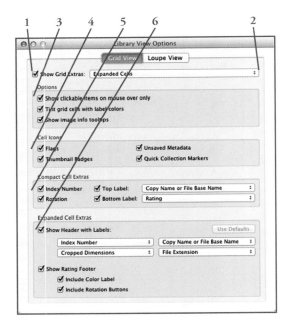

Figure 6.23

The Library View Options dialog.

This is a multipurpose dialog. It controls the view options for both the Grid view and the Loupe view. We'll talk about the Grid view for now. Our first choice is whether to show the Grid extras or not (1). If we decide to, then we have a choice in the drop-down of expanded or compact cells (2). In fact, there are actually three types of cells. The third could be called a regular cell or plain cell.

There are four main sections: Options (3), Cell Icons (4), Compact Cell Extras (5), and Expanded Cell Extras (6).

There are three checkboxes in the Options section.

- Show Clickable Items on Mouse Over Only
- Tint Grid Cells with Label Colors
- Show Image Info Tooltips

Clickable items are things like the star ratings and rotation controls. When checked these will appear and disappear on mouseovers. This can reduce clutter. If the small color frame isn't enough, you can tint the cell frame with the applied color tag. The last choice will let you show tool tips when you hover over the image. These tool tips have a good deal of info about the image and can be useful. Experiment with them and see what works for you.

Next we have the Cell Icons section. Flags are the Pick flags. Thumbnail Badges are the small icons in the lower-right corner that tell you if keywords have been applied, adjustments made, cropping, and so on. Unsaved Metadata is the File Alert icon that appears when you have changed something and have not yet saved the changes to the file (such as adding a keyword). Lastly, the Quick Collection marker is the small circle that appears in the upper-right of the image when an image has been added to the Quick Collection.

Before we look at the last two sections, let's see what the three cell views look like. The first is a plain view, and it's what you get when you uncheck the Show Grid Extras option (Figure 6.24).

Figure 6.24

A plain or regular cell. Simple and uncluttered.

It is reminiscent of slides (you remember slides don't you?). This is a very uncluttered cell with minimal information.

Next is the Compact Cell (Figure 6.25).

Figure 6.25

The Compact Cell offers a compromise between information and clutter.

More information but still a fairly compact view.

And finally, the Expanded Cell (Figure 6.26).

Figure 6.26

The Expanded Cell offers the most information in Grid view.

This adds an information header at the top and a controls footer at the bottom. There are four options in the Compact Cell Extras section [refer to Figure 6.23 (5)].

- Index number
- Rotation
- Top label
- Bottom label

Index Number is the large number in the upper-left. Rotation shows the rotation controls. The top and bottom labels can be shown or hidden, and you can choose what information each contains via the drop-down. The choices are the same for both the top and bottom labels, and there are quite a few to choose from, as you can see in Figure 6.27.

The Expanded Cell Extras section [refer to Figure 6.23 (6)] has two main areas controlling the header and the footer. The header has four variable information areas you can control via the drop-downs. The same choices are available as for the compact cell. For the footer you can choose to show or hide the color label and rotation buttons.

Spend a little time with this dialog to see what you like and don't like in your cells. But you don't have to visit the dialog in order to change some of the options. As is the case in many parts of the Lightroom interface, we have some shortcuts here as well.

You can change any (or all) of the four information sections in the header of the expanded cell simply by clicking on it. You will get a contextual menu with all of the choices from the drop-down in the dialog box. So just click and change. Doing a different kind of review? Click and change again.

One more keyboard shortcut before we move on. You can rotate through the three cell views (plain, compact, and expanded) simply by pressing the J key. Easy.

Copy Name or File Base Name

File Name
File Base Name
File Extension
Copy Name
Folder

✓ Copy Name or File Name
Copy Name and File Name
File Name and Copy Name
File Base Name and Copy Name
Copy Name and File Base Name

Common Attributes
Rating
Label
Rating and Label

Capture Date/Time
Cropped Dimensions
Megapixels

Caption
Copyright
Title
Sublocation
Creator

Common Photo Settings
Exposure and ISO
Exposure
Lens Setting

ISO Speed Rating
Focal Length
Exposure Time
F-Stop

Exposure Bias
Exposure Program
Metering Mode

Camera
Camera Model
Camera Serial Number

Figure 6.27

There is a long list of available information choices for the Compact Cell top and bottom labels.

Loupe

The Loupe view (Figure 6.28) puts one, and only one, image in the main display area. This lets you really examine the details in your image. To switch to Loupe view, simply double-click on a cell in Grid view, and that image will occupy the screen in Loupe view. You could also press the E key. I know, Loupe begins with L, but that was already taken, so Adobe chose the last letter in Loupe.

Figure 6.28

The Loupe view.

Click on the image to zoom in. Click again to zoom out. When you are zoomed in, you can click and hold while moving your mouse to pan the image. Double-click to return to Grid view. You can change your zoom in and zoom out settings using the Navigator panel (review our discussion of the Navigator panel earlier).

If you look in the upper-left corner of the image in Figure 6.28, you can see that Lightroom is telling you something about the image shown in Loupe view. There are three lines of information shown in this example:

- The filename and extension
- Some common capture data—shutter speed, aperture, ISO, focal length, and lens
- The image dimensions in pixels

You can set up two different sets of image information (Info 1 and Info 2) using the view options. We'll check that out in a minute. Pressing the I key will cycle you through No Info > Info 1 > Info 2. Command+I will toggle on and off whichever info set you have active. All of these are also accessible via View > Loupe Info.

Adjusting the View Redux

I mentioned that the Library View Options dialog was multipurpose. Take a look back at Figure 6.23, and you will notice a second tab labeled Loupe View. When you invoke this dialog in Grid view (by pressing Command+J or using the menu View > View Options) it defaults to the Grid View tab. You can switch to the options for Loupe view by clicking on the Loupe View tab. If you are already in Loupe view, then the dialog will open with the Loupe view options active (Figure 6.29).

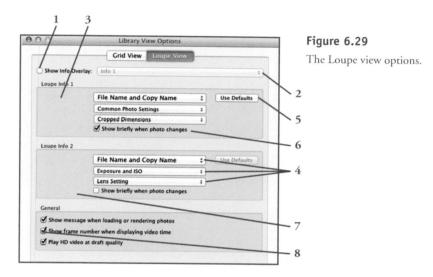

Figure 6.29

The Loupe view options.

The options for the Loupe view are a little less complicated than those for the Grid view. If you want one of the two Info sets always to show, check the Show Info Overlay checkbox (1) and then choose either Info 1 or Info 2 from the drop-down menu (2).

The next two sections in the dialog, Loupe Info 1 (3) and Loupe Info 2 (7), have basically the same choices. For each line of the info set there is a drop-down where you can choose what to show on that line (4). The choices available are the same as we saw for the different information fields in the Grid view display options (refer to Figure 6.27), with the addition of None, so you can turn off one of the three lines of information if you like.

Lightroom has default settings for these two info sets. If you change the information displayed in an info set and want to return to the default settings, click the Use Defaults button [refer to Figure 6.29 (5)], which appears in that info set's section.

At the bottom of the Loupe Info 1 (3) and Loupe Info 2 (7) sections is a checkbox labeled Show Briefly when Photo Changes (6). If you have unchecked the Show Info Overlay option (1) but would still like to see one of the info sets briefly whenever you switch from one image to another, this option is for you. Check the box for one of the info sets, and whenever you change the image, that info set will appear for about five seconds and then disappear. I find it useful to give me some basic info and then get out of my way so I can concentrate on the image. These two checkboxes are mutually exclusive. If the box is checked for Loupe Info 1, checking the box for Loupe Info 2 will uncheck the other. This makes sense because you can have only one set of information show up at a time.

The last section, General, has three options to choose from:

> **Show Message When Loading or Rendering Photos**—When you show an image in Loupe view, Lightroom must render a larger preview to let you show the image at a larger size and zoom in. If a 1:1 preview hasn't been rendered for the image you choose, this option will put up a small notice letting you know that Lightroom is building the preview. I keep this on so I don't have to wonder what Lightroom is up to when there is a delay switching to a new image in Loupe view.

> **Show Frame Number When Displaying Video Time**—This will append the frame number to the time when you work with video in Loupe view. Unchecked displays minutes and seconds (mm:ss). With the option turned on (checked), you see minutes, seconds, and frame number (mm:ss:frame).

> **Play HD Video at Draft Quality**—As more cameras come equipped to shoot video, photographers are discovering an entirely different post-processing workflow. Video is very processor and memory intensive. You can speed up Lightroom's video handling by checking this option. Instead of rendering full-quality HD video whenever you need to work on a video file, Lightroom will render the less-detailed (and smaller) draft version. I find this more than suitable for video work in Lightroom. At this point in Lightroom's evolution, I bring the more complicated and extensive video work to Premiere Pro and After Effects. If you are doing any video work, I recommend you check this option.

Compare

The Compare view (Figure 6.30) lets you look at two images side by side and make a comparison. Using Compare view is one way to come up with a "best shot" from a group of shots. This view will operate in a slightly different fashion, depending upon whether you have made a selection of images or not before switching to the view. You can switch to Compare view by pressing the C key. That's better—C for Compare. Luckily, C wasn't already taken.

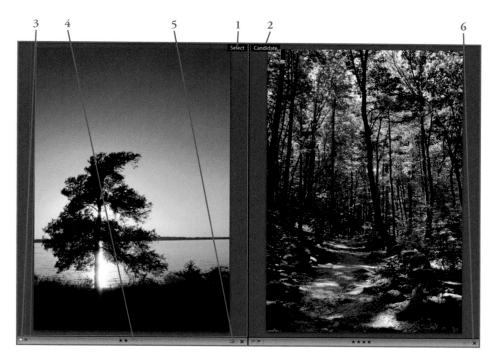

Figure 6.30

The Compare view.

When you switch to the Compare view, your target or most selected image shows on the left and is called the *Select* (1). The next image in the Filmstrip appears on the right and is called the *Candidate* (2). If you press the right arrow key, the next image in the Filmstrip becomes the Candidate. The Select remains unchanged. The left arrow key goes the other direction in the Filmstrip to choose the next Candidate.

I mentioned that this view changes its behavior slightly if you have images selected or not before switching to it. Here are the basic differences:

No images are selected—If no images are selected when you switch to Compare view, the first two images in the Grid or Filmstrip become the select and candidate, respectively. The left and right arrow keys will change the candidate using all the images in the Filmstrip.

Only one image is selected—When only one image is selected, it becomes the select when you switch to Compare view. The image immediately to the right of the selected image becomes the candidate. The left and right arrow keys behave in the same manner as when no images have been selected.

Several contiguous images are selected—When you select several images that are next to each other (contiguous), your target image becomes the select, and the first image in the selection becomes the candidate. However, if your target image is the first image in the selection, the next available image becomes the candidate. The left and right arrow keys still change the candidate, but now they restrict their action to only those images in the selection.

Several non-contiguous images are selected—If you have used your Command key to make a selection of images that are not next to each other (non-contiguous), the behavior is the same as for contiguous image selection. You will notice that the left and right arrow keys skip any unselected images between the non-contiguous images in the selection.

TIP
When you are in Compare view, Lightroom gives you some visual cues in the Filmstrip about your Select and Candidate (Figure 6.31). In the upper-right corner of the thumbnail for your Select you will see a small white diamond (1). The Candidate's thumbnail will have a small black diamond (2). As you move from image to image for your Candidate, this small diamond icon will move from thumbnail to thumbnail.

Figure 6.31

Finding your Select and Candidate in the Filmstrip.

For each image (refer to Figure 6.30), the Select and the Candidate, you have access to their respective flags (3), star ratings (4), and the color labels (5). You can update these with the click of a mouse. In the lower-right of each frame is an X (6). Clicking this will remove the image from the selection, so the left and right arrow keys will no longer consider it for the Candidate. If you click the X on the Select, it will be removed from the selection, and the next available image takes its place as the Select.

As you work your way through your images, you may decide that your Select and Candidate need to trade places. Press the down arrow key to swap the Select and the Candidate. You can also use the up arrow key to make your Candidate the Select, and the next image in line will take its place as the Candidate.

By default, Compare view is set to link the focus of the Select and the Candidate. That means if you zoom in on one, the other will zoom in as well. If you want to change that behavior, just right-click and choose Unlink Focus from the contextual menu.

When you finally decide that your Select is the "best shot," press the C key. I guess this time around, it's C for Choose since you are already in the Compare view. Pressing C at this stage deposits you in the Loupe view with your Select as the chosen image.

Survey

The last of our views is the Survey view (Figure 6.32). To switch to Survey view, press the N key. N for No other letter left? You'll just have to remember this one.

Figure 6.32
The Survey view.

Survey view is like a table where you spread out your images and decide which one you want. The number of images you select will show up in Survey view in rows and columns (at least when there is an even number of them). The target image is indicated by a small white border (1). Just below the image you can see if it has any flags, stars, or color labels applied (2). As in Compare view, Survey view provides the ability to assign flags, stars, and color labels. When you move your cursor over an image, you can see two small shadow flags (3). Click the left one to pick and the right one to reject. Five small dots also appear (4). Click the dot that matches the star rating you want to assign. Lastly, a small grayed-out rectangle appears (5). Click this to choose a color label.

The other thing that appears when you move your cursor over an image is an X in the lower-right corner (6). Click this to remove that image from the selection (and Survey view). All remaining images will move and resize to fill up the main display area. That's one of the treats in Survey view. As you get closer to your one best shot, the images get larger and larger (Figure 6.33).

Figure 6.33

Removing an image from Survey view rewards you with larger previews of the remaining images.

If you prefer to use your keyboard instead of your mouse, Lightroom has you covered. The up, down, left, and right arrow keys let you change which image in Survey mode is the target image. As you press them you will see the white border move from image to image. When you want to remove the target image from Survey view, press the / key.

At the end of this process your final image, that best shot, will fill the entire Survey view (Figure 6.35).

TIP

If you have trouble assigning flags, stars, or color labels because you just can't see those shadowed placeholders beneath an image, try changing the background in the main display area. Right-click anywhere in the main display area except on an image, and you'll get a convenient contextual menu that lets you change the background (Figure 6.34).

Figure 6.34

Change your background by right-clicking any non-image area.

White, light gray, and medium gray all show the placeholders well. Dark gray and black tend to obscure them. There is also a Pinstripes texture you can apply if you like.

Whatever you choose here will apply to the background for the other three views as well.

Figure 6.35

Your final image fills the Survey view.

Toolbar

At the bottom of the main display area is the toolbar (Figure 6.36). You can hide or show the toolbar by pressing T or choosing View > Show Toolbar (if it's hidden) or View > Hide Toolbar (if it's already showing).

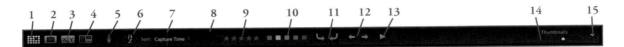

Figure 6.36

The toolbar with all bells and whistles.

Figure 6.36 shows the toolbar in Grid view with all of the options turned on. I'll show you how to turn these options on and off. The toolbar will change slightly for each of the four views. Let's take a walk around the toolbar for the Grid view first, as many of the features are persistent among the four views.

The first four icons represent the four views:

1. Grid view

2. Loupe view

3. Compare view

4. Survey view

If you don't like keyboard shortcuts, just click to switch views.

Next is the Painter (5). This neat little tool will bring out the organizational graffiti artist in you. You can grab the Painter and spray things onto your images like keywords, ratings, or rotations, to name a few. We'll spend some time with this tool when we talk about organizing your images later on.

Next we come to the Sorting options: Sort Order (6) and Sort (7). Click the Sort Order button to switch a to z to z to a and back again. This, of course, isn't just alphabetical sorting but represents oldest to newest or lowest to highest as well.

The drop-down menu next to the word Sort lets you choose what you want to sort your images by. Your choices are these:

- Capture Time
- Added Order
- Edit Time
- Edit Count

- Rating
- Pick
- Label Text
- Label Color
- File Name
- File Extension
- File Type
- Aspect Ratio
- User Order

The User Order sort option will appear only in certain situations. When you are viewing images in a collection (not a smart collection) or a folder that has no subfolders, this option is available. Choosing this sort option lets you move your images around manually the way you could on a light table or desktop.

Flags (8), stars (9), and color labels (10) are next in line. These three groups will display the status for a selected image as well as let you change or clear that status. Simply click on the attribute you want to change.

Rotation controls (11) can be used from the toolbar in addition to (or instead of) the rotation controls on the thumbnail. Just click to rotate the thumbnail in the indicated direction. Just as easily, you can navigate through the Grid with the Previous and Next navigation controls (12).

Would you like to sit back and relax while your beautiful images glide by on your screen? Click the Impromptu Slideshow button (13), and your screen will go dark while Lightroom presents your images one by one and full screen. This is an appetizer for the Slideshow module. While the slideshow is running, you can use the following keyboard controls:

Spacebar—This pauses and resumes the slideshow.

Left arrow key—Go back a slide.

Right arrow key—Jump to the next slide.

Esc (Escape) key—Stops the slideshow and returns you to Grid view.

To adjust the size of the thumbnails, use the Thumbnail slider (14). Slide to the left to decrease the size of the thumbnails and to the right to increase their size.

That's quite a toolbar! But you may not want all of these exciting features turned on. If you are working on a smaller monitor, all of them won't fit on the toolbar at the same time. Or perhaps you just don't want an Impromptu Slideshow button. That brings us to the last icon in the toolbar (15). Click this to display a menu from which you can pick and choose what to show on your toolbar. The options available are these:

- View modes
- Painter
- Sorting
- Flagging
- Rating
- Color label
- Rotate
- Navigate
- Slideshow
- Thumbnail size

The toolbar in the Loupe view is only slightly different (Figure 6.37). We see that the Painter is missing (1). That makes sense because the Painter is meant to spray things onto multiple images, and we have only one image in the Loupe view. The second difference is that the Thumbnail slider is replaced by the Zoom slider (2), and for some reason known only to the Adobe Lightroom Team, it moves from the far right over to meet the other controls.

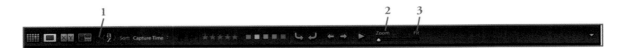

Figure 6.37

The Loupe view toolbar.

We need to talk a bit about this Zoom slider. Unlike the Thumbnail slider in Grid view, this one doesn't zoom in or out in a straight progression. Going from the left edge to the right edge won't always zoom in. Take a look at the word Fit over the right edge of the slider (3), and that may give you a hint how this slider works. As you slide from left to right, you progress through the zoom levels we talked about back in the Navigator panel. So moving the slider to the right would go from Fit to Fill. OK. That's zooming in. But slide a little further, and you go from Fill to 1:16. Unless you are on a very small monitor, you will zoom way out.

As you keep sliding to the right, you move through the levels 1:8 > 1:4 > 1:3 > 1:2 > 1:1 > 2:1 > 3:1 > 4:1 > 8:1 > 11:1. As you do, the indicator over the right edge of the slider will change to let you know what zoom level you are at. Once you understand that the slider is doing this, it all makes sense.

The toolbar we see in Compare view (Figure 6.38) is quite a bit different from the one in Grid view or Loupe view. The only familiar faces here are the four view buttons on the left side of the toolbar and the Navigation tools (6). The Previous and Next buttons work the same way as before except they act only on the Candidate. One more familiar tool, the Zoom slider (2), is also here and works the same way as it did in the Loupe view.

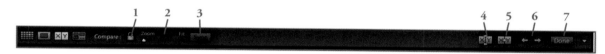

Figure 6.38

The Compare view toolbar.

We have a few new tools here. First is the Link Focus button (1), which looks like a small padlock. When it's locked, the focus is linked between the Select and the Candidate. If you recall, that means when you zoom one, you zoom the other. If you unlink the focus by clicking the Link Focus button, the lock will appear unlocked, and you can zoom the Select and the Candidate independently.

When focus is unlinked and the zoom levels of the Select and the Candidate don't match, the Sync button (3) becomes active. Click this to make the Select and Candidate zoom levels match.

> ### CAUTION
>
> Clicking the Sync button to match the zoom levels of the Select and the Candidate does not link focus. It merely matches the zoom levels. To link focus you must click the Link Focus button.

Click the Swap button (4) to swap the Select and the Candidate. To make the Candidate the new Select, click the Make Select button (5). Finally, when you've found that shot, press Done (7) to bring your masterpiece to the Loupe view.

The toolbar for Survey view (Figure 6.39) looks almost exactly like the toolbar for Grid view. There are no new tools added for Survey view. The two tools we had in Grid view that are missing here are the Painter and the Thumbnail slider. The tools that are here work the same way they do in Grid view. That's all there is to say about this toolbar.

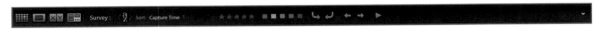

Figure 6.39

The Survey view toolbar.

The Road Ahead

We've spent the last two chapters digging into every nook and cranny of the Library module interface. If you're still on this trip, give yourself a pat on the back.

A lot of the foundation we've put down so far will make our examination of the other six modules' interfaces quicker. Many of the things you've learned during our tour of the Library module make the panels you will meet later make more sense more quickly.

Now that we have some idea of all the tools we have in our Library module toolbox, it's time to find out how to use them. In the remaining chapters of Part 2, we will start organizing our images. We will play with collections and publish services, dive into the deep pool of keywording, and explore the universe of metadata. Along the way we'll visit the Map module. Although it's a separate module and new to Lightroom 4, I think of it more as a super panel for the Library module.

We will also take some side trips and learn how to rate, review, and select our best shots.

To finish up Part 2, I'll show you everything you need to know about customizing Lightroom and setting up some of the myriad of presets Lightroom has to offer.

7

Organizing Your Images— The "Where"

Now it's time to say goodbye to your old filing system. Whether you have some sort of database to keep track of images or just a small paper notebook, Lightroom is here to make your organizational life easier. I mean, of course, that part of your organizational life that deals with your images. If you are having trouble remembering to put the trashcan at the curb on Tuesday night, that's another topic and another book.

Don't worry that you will be forced into a strict organizational regimen. There are certainly some parameters that Lightroom imposes on how you organize your images. But these are broad categories, and each of the individual tools can be adapted to fit your own individual organizing style.

Take stars for example. Lightroom provides a way to add one to five stars to an image. It's basically a way to rate an image in the same way you'd rate movies, hotels, or restaurants. Oh, that's a five-star shot! Hmm, I give it one star at best. That's a perfectly valid way to use the star rating system in Lightroom. However, I've met photographers who have used stars for other purposes. Instead of using one through five stars as a quality assessment, you might use them to denote where in your workflow an image is. One star? Needs color correction. Three stars? It's ready to be cropped. Keep that in mind as we talk about organizing your images. If you come up with a great new use for color labels or flags, let me know about it.

The first two fundamental principles of organization are *where* and *what*. You've probably heard the old saying, "A place for everything and everything has its place." So the cup belongs in the cabinet and not the sock drawer. The cabinet and the sock drawer are the "where." Cup is the "what." So my organizational system tells me, "if CUP then put in CABINET."

So let's start with the where and what of Lightroom.

167

Where

Think back a few chapters to our discussion about the panels in the Library module. Lightroom gathers the basic "wheres" in the left panel group (Figure 7.1).

- Catalog
- Folders
- Collections

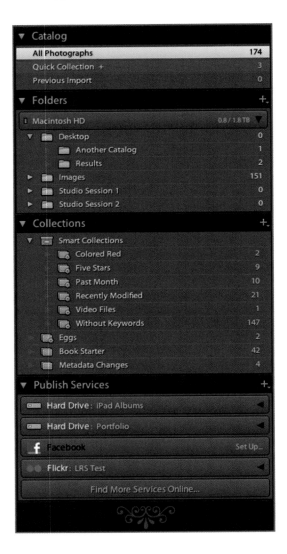

Figure 7.1

The basic "wheres" are all in the left panel group of the Library module.

We introduced these during our Library module interface tour. Now let's dig in deeper and see what else they can do.

Catalog

Your Catalog is where your images live in Lightroom. Nothing can happen in Lightroom until you open a Catalog. You can have more than one Catalog if you like, but Lightroom will deal with only one Catalog at a time.

Underneath it all, your Catalog is nothing more than an SQLite database. If you were to look at your Catalog with an SQLite database tool, you'd see something like Figure 7.2.

Figure 7.2

Your Catalog is actually an SQLite database.

Yikes! One look should immediately make you grateful that you don't have to manage your images that way. The wonderful team at Adobe has translated that into Lightroom's elegant interface. I won't frighten you again with SQLite databases. I think it's good to know what's behind the curtain, though.

Working with Catalogs

There are four basic Catalog skills you'll need to know:

- How to create a Catalog
- How to export images from a Catalog
- How to combine two or more Catalogs into one Catalog
- How to back up your Catalog

Creating a Catalog

The very first time you launch Lightroom, it prompts you to create a Catalog. If you let Lightroom call the shots, you have a Catalog called Lightroom 4 Catalog. It resides in your Pictures folder. If you look at that folder with the Finder, you'll see a file called Lightroom 4 Catalog.lrcat. All Catalog files end in .lrcat, so if you wind up creating a few Catalogs and lose track of them, you can search for that file extension.

If you want to create a new Catalog, go to File > New Catalog (it doesn't matter which module you are in, so if you are working on a slideshow and get the sudden urge to create a Catalog, go right ahead). This will bring up a Finder window titled Create Folder with New Catalog (Figure 7.3).

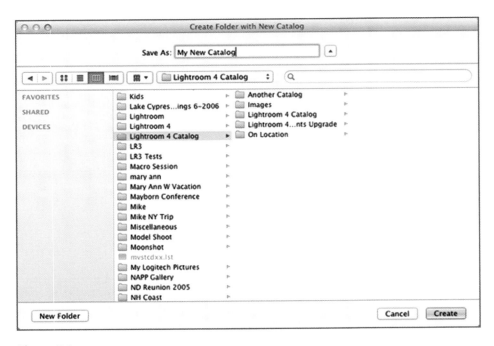

Figure 7.3

Creating a new Catalog.

Use the window to navigate to the location on your drive where you'd like the new Catalog to live. In the Save As field enter a name for your new Catalog and then click the Create button.

Lightroom then creates the new Catalog, closes whatever Catalog you have open, and opens your new Catalog. (Remember— Lightroom deals with only one Catalog at a time.)

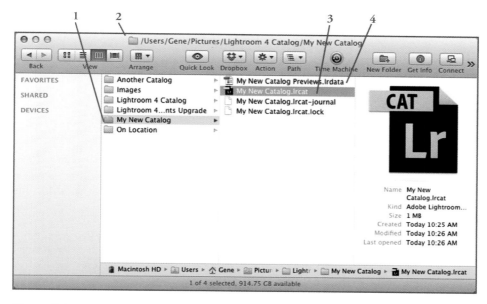

Figure 7.4

This is what Lightroom creates on your drive.

If you take a look on your drive at this point you'll see what Lightroom has done (Figure 7.4). You see that you have a new folder (1) at the location you chose (2). The new folder has the same name as your new Catalog. Inside that folder are two very important files:

3. **An .lrcat file**—This is your Catalog.

4. **An .lrdata file**—This is where your image previews are stored.

While your Catalog is open, Lightroom will create other working files in this folder such as .lrcat-journal and .lock, but these are only working files, and you don't need to be concerned with them.

TIP

Sometimes you will get an error message like the one in Figure 7.5 when you try to open a Catalog. This often happens after Lightroom unexpectedly closed (from a crash or power outage, for example) and didn't have time to clean up after itself. The first thing I look for is a .lock file that didn't get deleted. Choose the Quit option in the error message dialog and then check the folder where your Catalog lives. If you see a .lock file, delete it and try to open the Catalog again. This usually solves the problem.

Figure 7.5

Oops. Looks like there's a problem.

When your new Catalog opens, there's nothing there (Figure 7.6) but the gentle reminder in the middle of your screen to click the Import button to begin.

Figure 7.6

The wide open spaces of a fresh new Catalog.

Converting a Catalog

If you have used Lightroom prior to version 4, you will need to convert your old Catalog. Lightroom will help you through this. When you try to open a previous version's Catalog in Lightroom 4, you will be greeted with the Lightroom Catalog Upgrade dialog (Figure 7.7).

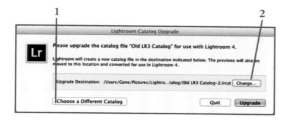

Figure 7.7

Lightroom 4 will convert your older Catalogs.

If you picked the wrong Catalog to open, you can click the Choose a Different Catalog button (1). The dialog lets you know that Lightroom will create a new Catalog and put it in the location shown. It will also update any previews you have already built. By default Lightroom will place the converted Catalog in the same location as the old Catalog. The new Catalog's name will be the old Catalog name with -2 appended to the filename.

If that's acceptable, click the Upgrade button. Should you want to change that, however, then click the Change button (2). A dialog just like the one you get when creating a Catalog will appear where you can choose the location and name for your converted Catalog (Figure 7.8).

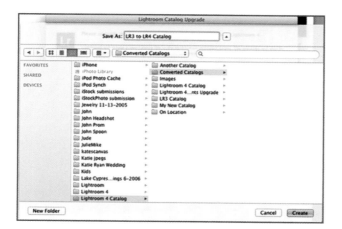

Figure 7.8

Change the name and/or location for your converted Catalog.

Make any changes and click Create. You will return to the Lightroom Catalog Upgrade dialog, and your changes will be reflected in the Upgrade Destination section. Now click Upgrade to proceed. Depending on the size of your old Catalog, it may take Lightroom a while to complete the conversion. You will see an Update in Progress dialog (Figure 7.9) while this is going on.

Figure 7.9

Patience! Upgrade in progress.

When the process is complete, the dialog disappears, and Lightroom opens your newly converted Catalog.

> **NOTE**
>
> Lightroom looks out for you. When you convert a Catalog from an earlier version to Lightroom 4, your old Catalog isn't damaged or deleted. When you are done, you will find both the old Catalog and the newly converted Catalog on your drive.

Export

From time to time you may need to export things from your Catalog. That can mean one of two things: you want to export a group of images as a new Catalog, or you just need to export some files. The process is a little different in each case, so let's begin by looking at how to export images as a new Catalog.

Catalogs

At present Lightroom is not a multiuser application, so the ability to export images as a Catalog becomes a useful way to hand off a part of your Catalog to an assistant for keywording or other adjustment. There are some complications when using multiple Catalogs for this purpose, but if you're careful not to "cross the streams," it works out wonderfully.

There are three ways to export a group of images as a new Catalog:

- From the Grid
- From a folder
- From a collection

To export from the Grid, first select the images you want to export. Then choose File > Export as Catalog to bring up the Export as Catalog dialog (Figure 7.10).

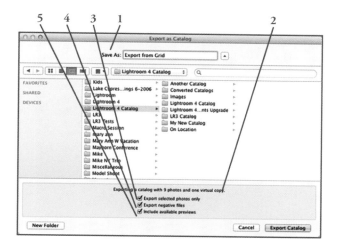

Figure 7.10

The Export as Catalog dialog when exporting from the Grid view.

Enter the name of your new Catalog in the Save As field (1). Near the bottom of the dialog Lightroom tells you how many photos and virtual copies will be exported to the new Catalog (2). The next three options need some further explanation.

> **Export Selected Photos Only (3)**—When you are selecting images in Grid view, there may be many more images showing than you intend to export to your new Catalog. Check this box to export only the selected files. If you uncheck it, every image currently showing in the Grid will be included. Keep in mind that "currently showing" doesn't just mean the thumbnails you can see on your screen but includes every image you can scroll to in the Grid.
>
> If you have preselected the group of images by using the filter bar, the Grid may contain only the images you want to use. In that case, unchecking the option would be a way to export those images without having to first select them after filtering. In either case, keep an eye on the total Lightroom is reporting just above this option (2). If you see more images than you intend to export, check the box.
>
> **Export Negative Files (4)**—This isn't a metaphysical conundrum like "what is the sound of one hand clapping." (If I export three negative files is that an import?) Lightroom is using photographic jargon and referring to the original image files as negatives (as in the film sense) rather than exporting fewer than zero files. By checking this box you are telling Lightroom to include copies of the original image files with the new Catalog.

If you are giving the new Catalog to an assistant to keyword, there really isn't any need for him to have copies of the image files. He doesn't even need access to the original image files. Remember that your Catalog is a database. Even when you can't get to your image files, you can keyword. It is only when you need to work on the image itself that you need to get to the original file. In fact, many of the organizational tasks in the Library module can be done without access to the image files. So you may not need to take up additional space to hold copies of image files.

Include Available Previews (5)—Lightroom builds previews of your images to be used in several areas. The thumbnails you see in Grid view are previews. When you zoom in for a better look, that's a preview. The Develop module uses another preview to make it possible to see what you are doing when making adjustments. Previews take time to build and require access to the original image files in order to construct them. Uncheck this option if you will have Lightroom rebuild the previews in the new Catalog.

CAUTION

If you uncheck both the Export Negative Files and the Include Available Previews options you will have a Catalog of gray images. If Lightroom can't reach the original image files to build its previews and you haven't included either copies of the original files or previously built previews, Lightroom has nothing to work with to build a preview. All of the other information will be there (keywords, metadata, etc.), but you won't be able to tell what the image is. So use caution here.

Once you have everything in place, click the Export Catalog button. Lightroom will export the new Catalog and let you know when that's done. Your existing Catalog remains open.

The other two methods—from a folder and from a collection—are nearly identical. To start, right-click on a folder or a collection. Choose Export This Folder as a Catalog (in the case of a folder) or Export This Collection as a Catalog (in the case of a collection). Lightroom will display a slightly different Export as Catalog dialog (Figure 7.11).

This is almost the same dialog as when we exported from the Grid. The only difference is that this dialog is missing the option to Export Selected Photos Only. Lightroom assumes that since we are choosing an already defined group of images, we want all of them.

The rest of the procedure remains the same as exporting from the Grid.

Figure 7.11

A slight variation of the Export as Catalog dialog when exporting from folders or collections.

Exporting as a Catalog has some additional benefits. All of the data points for the exported images (keywords, collections, metadata, etc.) come along for the ride, so your new Catalog has all the information about those images that the source Catalog has.

> **NOTE**
>
> If you choose to export negative files and the files are in different folders and subfolders, that folder structure is retained when the image files are duplicated and moved to the new location you specified.

Files

There are many reasons to export one or more files from your Catalog, and Lightroom offers quite an extensive array of options to meet your export needs. To export one or more files, you start by selecting the files to be exported. Then, of course, there are multiple ways to start the export itself.

The first is obvious. Click the Export button at the bottom of the left panel group. Or you can go to the File menu and choose one of the following options:

> **Export**—This is the same as pressing the Export button at the bottom of the left panel group.

> **Export with Previous**—If you have already exported some files and all of the Export settings are the way you want them, this option will use the same settings as your previous export.

> **Export with Preset**—This presents a submenu listing all of the built-in presets and any presets you've created. You can choose any of these and continue with your export using the settings in the preset.

You can also right-click any of the selected images, and these three options will be in the contextual menu under Export.

And, of course, you could use the keyboard shortcuts Shift+Command+E for Export or Option+Shift+Command+E for Export with Previous.

When you choose the regular Export option you will get the Export dialog (Figure 7.12).

Figure 7.12

The Export dialog.

Figure 7.13

The CD/DVD export options.

At the top of the dialog is a drop-down menu labeled Export To (1) where you decide the general destination for your exported files. You can choose from:

- Email
- Hard Drive
- CD/DVD

If you're like me, you will spend most of your exporting time with the Hard Drive option.

The left side of the Export dialog is occupied by the Preset area (2), where you can keep track of and access export presets. To the right of that is where we will be spending our time right now. Here you will find a series of panels, each devoted to a particular aspect of the export process (3). Which panels appear is dependent upon what output destination you've chosen in the Export To drop-down (1).

Not all of the panels are available for every option. For example, if you choose CD/DVD you will see a shorter list of panels (Figure 7.13). Lightroom removes the panels that don't pertain to CD/DVD export. This makes the dialog easier to use.

Let's return to the hard drive export (refer to Figure 7.12) and walk through each of the panels to find out what they do.

If you click on a panel header, you can expand or collapse the panel. Figure 7.14 shows three of the panels collapsed. When panels are collapsed, a summary of the options you have selected will appear on the right side of the panel header (1).

Figure 7.14

Panels can be collapsed.

Export Location Options in the Export Location panel (Figure 7.15) control where your exported images wind up after the export operation is complete. There are several options in the Export To drop-down.

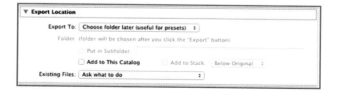

Figure 7.15

The Export Location panel.

Specific Folder—This lets you choose a folder to receive your exported images.

Choose Folder Later (Useful for Presets)—You can use this option if you would like Lightroom to prompt you for a location when you start an export. As the hint suggests, this is useful for presets because you can export using a preset directly from within Lightroom without having to open the Export dialog.

Home Folder—This will place the exported images in your Home folder (in Windows this will say User Folder).

Documents Folder—This puts the exported images in your Documents folder (called My Documents in Windows).

Pictures Folder—Uses your Pictures folder to receive the exported images (called My Pictures in Windows).

Desktop—Places the exported files on your desktop.

Same Folder as Original Photo—Exported images are saved in the same folder as the original image.

If you would like a subfolder created to store the exported images, check the Put in Subfolder box and enter a name for the new subfolder in the field to the right. This option is not available if you select Choose folder later (useful for presets).

In some cases you may want the exported images added to your Catalog. If so, check the Add to This Catalog box. When you have chosen to add exported images to the same folder as the original image, and you are adding them to your Catalog, the Add to Stack option becomes available. Check this to stack the exported version with the original version. You can decide if the new image is added below or above the original using the drop-down to the right of this option.

Some of your choices might result in files having the same name as files already saved at your chosen destination. The Existing Files drop-down at the end of this panel is where you instruct Lightroom how to handle this situation. Your choices are these:

Ask What to Do—Lightroom will stop and ask you what you'd like to do every time if comes upon a file with the same name as the one it is exporting.

Choose a New Name for the Exported File—Lightroom will append –2 to the filename to make the exported filename unique. If a file already has –2 added, Lightroom will continue to increment the addition and add –3 and so on. For example, if MyFile.jpg is already in the folder, Lightroom will change the name of the exported file to MyFile-2.jpg. If that's already there, Lightroom changes the name to MyFile-3.jpg.

Overwrite WITHOUT WARNING—If the filename already exists, Lightroom will overwrite the file. You will not receive any notification about this, so be careful.

Skip—The export for that image will be skipped.

File Naming

Figure 7.16

You can rename your images during the export.

The full array of file naming options are available in the File Naming panel (Figure 7.16). (We'll cover these later on.) To activate file naming for your export, check the Rename To box. Depending on the renaming option you select from the drop-down, the Custom Text and Start Number fields will be available. If the option you choose uses either of those parameters, enter the appropriate data here. A sample of what your new filenames will look like appears in the Example field. Lastly, you can decide whether your file extension will appear in lowercase (dng, psd, tif) or uppercase (DNG, PSD, TIF) using the Extensions drop-down menu.

Video If your selection contains any video files, you can export those as well by checking the Include Video Files box in the Video panel. Lightroom can export your videos in their original format, H.264, or DPX. Figure 7.17 shows the Video panel with H.264 chosen in the Video Format drop-down. Below that is the Quality drop-down menu. As with other quality choices (such as JPEG quality), your decision is a tradeoff between file quality and file size. Lightroom provides some help at the bottom of the panel by describing the quality choice. You will also see a Source field and a Target field, which provide additional data for you to compare the original file to the potential exported file.

Figure 7.17

The Video panel.

The quality choices available for the H.264 format are these:

Max—As close to the source file as possible.

High—High quality, but with a possible reduction in video bit rate.

Medium—Suitable for Web sharing and higher-end tablets.

Low—Suitable for mobile devices.

While Lightroom 4 offers more video capability than Lightroom 3 did, it is still by no means a full-featured, high-end video application. However, the other file format choice in the Video Format drop-down, DPX, offers a connection to your full video workflow. DPX files are exported at 1920×1080, with choices for 24p, 25p, and 30p. These files can then be used in professional video applications such as Premiere Pro and After Effects.

File Settings The File Settings panel is like five panels in one. The options presented will change according to the file format you choose to export your images in. Figure 7.18 shows the panel with JPEG as the chosen file format.

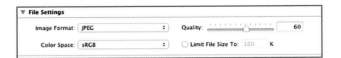

Figure 7.18

The File Settings panel with JPEG image format selected.

The choices you have in the Image Format field are as follows:

- JPEG
- PSD
- TIFF
- DNG
- Original

When you choose JPEG as your file format you can set the quality of the resulting file using the Quality slider. The slider is on a scale from 0 to 100. If you have used Photoshop, you may remember that JPEG quality is expressed on a 0 through 12 range. Lightroom roughly maps this out, where 100 is 12, 80 is 10, and so on. You can also enter a number from 0 to 100 directly in the box to the right of the slider.

In addition to the output quality, you can decide what color space your resulting images should use. You can choose from sRGB, AdobeRGB (1998), ProPhoto RGB, and Other.

> **NOTE**
>
> The art and science of color management are well beyond the scope of this book. If you would like to learn more about color spaces and color management, take a look at the dpBestFlow website (www.dpbestflow.org/color/color-space-and-color-profiles#space).

An extremely basic explanation of the difference between these color spaces is that they set the limit on what colors can be in your final image. A very tenuous analogy might be to equate sRGB with a drawer in your kitchen, AdobeRGB (1998) would then be your kitchen and ProPhoto RGB your house. If the colors in your image are equivalent to a chair, then that would fit within your kitchen [AdobeRGB (1998)] and your house (ProPhoto RGB), but you will have to make some sacrifices if you are going to fit that chair into the drawer (sRGB). So your choice of color space will determine how many of your image's colors will fit into the final image file.

The Other choice in the Color Space drop-down enables you to use additional ICC color profiles for your exported images. You would choose this if, for example, a lab you are using to print images has provided you with their preferred ICC profile to ensure that the colors are interpreted correctly by their equipment. Choosing this option will open a dialog where you can indicate the ICC profile to use.

You can also have Lightroom limit the size of the exported JPEG by checking the Limit Files Size To box and entering a number for the maximum file size.

If you choose to export PSD files (Photoshop's native file format), in addition to the color space options you can choose a bit depth (Figure 7.19).

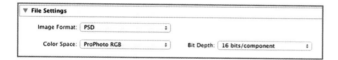

Figure 7.19

Choosing PSD as your image format.

When shooting raw, your camera may capture a bit depth anywhere from 8 to 16 bits. Most cameras fall in the 12 or 14 bit range. Basically, more bits equals more gradations or steps from dark to light or black to white. An 8-bit file has 256 steps while a 16-bit file has 65,536. Choosing 16 bits will assure that every last bit of information in your raw image is preserved. That comes at the price of a larger file. Whether you choose 8 or 16 bits will be determined by what you intend to do with the file in Photoshop. If you are going to do extensive image manipulation, you would want 16 bits. Just a few basic corrections—then 8 bit might be the way to go.

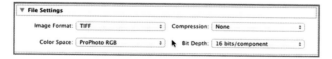

Figure 7.20

Choosing TIFF as your image format.

The File Settings panel for TIFF is the same as that for PSD, with the addition of a Compression drop-down (Figure 7.20). You have three choices here: None, LZW, and ZIP. LZW is a lossless compression (meaning no pixels are lost), while ZIP is a lossy method that can result in slightly smaller file sizes than LZW with only a minor loss in quality. If you choose a bit depth of 16, the LZW option isn't available because LZW compression can actually result in larger file sizes for 16-bit files. Unless you have a specific need for compressing your TIFF files, I suggest you leave this set to None.

Choosing DNG as your file format radically changes the options you have available in the File Settings panel (Figure 7.21). DNG (Digital Negative) is an open raw file format proposed by Adobe in an effort to standardize how raw files are recorded. Each camera manufacturer that offers raw capture seems to come up with one or more proprietary formats for their raw image data. This creates many problems when working in applications like Lightroom. For each new camera or raw format, application developers need to engineer support for these files into their applications. You often will be frustrated when you get that cutting edge camera and find that you can't import the raw files until Lightroom is updated to support the new file.

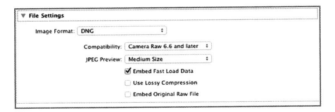

Figure 7.21

DNG has yet another set of options.

There are many places in Lightroom where you can convert to DNG. I am a big proponent of the DNG workflow and will usually convert files either during the import process or shortly thereafter. We'll talk about the advantages (and the few disadvantages) of DNG throughout this book. For now, let's return to the File Settings panel and see what options are available for DNG on export.

TIP

If you would like to learn more about DNG, visit Adobe's site (www.adobe.com/products/photoshop/extend.displayTab2.html) or dpBestFlow (www.dpbestflow.org/node/305#dng) for extensive examinations of this format.

The first choice you need to make is DNG compatibility. If you intend to use your exported DNG files in other applications such as Photoshop, your choice in the Compatibility drop-down will be important. Here are the choices and what they mean:

Camera Raw 2.4 and later—Readable by Camera Raw 2.4 (Photoshop CS) and later, and Lightroom 1.0 and later.

Camera Raw 4.1 and later—Readable by Camera Raw 4.1 (Photoshop CS3) and later, and Lightroom 1.1 and later. Depending on the camera, it may be readable by earlier versions.

Camera Raw 4.6 and later—Readable by Camera Raw 4.6 (Photoshop CS3) and later, and Lightroom 2.1 and later. Depending on the camera, it may be readable by earlier versions.

Camera Raw 5.4 and later—Readable by Camera Raw 5.4 (Photoshop CS4) and later, and Lightroom 2.4 and later. Depending on the camera, it may be readable by earlier versions.

Camera Raw 6.6 and later—Readable by Camera Raw 6.6 (Photoshop CS5) and later, and Lightroom 3.6 and later. Depending on the camera, it may be readable by earlier versions.

> **NOTE**
>
> As this book is being written, Adobe has released the public beta for Photoshop CS6, which brings with it a new version of Camera Raw. Undoubtedly your version of Lightroom will include an additional option for Camera Raw 6.7 or Camera Raw 7.0, since Adobe likes to keep Camera Raw and Lightroom somewhat in synch to avoid compatibility issues with Photoshop.

Two of the exciting new features Lightroom 4 brings to DNG are shown in the next two options. Embed Fast Load Data enables DNG files to load significantly faster in the Develop module but results in a slightly larger file size than a DNG without this option.

> **NOTE**
>
> Converting a raw file to DNG usually results in a smaller size file without any loss of data. In examining file size results, I've found that including Fast Load Data in DNG files does result in a slightly larger DNG file, but in many cases that file is still smaller than the original raw file. So you have the opportunity to decrease file sizes and drastically increase load performance in the Develop module. That's a win-win situation.

Use Lossy Compression will apply a compression algorithm to your DNG. This will greatly decrease the size of your DNG (in most cases). However, this is a lossy compression algorithm, but it is not nearly as damaging to the data integrity as lower-quality JPEG compression. For nearly all uses this option will save you a lot of space and result in images of nearly the same quality as your uncompressed DNG.

CAUTION

Using the Lossy Compression option on your DNG files will reclaim quite a bit of space throughout your Catalog. But you should always keep in mind the value of archiving full versions of your images, whether that is in their original raw file format or DNG. As we have seen so many times, technology advances, and old files can be enhanced in ways you never imagined. That is, or course, if you have all of your data.

So while I think DNG files with lossy compression are great for current workflows, I strongly encourage you to keep archival versions at least for your portfolio-level images. You never know what magic Lightroom 10 will bring to those old images.

The last option is for the belt and suspenders crowd. You can choose Embed Original Raw File to convert your raw file to DNG and include the entire contents of the original raw file inside the new DNG. You can extract the original raw file at any time. If you really love huge files and using tremendous amounts of drive space, this option was made for you. Seriously, this will nearly double the size of all your files. I have yet to meet a single photographer who has used this option. The only case I have heard that seems to make some sense is when you want to archive your original raw files and have them in DNG format. Personally, I would archive the original raw files alongside their DNG cousins and avoid this step altogether. However, it remains an option you can choose.

As you can see in Figure 7.22, if you select Original, there are no other options. You're telling Lightroom to keep the file format exactly as it is.

Figure 7.22

Choosing your original file format.

Image Sizing The Image Sizing panel (Figure 7.23) is where you tell Lightroom what size the exported files should be. If you want to resize the exported files, check the box next to Resize to Fit.

Figure 7.23

The Image Sizing panel.

There are several options available in the Resize to Fit drop-down.

Width & Height—This will resize the exported image to fit within the width and height specified while retaining its original aspect ratio.

Dimension—The longer of the two numbers entered will be applied to the longer side of the image, and the shorter dimension will be applied to the shorter side of the image. The original aspect ratio is maintained.

Long Dimension—Here you enter only one number, and Lightroom applies that to the longer side of the image using the aspect ratio to calculate the shorter side.

Short Dimension—Like the previous option except the number is applied to the shorter side, and the aspect ratio is used to calculate the longer side.

Megapixels—Enter the number of megapixels for the exported image.

For the dimensional options, the numbers you enter can be in pixels, inches, or centimeters, which you choose in the drop-down next to the number.

To avoid upsizing an image you can check the Don't Enlarge box. Lightroom will then avoid upscaling the image if the dimensions you set are larger than the original image.

The Resolution field is where you enter the pixel resolution. This can be either pixels per inch or pixels per centimeter. You decide using the drop-down menu after the field. This option lets you fine-tune images that are intended for print.

Output Sharpening We will discuss the art of sharpening in greater detail when we get to the Develop module. Lightroom provides some sophisticated output sharpening in this panel (Figure 7.24). The Lightroom team has wisely incorporated the sharpening algorithms developed by the folks at Pixel Genius. Their PhotoKit Sharpener plug-in has been the gold standard for sharpening for years (www.pixelgenius.com/sharpener2/index.html). Even though this output sharpening is automated, it does a fantastic job.

Figure 7.24

The Output Sharpening panel.

To sharpen exported images, first select the checkbox. You then have only two decisions to make—what medium your image is intended for and how much sharpening you want to apply.

TIP

Output sharpening is one of three distinct sharpening stages. If you have applied too much sharpening before getting to this stage, you may want to dial it back a bit in the Develop module or turn off output sharpening altogether.

Metadata The metadata associated with your original image file can be included in your exported file. If you don't want all of that metadata going along for the ride, you can use the Metadata panel (Figure 7.25).

Figure 7.25

The Metadata panel.

NOTE

If you have chosen Original or DNG as your exported file type, all of the options in this panel will be unavailable to you except the Write Keywords as Lightroom Hierarchy option.

The drop-down menu provides four metadata inclusion options:

Copyright Only—This includes only the IPTC copyright metadata in your exported files.

Copyright & Contact Info Only—This adds the IPTC contact info to the previous option. For images whose destination is a website, I recommend that this be the absolute minimum amount of data you embed. This makes it easy for someone to contact you and license one of your images legally.

All Except Camera & Camera Raw Info—This includes all metadata except the EXIF data.

All—This includes all metadata.

If you want to make it difficult for the paparazzi to find you, check the Remove Location Info option and all GPS data will be excluded. This overrides either of the two All options.

The last option, Write Keywords As Lightroom Hierarchy, adds the pipe (|) character to indicate keyword hierarchy. This is useful if your image will be used in an application that doesn't understand hierarchical keywords. To illustrate, suppose you have a keyword hierarchy for animals, which includes mammals, which includes dogs. With this option active, that would be written to the exported file as animals|mammals|dogs.

Watermarking You can include a watermark on your exported images using the Watermarking panel (Figure 7.26). To include a watermark, check the box and select a watermark from the drop-down menu. You can also edit existing watermarks or create new ones via this drop-down.

Figure 7.26

The Watermarking panel.

Post-Processing

Figure 7.27

The Post-Processing panel.

The final panel in the Export dialog lets you extend your Lightroom workflow. The Post-Processing panel (Figure 7.27) offers several options that instruct Lightroom to do something after the export operation is complete. The choices in the After Export drop-down are as follows:

Do Nothing—That's it. Your export workflow ends when the export operation finishes.

Open in Primary External Editor—When you have another Adobe image editor installed, Lightroom will see that and make it your primary external editor. If you have Photoshop 5 installed, this option will say Open in Adobe Photoshop CS5. If you have Photoshop Elements, then Tab Program will appear. This instructs Lightroom to take the exported images and open them in Photoshop.

Open in Secondary External Editor—When you tell Lightroom you have another external editor (in Preferences), that application will appear here. When your export is completed, the exported images will open in the editor named.

Open in Other Application—When you choose this, the next set of options in the panel becomes active. The Application field will show the last application you sent exported files to. At the end of that field is a small disclosure triangle. Click this to reveal a list of the most recent applications you sent exported files to. Click one to quickly select it. The Choose button on the right will open a dialog where you can navigate to other applications.

List of Actions—After these options there will be a list of actions from the Export Actions folder. These can be utilities, scripts, macros, and so forth. You can include anything here that will accept image files as input. If you want to add an action to the Export Actions folder, use the next option on this drop-down menu.

Go to Export Actions Folder Now—Click this to open the Export Actions folder. There you can add any actions you want to appear in the After Export drop-down menu.

Export Presets

When you have completed all of your choices, click the Export button at the bottom of the Export dialog, and Lightroom will happily process your instructions. But that was a lot of work setting up all those options in all those panels. What if you want to do that again tomorrow? You can create an export preset.

If you recall, the left side of the Export dialog is occupied by the Preset area [refer to Figure 7.12 (2)]. Click the Add button at the bottom of this area to get the New Preset dialog (Figure 7.28).

Figure 7.28

The New Preset dialog.

There are only two things to do here. First enter a name for your new preset in the Preset Name field. In the Folder drop-down menu, select the folder where you want this new preset to live. If there isn't a folder yet that you like, choose the New Folder option.

Should you choose to create a new folder, you will get the New Folder dialog (Figure 7.29). Enter your new folder name and click the Create button. That new folder will appear in the Folder field of the New Preset dialog.

Figure 7.29

The New Folder dialog.

Click the Create button, and your new preset is stored safely on the left side of the Export dialog ready for future use. All of your option settings are included (Figure 7.30).

Figure 7.30

Your new preset is safely tucked away in your new folder.

Collections

A collection is a brilliant and powerful organizational tool in Lightroom. I would argue that collections are more important than folders. For one thing, collections are fluid. They are creatures of the underlying database that drives your Catalog. Unlike folders, images can live in multiple collections simultaneously without having to be physically duplicated. Folders are dumb. But collections can be smart and quick.

Quick Collection

Let's start with a collection that comes with every Catalog, the Quick Collection. Even new and empty Catalogs have this collection. The Quick Collection lives in the Catalog panel, right below All Photographs (1). To the right of the Quick Collection label is a small + (2). The significance of this little marker will become apparent in a moment. To the far right you will see the number of images in the Quick Collection (3).

The Quick Collection is a way to create a collection of images on the fly. As you wander around your images, you might want to gather some together to export or to upload to Flickr. You could simply select them, but have you ever been selecting multiple images and then forgot to hold down the Command key when you click the next one? Poof—you have only one image selected instead of the 40 you just had. Quick Collection to the rescue!

When you move your cursor over an image, a small ghosted dot appears in the upper-right corner of the thumbnail (if you have this feature enabled in Preferences). As you bring the cursor to this dot, a small dotted circle appears around it. Hovering will get you a tool tip reminding you this will Add Photo to Quick Collection. When you click this dot it will turn solid and remain in the upper-right corner even after your cursor moves on, indicating that the image is part of the Quick Collection.

You could also drag and drop images onto the Quick Collection in the Catalog panel. They are added, and the dot will appear on their thumbnails as well. If you prefer keyboard shortcuts, select one or more images and press B.

After you've collected all the images you want, you can switch to the Quick Collection by clicking on the Quick Collection in the Catalog panel or using the keyboard shortcut Command+B. From there you can do what you want with your collected images.

There are other things you can do with the Quick Collection. In the File menu you will find these Quick Collection commands:

- Show Quick Collection
- Save Quick Collection
- Clear Quick Collection
- Set Quick Collection as Target

If you right-click on the Quick Collection in the Catalog panel, you'll get a contextual menu with the last three commands listed above.

You look at the images you've gathered and decide that you'd like to make this collection more permanent. Select File > Save Quick Collection or press Option+Command+B, and Lightroom presents the Save Quick Collection dialog (Figure 7.31).

Figure 7.31

The Save Quick Collection dialog.

Where will it be saved? To a regular collection. Enter the name you want in the Collection Name field. Right below that is the Clear Quick Collection After Saving option. Check this, and when you save your new collection Lightroom will clear out the Quick Collection [Figure 7.32 (1)].

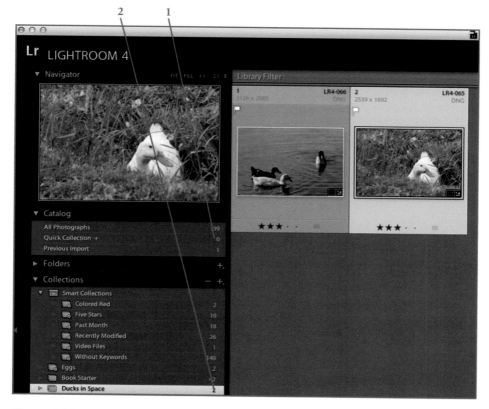

Figure 7.32

Our new collection is created, and Quick Collection is cleared.

The Quick Collection has been cleared, and a new collection has been created (2). This is an easy way to stroll through your Catalog, gathering images along the way and creating new collections. Gather, create, clear, gather....

To clear the Quick Collection without creating a new collection, use File > Clear Quick Collection or press Shift+Command+B. If the Quick Collection isn't currently the Target Collection, File > Set Quick Collection as Target will be available. The keyboard short-cut for that is Option+Shift+Command+B.

Target Collection? Read on.

Target Collection

The idea behind the Quick Collection can be extended to other collections. We just saw how easily we can wander around our Catalog and tap B on any image to pop it into the Quick Collection. What if you already have a collection and you want that same one-key functionality? That's where the Target Collection comes in.

Suppose you have a collection called Flora, and you want images to go there instead of the Quick Collection. You need to make Flora the Target Collection.

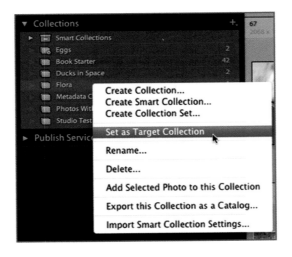

Figure 7.33

Setting a Target Collection.

Right-click on the collection you want as your Target Collection and choose Set as Target Collection from the contextual menu (Figure 7.33). Remember that + next to the Quick Collection label? It's now next to Flora (Figure 7.34).

That + lets you know at a glance which collection is the current Target Collection. Any images currently in the Target Collection will get the small gray dot in the upper-right corner of their thumbnail to let you know which images are already in your Target Collection as you wander through your Catalog.

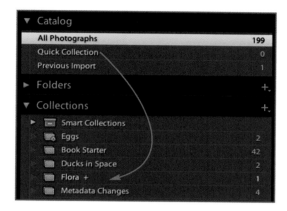

Figure 7.34

The + indicates which collection is the Target Collection.

So when you tap B on a thumbnail, it goes into Flora instead of the Quick Collection. When you finished adding to Flora and want to switch the Target Collection back to the Quick Collection, just type **Option+Shift+Command+B** or select File > Set Quick Collection as Target.

TIP

Being able to switch which collection is the Target Collection can enhance your work-flow. Take wedding albums, for example. Many times you need to create an album for the couple, one for the bride's family, and one for the groom's family. They'll all be choosing from the same pool of images, so how do you keep track? One way is by using the Target Collection feature.

Before meeting with each of these groups, create three collections: Bride & Groom, Bride's Family, and Groom's Family. When the happy couple come in to select the images for their album, make the Bride & Groom collection the Target Collection. Then as you go through the images, just press B to add it to their collection. When the groom's family arrives, switch the Target Collection to the Groom's Family collection and repeat the process. Once again for the bride's family when they arrive. Now you'll have each group's selected images in their respective collections. Since images can live in multiple collections at the same time, there's no problem if everyone picks some of the same shots.

We have two main types of collections in Lightroom: regular collections (or just collections) and smart collections. Flora and Ducks in Space are both regular collections. What is a regular collection?

Regular Collections

A collection is a way to organize and group multiple images. Regular collections are manually maintained by you. Smart collections, as we'll see shortly, maintain themselves. But why have collections when you have folders? Aren't folders a way to organize and group together multiple images? Traditionally, folders were the main way we organized things. Folders are great storage devices, but they can only go so far in helping organize images. Let's use an example to illustrate how folders and collections differ.

Here's a simple scenario: You have two children, Jack and Jill. You've taken photos of them over the years. You have a pretty decent camera, and each of those files is 20MB. You put 10 photos of Jack in a folder called, you guessed it, JACK. You also have 10 photos of Jill that you put in a folder called JILL. So far so good. But you also have 10 photos of both Jack *and* Jill. Do you put them in a folder called KIDS? If you do, you have to remember to look in two folders to find all the photos with Jill in them. To avoid that you decide to make another copy of each of the 10 Jack and Jill photos and put one copy in the JACK folder and one copy in the JILL folder. Problem solved. But let's look at the result.

Your JACK folder has 10 Jack images at 20MB each, so that's 200MB. It also has 10 Jack and Jill images at 20MB each for another 200MB. That's 400MB for JACK. You have the same thing going on in the JILL folder, and 400MB+400MB = 800MB.

You see the problem? Images can only live in one folder at a time. To have an image in two different folders, you need to duplicate it. Aside from the storage problem, this also creates problems when you edit one of those Jack and Jill photos. If you edit the image in the JILL folder, its twin in the JACK folder won't look the same anymore.

Now let's replay this scene using collections instead of folders. You create a collection called JACK and a collection called JILL. You put the images with only Jack in the JACK collection and the images with only Jill in the JILL collection. Where do the Jack and Jill images go? In BOTH collections. Drag those images into the JACK collection and then drag them again into the JILL collection. Adding this up, you get 200MB for the Jack images+200MB for the Jill images+200MB for the Jack and Jill images = 600MB. You save 200MB. Multiply this across your entire Catalog, and you could be saving terabytes.

This works because Lightroom lets images reside in more than one collection simultaneously without the need to duplicate the original image file. Collections are more fluid than folders. You can create them quickly and add images to your heart's content and never eat up additional drive space no matter how many collections you add an image to.

Some features of collections are these:

- Images can belong to more than one collection (as we've already seen).
- You can change the sort order in a collection, including manually arranging images.

- You can stack images inside a collection even if they reside in different folders.
- Removing an image from a collection doesn't remove it from the Catalog.
- Removing an image from a collection doesn't remove it from the drive or send it to Trash/Recycle Bin.
- Collections remember their own filter settings.
- Collections are available in every module via the Collections panel.

We've already seen how to use the Quick Collection to create a new collection. When we talked about the Collections panel we saw how to create a new empty collection. But, as you'd expect, Lightroom provides many ways to create a collection.

One way is to first select one or more images. You can make that selection in the Grid. You can also select the results of a search or even images in an existing collection.

In Figure 7.35 I am in an existing collection called Flora (1), and I've selected images of water lilies (2). To make a new collection called Water Lilies, I would click the + on the right side of the Collections panel header and select Create Collection from the contextual menu.

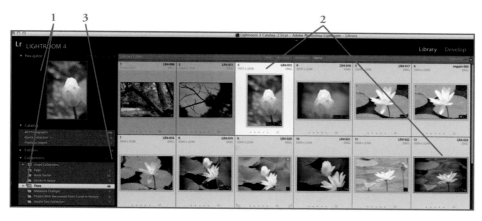

Figure 7.35
Select images to create a new collection.

I could also choose Library > New Collection or press Command+N. Any of those would get me the Create Collection dialog (Figure 7.36).

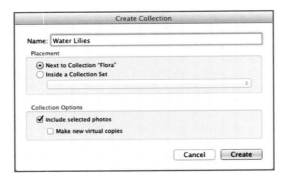

Figure 7.36

The Create Collection dialog.

The name I want for my new collection is Water Lilies, so I'll enter that in the Name field. In the Placement section, I choose Next to Collection "Flora."

> ### TIP
>
> Since we started by selecting images within the Flora collection, the Create Collection dialog offers to create the new collection Next to Collection "Flora," which means at the same level as Flora. This will make more sense after we talk about collection sets (which is the other option in the Placement section). If I had started out by selecting images from a folder or All Photographs, this option would read Top Level.

In the Collection Options section I want to be sure to check the box next to Include selected photos so that my selection is added to the new collection for me. The other option in this section is Make New Virtual Copies. This can be useful, depending on how you intend to use this new collection. We'll be talking about Lightroom's virtual copy feature when we get to the Develop module. I'm done with my options, so I click the Create button.

Lightroom creates my new collection, populates it with my selected images, and takes me to the new Water Lilies collection (Figure 7.37).

Remember those badges we talked about? There's a badge that lets us know an image is part of a collection. It looks like two rectangles. If we click that badge we see a small contextual menu [Figure 7.38 (1)].

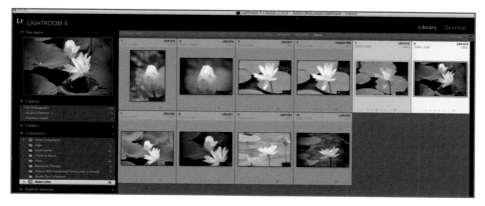

Figure 7.37

My new Water Lilies collection.

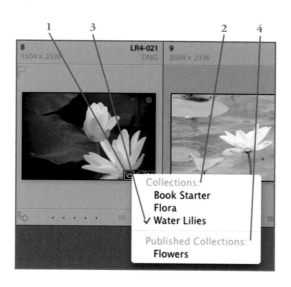

Figure 7.38

The Collections badge in action.

From here we can see a list of all the collections this image is part of (2). The checkmark (3) next to Water Lilies tells us this is the collection we are currently viewing this image in. If we click any of the other collections listed, Lightroom will take us to that collection and select the image there. There is also a section listing any published collections this image is in. Published collections are those we create in Publish Services. These are collections with a connection to the outside world.

I can also create a new collection by dragging and dropping a folder, as seen in Figure 7.39.

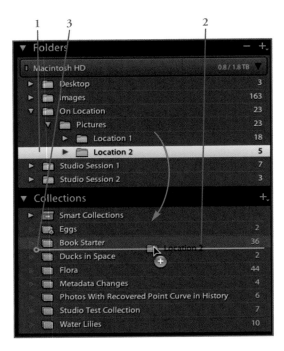

Figure 7.39

Drag a folder to the Collections panel to create a new collection.

Simply drag the folder you want to use to create the new collection (1) from the Folders panel to the Collections panel. The name of the folder will appear next to your cursor (2) while you are dragging it. When you see a small circle with a line extending to the right (3), you can drop the folder. That creates a new collection with the same name as the original folder and automatically populates it with all of the images from that folder (Figure 7.40).

Figure 7.40

Our new collection created by dragging and dropping a folder.

TIP

This drag-and-drop technique also works for folders with subfolders. If you have Parent Folder that contains Child Folder 1 with five images and Child Folder 2 with 10 images, dragging and dropping Parent Folder will create a new collection called Parent Folder with all 15 images from the original subfolders Child Folder 1 and Child Folder 2. But this works only if you have Show Photos in Subfolders turned on in the Folders panel. If that is turned off, you will still get a new collection called Parent Folder, but it won't contain any of the images from its subfolders.

You can also use drag and drop to add images to an existing collection (Figure 7.41).

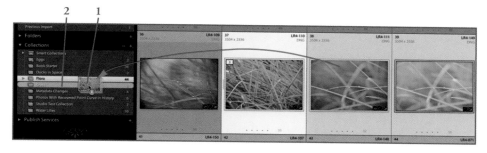

Figure 7.41
Use drag-and-drop to add images to a collection.

Select the images you want to add to the collection (or you can just add a single image) and drag them to the Collections panel. As you drag you will see a small stack of images with your primary selection on top underneath your cursor (1). When the collection you want is highlighted (2), drop the images into the collection.

TIP

When you see the instruction to drag an image or a group of selected images, remember to start your drag from within the image thumbnail and not from the image border. If you try to grab a group of selected images by the border, it will immediately deselect all of the images except the one whose border you are trying to grab. You can save hours of frustration by remembering this simple tip.

You can also add selected photos to a collection by right-clicking on the collection in the Collections panel. From the contextual menu choose Add Selected Photos to This Collection.

Removing images from a collection is just as easy. Select one or more images and press the Delete key. The image is immediately removed from the collection. But don't worry; it hasn't been removed from the Catalog or the drive. If you want to remove the images from the Catalog entirely (and therefore all collections), then press Option+Delete. You can also right-click on the image and choose Remove from Collection from the contextual menu. Yet another way is to choose Photo > Remove from Collection.

To delete an entire collection, select it in the Collections panel and either right-click and choose Delete from the contextual menu or click the − in the panel header. Lightroom will ask you to confirm that you want to delete the collection (Figure 7.42).

If you decide you don't like the name of a collection and want to change it, right-click on the collection in the Collections panel and choose Rename. Enter the new name for the collection in the Rename Collection dialog and click the Rename button (Figure 7.43).

Figure 7.42

Are you sure?

Figure 7.43

The Rename Collection dialog.

Collections also give you the freedom to rearrange images manually. If you don't like the order of the images in your collection, and one of the predefined sort orders won't do, you can just drag things around (Figure 7.44). It's a lot like using a light table, if you remember those.

Grab an image and start dragging it to where you want it to appear. You'll see a small copy of it under your cursor (1) while you are dragging it. As you drag, Lightroom places a black bar between images (2), indicating where your image will be placed if you drop it. Figure 7.45 shows the image in its new location.

The process works the same way for multiple images. If you first select multiple images and then drag them, they will insert themselves between the two images indicated by the black bar. The order they take after the move will be the same order they had before the move.

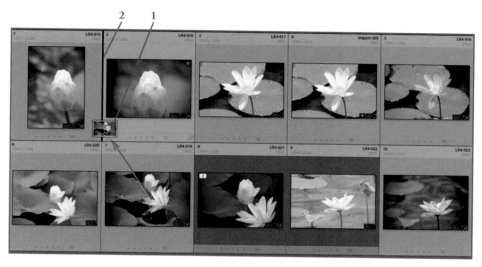

Figure 7.44

Drag images where you'd like them to appear.

Figure 7.45

The image in its new location after the drag and drop.

Smart Collections

A computer is good at performing logical tasks. If we hand one a set of simple instructions, it sets about doing as told until the task is complete. That takes work off our desk so we can direct our attention to more important matters, such as "What's for lunch?" That's where smart collections come in.

Smart collections gather together images that meet a set of rules you set up. You don't have to add or delete images manually from a smart collection. Lightroom does that all for you automatically. Any image that meets all the requirements is added to the smart collection. As soon as an image no longer meets the requirements, it disappears from the collection. This has widespread productivity improvement implications. So what are we waiting for? Let's dig in.

Lightroom starts you off with a sample set of smart collections (Figure 7.46).

Figure 7.46

Here's your smart collections starter set.

> **Colored Red:** All images with a red label applied.
>
> **Five Stars:** All images with a five star rating.
>
> **Past Month:** All images captured within the last month.
>
> **Recently Modified:** All images edited within the past two days.
>
> **Video Files:** All video files.
>
> **Without Keywords:** All images that have not had any keywords applied.

Those are nice, but let's create one of our own. We can start, as usual, in one of several ways. Choose Library > New Smart Collection or click the + in the Collections panel header and choose Create Smart Collection or right-click anywhere in the Collections panel and choose Create Smart Collection from the contextual menu. Whichever method you choose, you'll wind up at the same dialog—Create Smart Collection (Figure 7.47).

Figure 7.47

The Create Smart Collection dialog.

The top part of this dialog is the same as the Create Collection dialog. Enter a name in the Name field and then decide if it will live at the top level or inside a collection set. Just as with the Create Collection dialog, if you got here by right-clicking a collection in the Collections panel you will see Next to Collection *<name of collection clicked on>* in place of Top Level in the Placement section.

The heart of this dialog comes next. You first decision is how the rules are to be matched. You have three choices:

- Any
- All
- None

When using multiple conditions, Any is the equivalent of OR. For AND, we'd select All. If there are only a few conditions we don't want an image to have in this smart collection, we can use None. The conditions we will be using go in the large box below. Each line in this area is a single contrition (2). Conditions, or rules, take this general form:

Data Type (3)—**Operator** (4)—**Value** (5)

The available operators and values will differ from one data type to another. Let's start with a simple example. I want a smart collection that contains images meeting these conditions:

- The label color is purple *and*
- It has more than a one-star rating *and*
- The file type is DNG

In our first example the three conditions are all connected by *and*, meaning all three must be true for an image to make it into the smart collection. To achieve this you select All in the Match ____ of the Following Rules field [Figure 7.48 (1)].

Figure 7.48

Constructing the rules for our first smart collection.

For the first condition you select Label Color for the data type, Is for the operator, and Purple for the value (2). To add another rule, click the + at the end of this line (3).

Next you'll set up the rating rule and click + again to get a third rule. Enter the File Type condition and you're done. If you add a line you don't intend, click the – to remove it.

Click the Create button to create your new smart collection.

Examining the results, we find our new smart collection, My Simple Smart Collection, in the Collections panel [Figure 7.49 (1)]. Five images made the cut. Each has a star rating greater than one star (2), has a purple color label (3), and is a DNG file (4). Well done!

Before we look at a more complicated smart collection, let me point out a few house-keeping items. If you want to rename your smart collection, right-click on it and choose Rename. You can delete the smart collection by selecting it and clicking the – in the Collections panel header or right-clicking and choosing Delete.

After examining the results of your creation you decide you want images to have more than two stars instead of more than one star. You don't have to start all over. Just right-click on the smart collection and choose Edit Smart Collection. This will open a dialog like the Create Smart Collection dialog you used to create the smart collection. The only difference is it will have the title Edit Smart Collection. All of your rules are there, so just make the necessary changes and click the Save button.

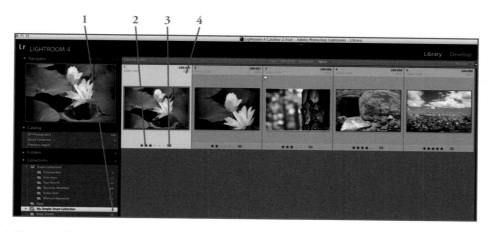

Figure 7.49

Success! You have made your first smart collection.

Let's continue our example. Look at the results in Figure 7.49. Two of the images have a rating of three stars. What if we want the same smart collection but want to exclude any image with a three-star rating? In other words, include all images with a star rating greater than one star EXCEPT those with a rating of three stars. Two stars—OK; five stars—OK; three stars—go away.

You start out the same way as before. Figure 7.50 looks as though we haven't changed anything.

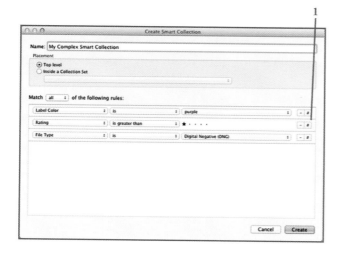

Figure 7.50

Building a more complex smart collection.

But wait. Instead of + at the end of the rules you see a hash tag (#) (1). To get that, hold down the Option key, and the + changes to #. Click the # at the end of the Rating rule. This creates a nested rule [Figure 7.51 (1)].

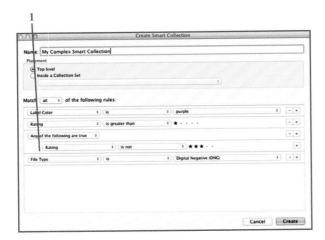

Figure 7.51

Creating a nested rule.

So you set up your nested rule to exclude images with a three-star rating. When you click the Create button and examine the new smart collection, it is exactly what you were after. It contains all the same images as My Simple Smart Collection with the exception of the two that were rated at three stars (Figure 7.52).

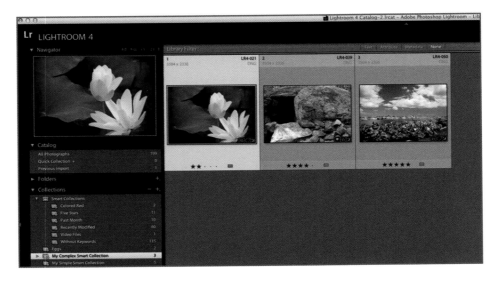

Figure 7.52

No three-star images here.

There is a great deal of power hidden in this innocent-looking dialog. You're not limited to only one level of nested rules. You can nest several and even create nested rules within nested rules. The subject of smart collections and their accompanying logical constructions could fill a book all by themselves. I think, though, you have a taste now of what's possible. Now that you've been exposed to the tools, try them out for yourself.

Collection Sets

OK. Time to give your brain a little bit of a rest with a far simpler collections subject—collection sets.

Collection sets are like folders that contain collections. They can even contain other collection sets.

Creating a collection set is simple. You start in the same places you do for collections and smart collections. Click the + in the Collections panel header, right-click anywhere in the Collections panel and choose Create Collection Set, or select Library > New Collection Set to open the Create Collection Set dialog (Figure 7.53).

You've seen this setup before. Give the collection set a name and decide if it will go at the top level or inside an existing collection set; then click the Create button. You will see your new collection set in the Collections panel (Figure 7.54).

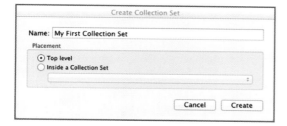

Figure 7.53

The Create Collection Set dialog.

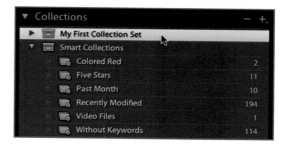

Figure 7.54

Your new collection set.

To add collections to your new collection set, simply drag and drop them in. Let's add the two smart collections you created to your new collection set. Select My Complex Smart Collection. Hold down the Command key and click My Simple Smart Collection to select it as well. Now you can drag both at the same time. When your new collection set is highlighted, drop them in (Figure 7.55).

After you drop them in they will be included in the collection set (Figure 7.56).

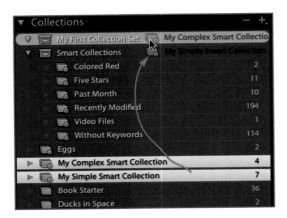

Figure 7.55

Simply drag and drop collections into your collection set.

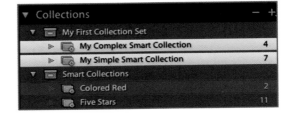

Figure 7.56

Your collections are now in your collection set.

Aside from helping you organize your collections, collection sets are also another way to view your images. When you choose a collection set, all of the images in the collections inside that collection set are shown in the grid.

To remove collections from the collection set, just drag them out. Right-clicking on the collection set will give you access to the Rename and Delete commands.

CAUTION

If you try to delete a collection set that contains collections, you will receive a warning from Lightroom (Figure 7.57).

Figure 7.57

Be careful.

Continuing with the deletion will delete the collection set and all the collections it contains! The images themselves, however, will be unharmed. If you don't intend to also delete the collections within the collection set, drag them out before you delete the collection set.

Stacks

Stacks are another organizational tool to make your life easier and reduce clutter in your Catalog. They are yet another digital metaphor for something we used in the film days.

Very often you'll take more than one shot of a subject, trying out angles, lighting, lenses, apertures, and so on. When you bring these into your Catalog, you see groups of visually similar thumbnails. When we looked through slides or negatives, it was common to stack similar shots on top of each other. Often, the current best shot of the series would be on top of the stack. This reduced the visual clutter and served to organize the slides. So let's apply this in our Lightroom Catalog.

Figure 7.58 shows a simple example of multiple shots that are visually similar. You may not need to see two lakes and two trees and three stairways. It would be beneficial to stack these because you don't want to delete the similar shots, just get them out of site.

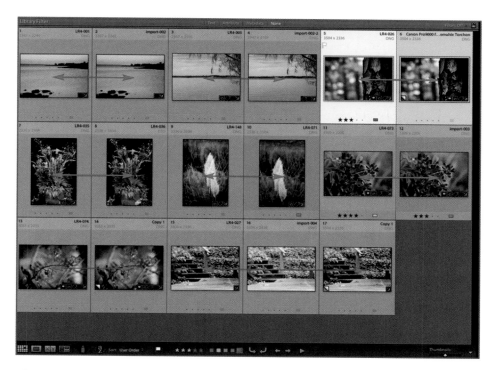

Figure 7.58
Similar shots in Grid view that are begging for stacks.

I've selected the two images of the tree (in the upper-right corner of Figure 7.58). To stack these two images together I can press Command+G (think G for Group) or use Photo > Stacking > Group into Stack or right-click on the image and choose Group into Stack from the Stacking menu. When I do, I see only one of the images, but there are clues that I am looking at a stack (Figure 7.59).

In the upper-left corner of the thumbnail, there is an icon that looks like a small stack of paper with the number 2 (1). The number tells me how many images are in the stack. On either side of the image border are two embossed lines (2), also indicating that this is a stack.

When I click on the stack icon or press S with the stack selected, the stack will expand to reveal all of the images in it (Figure 7.60). The stack icon in the upper-left corner will change to show where this image is in the stack (1), using the format *x of y*, where *x* is that image's place in the stack and *y* is the total number of images in the stack. Also notice that the two embossed lines now move to the far edges of the entire stack (2).

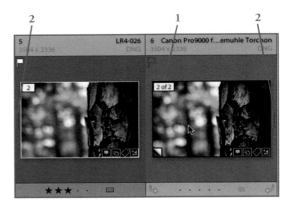

Figure 7.60

An expanded stack.

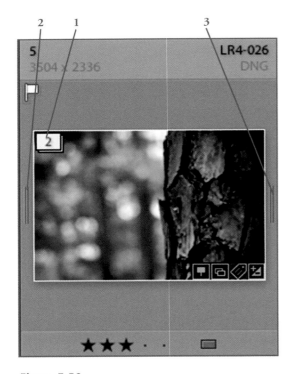

Figure 7.59

This is a stack.

Figure 7.61 shows the same Grid view with the different set of images stacked. The pink flower stack is expanded (1), and we can see that the stairway stack has three images in it (2).

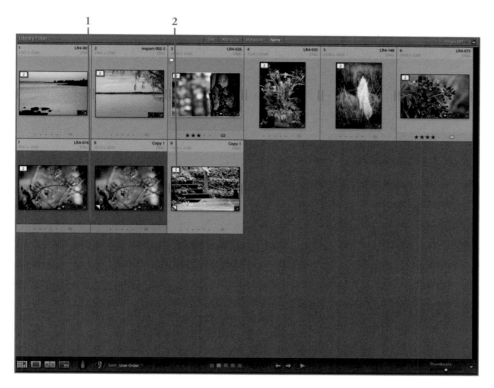

Figure 7.61

A less cluttered and more organized view using stacks.

If you have included too many images in a stack or inadvertently grouped dissimilar shots into a single stack, you can split the stack into multiple stacks.

Figure 7.62 shows that I mistakenly grouped the two purple flower shots with the two pink flower shots. I'll select the two pink flower shots (Figure 7.63) and choose Photo > Stacking > Split Stack.

I can see the results I was looking for (Figure 7.64). The stack icons now show two stacks with two images each (1).

Figure 7.62

This really should be two separate stacks.

Figure 7.63

Select the images to split out as a separate stack.

Figure 7.64

Success. Two distinct stacks.

It's easy to manage your stacks. To move an image to the top of the stack, select it and press Shift+S. You can move an image up or down in a stack using Shift+ [to move it up and Shift+] to move it down. To unstack images, select any image in a stack and press Shift+Command+G. You can also drag images into and out of a stack.

Some things to remember when using stacks:

- You cannot stack images that are in different folders when viewing them from the Catalog or Folders panels.
- You cannot stack images in a smart collection.
- Adjustments, flags, stars, color labels, and such applied to one image in a stack apply only to that image, even if the stack is collapsed.
- Adding a stacked image to the Quick Collection only adds that image, not the entire stack.

Lightroom will also help you stack images by capture time. Typically during a shoot you will have groups of shots that are taken within a common timeframe. Then there will be a pause for a new lighting setup or a scene change, then another set of shots relatively close in time. Go to the folder where you imported the images from your shoot and select Photo > Stacking > Auto-Stack by Capture Time. This will bring up the Auto-Stack by Capture Time dialog (Figure 7.65).

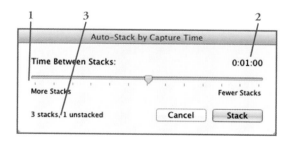

Figure 7.65

The Auto-Stack by Capture Time dialog.

Use the slider (1) to change the duration between stacks (2). This can range from 0 to one hour. As you move the slider, Lightroom reports the number of stacks that will be created (3) based on the current duration selection. The less time, the more stacks you will get.

In this chapter, we looked at different ways to organize images based on where they are. In the next chapter, we will look at organizing based on what the images are. Get yourself ready for the world of keywords and metadata.

8

Organizing Your Images—
The "What"

Organizing your images by where you store them is only part of the solution Lightroom offers. By now I hope you see that Lightroom will not force you to fit some rigid system of organization. Whatever method of organization you use can be accommodated by Lightroom. But as you work with the application more, you may start to see some of the subtle ways it will guide you on your organizational quest.

Organizing images in folders, collections, and stacks is only part of the story. Knowing where something is can be extremely useful. However, knowing what something is can be even more powerful. In this chapter we're going to explore the "what" side of image organization in Lightroom.

What

At first, many photographers are overwhelmed by the seemingly monumental task of keywording and metadata management. My advice to them (and to you) is to step back and think about the process in a different way.

You already do this in your everyday life. It comes rather naturally whether you realize it or not. Whenever you look at anything, a whole series of associations forms in your mind. Some are conscious, and others subconscious. For example, you look at a car. You know it's a car, an auto, an automobile, a vehicle. Other things register in your head—blue, Ford, Fiesta, fun, drive, wind, highway, wheels, gas, insurance... These are some of the "whats" of that car. If I sat you down in an empty room and said some of these words to you, most likely that car would be what comes to mind. We do this all the time with thousands of things. It's all quite natural.

Keep that in mind as you wander through this chapter. Keywords and metadata don't have to be overwhelming tasks. As your Catalog grows and grows, even a small commitment to keywording and metadata can have a stunning impact on your ability to find that shot years later.

Keywords

Keywords are descriptors. They are words you attach to an image that describe something about it beyond the technical data of shutter speed, aperture, and the like. A keyword can describe what an image is: person, dog, table, lamp. It can describe an attribute: blue, wooden, shiny. It can even describe a mood or an impression: sad, happy, surreal. The sum of all keywords for an image can evoke the essence of what you are looking at.

Aside from the organizational benefits that come with keywords, this descriptive nature is useful all by itself. Having a rich set of keywords on an image can give you a sense of what's there. That sense can be helpful when coming up with a title for the image. When adding a caption to your image, seeing that list of keywords gives you some building blocks to work with.

Why Use Keywords?

There are many reasons to use keywords.

- **Personal**: For no other reason than to help you understand what is in the image or what you were feeling when the image was captured. That may all be fresh in your mind today, but five years from now those keywords will definitely help.

- **Organization**: Keywords are a great way to organize your Catalog. Using the powerful filtering features in Lightroom will let you instantly find images by one or more keywords. All that power, however, goes unused if your images aren't keyworded.

- **Commercial**: If you have any inclination to enter the world of stock photography, keywords are absolutely necessary. Clients looking for images are going to enter all sorts of things in their quest for the perfect image. The more keywords you have, the more likely you are to make a sale.

These are just a few reasons to keyword. I'm sure you will discover other reasons as you start to add keywords to your images.

The Art and Science of Keywording

In a previous chapter we looked at the tools available in the Keywording and Keyword List panels. Now it's time to see how they work in the context of keywords and keyword strategies. To help us focus on that task we will use the sample Catalog shown in Figure 8.1, which includes only two images and no keywords.

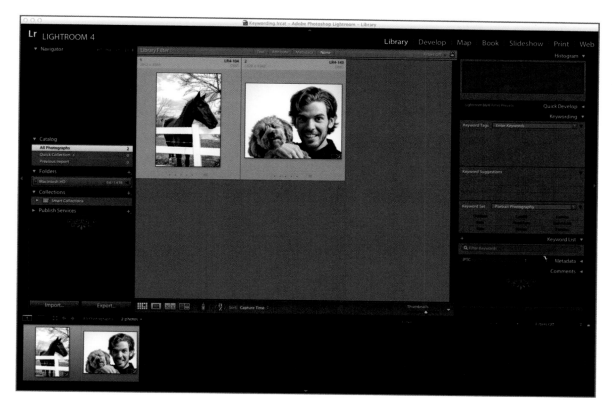

Figure 8.1

Let's start with a simple Catalog and no keywords.

We'll start with the art of keywording by looking at how to approach this process and how to use the tools Lightroom provides. Then we'll switch to the other side of your brain to talk about the science of keywording—where they are stored, how they can be organized, what other characteristics they have, and so on. The combination of these two will give you a solid foundation in keywording.

What You See Here

How do we begin? Just by looking. Start with the obvious and move to the subtle. Look at the first image of the horse (Figure 8.2).

Figure 8.2

What do you see?

The first and most obvious word that comes to mind is *horse*. So there's your first key-word. What else do you see? Compare your list to mine:

- fence
- grass
- water
- sky
- tree
- sky
- cloud
- barbed wire
- truck

Did you come up with others? Great.

As I'm doing this, I type the words into the Keywording panel. In the top section of the Keywording panel, find the entry field (this is the one with the default text Click Here to Add Keywords) and type the words there (Figure 8.3).

Figure 8.3

Entering keywords.

You can enter these keywords one at a time or separated by commas. Keywords can have spaces in them if you are using commas to separate them. Entering *black dress* followed by a comma would create one keyword. You can change this behavior in Preferences to separate keywords by a space instead of a comma. If you have chosen to use spaces as a separator, then to get one keyword for *black dress* you will need to enclose it in quotes ("black dress") or you will get two keywords: *black* and *dress*. When you press Return, Lightroom adds them to the list above the field and automatically alphabetizes them.

CAUTION

Now is the time to decide on plural versus singular. The keyword *tree* is different from the keyword *trees*.

Of course, there are instances where having both a plural and a singular fits into your keywording scheme. So use your judgment and plan ahead a little. The good news is that Lightroom makes it easy for you to correct this at a later time. But as your list of keywords grows, it can become a big job to make these corrections.

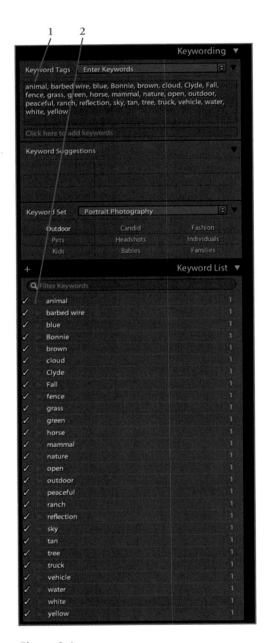

Figure 8.4

Here are the Keywording and Keyword List panels after entering our first set of keywords.

The next obvious choice is name. I don't know the names of the two horses, but let's suppose they're Bonnie and Clyde. So I'll enter those as keywords. Next we can move on to colors:

- blue
- white
- green
- brown
- tan
- yellow

What else do you see? What does the image call to mind? How about

- open
- Fall
- ranch
- reflection
- peaceful
- nature
- outdoor

Anything else? Perhaps

- animal
- mammal
- vehicle

OK, I think we have enough now. If this were going to be a stock image, however, we'd need to stretch ourselves and come up with about 20 or 30 more keywords.

Applying Keywords

With the horse image selected, Figure 8.4 shows how the Keywording and Keyword List panels look. The main section of the Keywording panel displays our keywords for this image (1), and we can see our list of keywords growing in the Keyword List panel (2). Notice that each keyword has a checkmark to its left and shows a total of one image with that keyword. Right now we've only keyworded the first image, so all the keywords we have are applied to this one shot.

Let's see what happens now when we start on our second image (Figure 8.5).

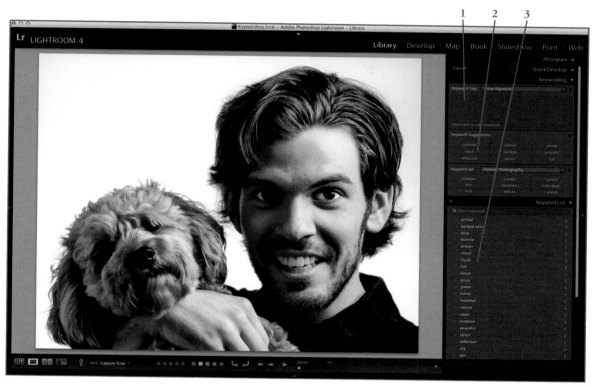

Figure 8.5

Let's keyword our second image to see how this process continues.

When we select the second image, a few things change in the panels. The Keyword Tags box is now empty (1) because we haven't entered any keywords for this image yet. Now that there is at least one other keyworded image, the Keyword Suggestions section (2) shows some keywords that Lightroom thinks might apply. These suggestions tend to get better and better as you keyword more images in your Catalog. Finally, notice that the Keyword List panel shows all of our keywords, and none are checked. We still see the number one to the right of each keyword since each has been applied to one image so far.

With an existing keyword list a few other options start working for us (Figure 8.6). As you hover over a keyword in the Keyword List panel, an empty box will appear to the left of that keyword. If you click to check the box (as the helpful tool tip suggests) (1),

it will apply that keyword to the image. The keyword appears in the Keyword Tags section (2). Also notice that the count has incremented to two now that we have two images tagged with the keyword *animal* (3). We've seen the small arrow to the right of the image count when we toured the panels earlier (4). This gives you instant access to all images with that keyword. Whenever you click this arrow, your grid will show only those images with the selected keyword.

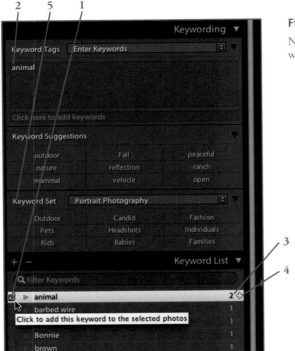

Figure 8.6

New options start working now that we've begun keywording.

Another way to apply some keywords is to use the Keyword Set option (5). In this case we are looking at the Portrait Photography set, and some of these seem to apply. Click any that apply to add them to the image. Another way is to use the Option key. Remember that holding down the Option key puts numbers from 1 through 9 next to the keywords in the keyword set. Press the number to apply the keyword.

Now that you have some keywords in your Catalog, Lightroom will try to anticipate what you are typing and present you with a list of existing keywords to choose from (Figure 8.7). In this image the dog's name is Frankie, so I start to type that. After I type *F*, Lightroom shows me the existing keywords *Fall* and *fence*. *Fall* is highlighted. If that's what I was typing, all I need to do is press Return or the Tab key to complete the word. If I want *fence*, I would use my arrow keys to move the highlight to that word and follow the same procedure. This can speed things along.

Figure 8.8 shows our progress after keywording two images. Now the checkmarks make a little more sense. Since the second image is selected, only the keywords that have been applied have a checkmark. That checkmark, by the way, is also an easy way to remove a keyword. Just click to uncheck it, and the keyword will be removed.

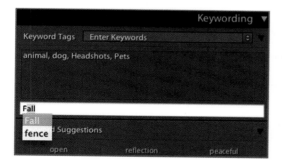

Figure 8.7

Lightroom will suggest keywords as you type.

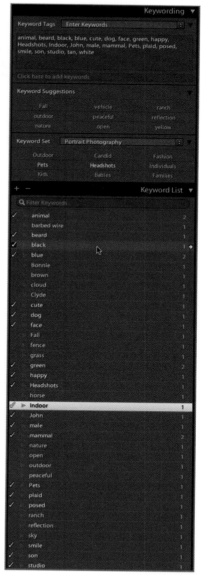

Figure 8.8

Our results after keywording two images.

Everything we've done so far can also be done to multiple images simultaneously. Figure 8.9 shows both images selected in Grid view. Once again things look a bit different.

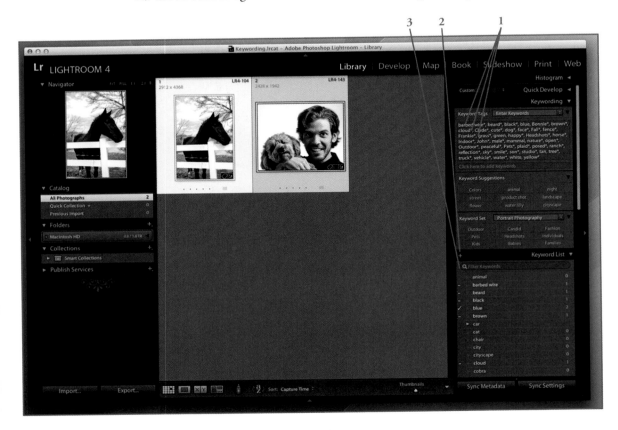

Figure 8.9

Keywording can be done with multiple images selected.

Lightroom gives you visual clues when keywording multiple images at the same time. For example, look at the Keyword Tags section. Some of the keywords have an asterisk (*) after them (1), which tells you that these keywords have been applied to at least one of the selected images but not to all of them. The keywords without the asterisk have been applied to all selected images.

There are similar clues down in the Keyword List panel. Keywords with a dash (−) to the left (2) have been applied to at least one selected image but not all of them. Yes, it's the same as the asterisk in the Keywording panel. When you have multiple images selected, a checkmark before the keyword means all the selected images have that keyword. As with the single image, clicking here will apply or remove the keyword from all selected images.

In Figure 8.10, I've added a few more images to the Catalog. Remember that Lightroom installs a few sample smart collections for you. One very useful smart collection is the Without Keywords collection (1). This is a great place to start when you are going to review your existing Catalog and do some keywording. Just go to this collection, and you will be looking only at images that still need some keywording. You can even make this a challenge for yourself—get the image count for this smart collection down to ZERO.

Figure 8.10

Keywording multiple images.

The Painter Tool

When keywording multiple images, the Painter tool (2) can come in handy (Figure 8.11).

Figure 8.11

The Painter tool.

When you click on the Painter tool, your cursor will change into a small spray can (1). When the tool is active, you can choose what you want to spray from the drop-down (2) menu. We're going to spray on some keywords, but you have several options to choose from:

- **Keywords:** This will use the current keyword shortcut, or you may enter other keywords to be used.
- **Label:** Choose one of the color labels to spray on.
- **Flag:** Spray on a flagged, unflagged, or rejected status.
- **Rating:** Spray on star ratings.
- **Metadata:** Choose a metadata preset to spray on.
- **Settings:** Apply any of your Develop presets.
- **Rotation:** Choose a rotation and spray it on.
- **Target Collection:** Add images to the current target collection.

After selecting Keywords as the "paint" we'll use, a field appears to the right (3). If there is a keyword shortcut already set, those keywords will appear here. If not, the field will say Enter Keywords Here. Enter one or more keywords in the field. When entering multiple keywords, separate them with a comma. When you're finished with the Painter tool you can put it away by clicking on the circle where you got the tool, or you can click the Done button (4) at the end of the toolbar.

After looking through the new images, I see that many are outdoor shots, so I enter the keyword Outdoor and get ready to spray that on.

TIP

You can enter existing keywords or new keywords when using the Painter tool. Lightroom will handle the new keywords and set them up in the Keyword List panel the first time you spray them on.

CAUTION

The Without Keywords smart collection is useful for finding images that haven't been keyworded. However, if you are about to spray on keywords, you might want to switch to a different view. Remember that this is a smart collection, so the instant a keyword gets added to an image it will disappear. Smart collections don't waste any time. This can be confusing and could lead to keywords being misapplied as images disappear and others shift around in the grid.

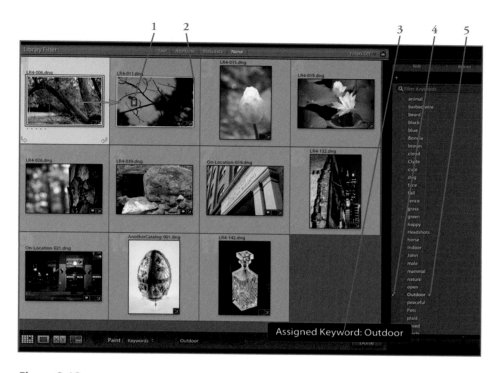

Figure 8.12

Spraying on keywords with the Painter tool.

To apply keywords with the Painter tool, simply go to the first image, hold down the mouse button, and drag the tool over the images that require that keyword (Figure 8.12). As you do this you'll see the paint can "spraying" the keywords on the images (1). (I really like these little finishing touches that the team puts into Lightroom.) While the tool is active, each image that has already received the keyword will have a small white border (2). Don't worry if you spray it again, Lightroom will apply the keyword only once. You will also be treated to a small pop-up with the message Assigned Keyword and the keyword that is assigned (3). The keyword appears in the Keyword List panel with a checkmark, indicating it has been applied (4). The small + to the right of the keyword (5) tells you that it is now the current keyword shortcut.

Unlike a real can of spray paint, the Painter tool comes with a built-in eraser. If you accidentally apply a keyword to an image, hold down the Option key, and the paint can turns into an eraser [Figure 8.13 (1)]. Click on an image or drag it across several images to remove the misplaced keyword. You will get a similar pop-up saying Removed Keyword and the keyword that was removed (2). No need to run out to the hardware store for some paint thinner.

You can repeat this process several times. Spray on some keywords. Then go back to the toolbar and change the keywords. Spray some more. Rinse. Repeat. When you are finished you can put the can back where you found it in the toolbar by clicking on the empty circle, or you can click the Done button.

Drag-and-Drop Is a Two-Way Street

Another quick way to apply keywords is by drag-and-drop. Drag-and-drop keywording works in both directions.

You can select one or more keywords in your keyword list (Figure 8.14). Grab any of the selected keywords and drag it to an image (1). The keywords will appear next to your cursor. When you hover over an image it gets a dark black border (2), indicating that if you drop, those keywords will be applied. If multiple images are selected, the keywords will be applied to all images in the selection.

Figure 8.13

Correcting mistakes is easy.

Figure 8.14

Drag keywords to images.

This works in the other direction as well (Figure 8.15). Select one or more images and drag them to the keyword list. A small image or stack will appear with your cursor. When the keyword you want is highlighted, release the mouse button. That keyword will then be applied to all of the selected images.

Figure 8.15

Drag images to keywords.

Your Keyword List

The Keyword List panel contains the entire list of keywords you have created in your Catalog (Figure 8.16). Even a simple Catalog with only 13 images has resulted in a long list of keywords. Imagine how long the list can get when your Catalog grows to thousands of images. Lightroom remembers every keyword, even when there are no longer any images that use a keyword. The example shows the keyword UNUSED KEYWORD with an image count of zero. You will find keywords like this in your list if you've removed a keyword from all images or you've removed all images that had the keyword applied. There are other reasons you may have these zero-count keywords, and we'll talk about that in a moment.

If you want to get rid of one or more keywords, you can select them and either right-click and choose Delete or click the – in the header of the Keyword List panel. If you try to delete a keyword that is applied to one or more images you will get a warning first (Figure 8.17). If you are sure, go ahead and click the Delete button. Nothing will happen to the images. They will simply have those keywords removed.

Creating Keywords

So far we've let Lightroom create keywords for us. Whenever you add a keyword to an image, Lightroom creates it for you and puts it in the keyword list. But there's more going on behind the scenes. You can create keywords before you apply them to an image. Click the + in the header of the Keyword List panel to bring up the Create Keyword Tag dialog (Figure 8.18).

You might be wondering why you would go through the process of bringing up a dialog to create a keyword when all you need to do is add it to an image, and Lightroom takes care of the rest. You don't have to, but there are some great options here to let you manage keywords and help you find things later.

Your first task here is to enter the keyword in the Keyword Name field (1). Next is a large space to enter Synonyms (2). Synonyms are words you associate with the keyword. For example, if your keyword is *dog*, some synonyms you might enter are *puppy*, *pup*, *canine*, *hound*, and *doggy*. These don't become keywords but aid you in finding images. We'll cover these shortly.

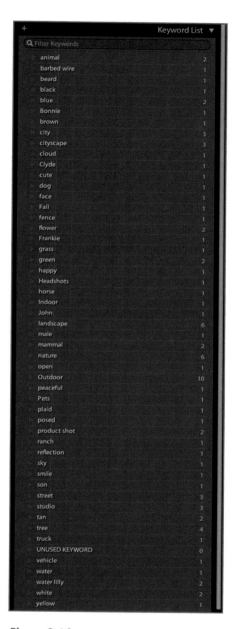

Figure 8.16

Your keyword list so far.

Figure 8.17

Lightroom warns you before deleting a keyword with active images.

Figure 8.18

The Create Keyword Tag dialog.

The Keyword Tag Options section (3) offers you three checkboxes:

> **Include on Export:** Selecting this option will cause the keyword to be included when exporting images. When not selected, the key will not be exported. This can also be used to generate a keyword category.

> **Export Containing Keywords:** This option includes any higher-level keywords that will contain this keyword. That statement will make much more sense in a little while.

> **Export Synonyms:** Synonyms you have associated with this keyword in the Synonyms field will be included when the image is exported.

The choices that appear in the Creation Options section (4) depend on what was selected when you opened the Create Keyword Tag dialog. If a keyword was selected when you clicked the + in the header, you will see the option Put Inside *<selected keyword>*. Selecting this will nest the keyword you are creating inside the selected keyword.

If one or more images are selected when you start this process, you will see the Add to Selected Photos option. This will save you the step of applying the new keyword after you create it.

Flat or Hierarchical?

A flat list of keywords, like the one shown in Figure 8.19, has one keyword per line and all keywords at the same level. The list is kept in alphabetical order and is understood by nearly every image program and operation system. It is simple and direct.

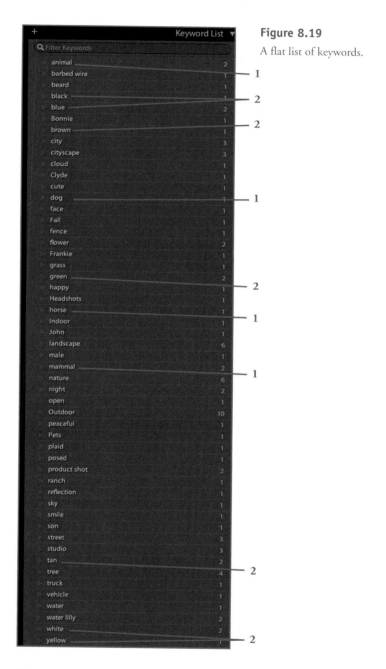

Figure 8.19

A flat list of keywords.

However, more modern applications like Lightroom provide a different structure for organizing your keywords: the hierarchical list. Let's look at the problem.

I've marked two different groups that go together. The first (1) includes the keywords *animal*, *dog*, *horse*, and *mammal*. The second (2) includes *black*, *blue*, *brown*, *green*, *tan*, *white*, and *yellow*. The problem with a large flat list of keywords is that related keywords can be widely separated in the list, forcing you to scroll around a lot. Consider an image of a blue car with tan interior and black tires in a green field. If I wanted to use those keywords on that image, you see the problem. Now take a look at Figure 8.20.

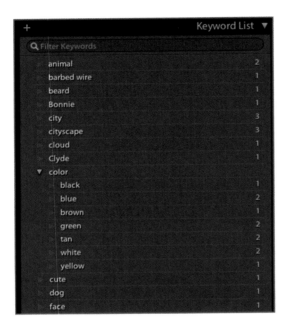

Figure 8.20

Color-related keywords gathered into a hierarchy.

All of the color-related keywords in my list have been gathered together and put under the keyword Color. This is the beginning of a hierarchical list. We aren't limited to a single level, either. Let's walk through the process of turning a flat list into a hierarchical list using the first set of related keywords I highlighted: *animal*, *dog*, *horse*, and *mammal*.

Before rearranging keywords, we need to consider what hierarchy exists here. Dogs and horses are both mammals. All mammals are animals. So the hierarchy would be *animal* contains *mammal*. Further, *mammal* contains both *dog* and *horse*. Great! Let's put that in place.

To place *mammal* within *animal*, drag it to *animal* (Figure 8.21).

As you do, *mammal* will appear next to the cursor (1) to remind you what you are dragging. When *animal* is highlighted (2), drop *mammal*. Now we have *mammal* contained within *animal* (Figure 8.22).

Repeat the process with *dog* and *horse*, but this time drop them on *mammal* instead of *animal*. You will end up with a multilevel hierarchy (Figure 8.23).

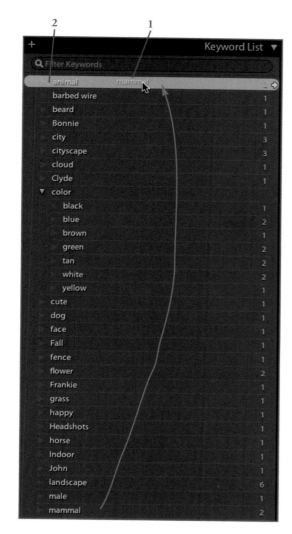

Figure 8.21

Drag one keyword onto another to create a hierarchy.

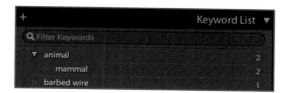

Figure 8.22

The first step in creating this hierarchy.

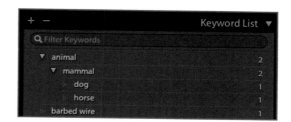

Figure 8.23

A multilevel keyword hierarchy.

Containing Keywords Keywords that contain other keywords can serve two functions. The first is as a normal keyword. Their level in the hierarchy is merely a way to organize logically related keywords. You still apply them to images in the same way.

The other purpose a containing keyword can serve is purely organizational. It can be excluded from exports by choosing that option when it is created and used as a category name. Typically these are at the top level of the hierarchy and not usually applied as keywords themselves. One example might be Colors. Create the keyword *Colors* and uncheck the Include on Export box. Then put all of your colors (red, green, blue, etc.) under that category. Lightroom, unfortunately, provides no visual distinction between keywords and categories. Some users add characters to the category name to distinguish it from a regular keyword. For example, instead of *Colors* you might name it ==>*Colors* or **Colors*. This has the added advantage of floating these to the top of your list.

Containing keywords have another subtle advantage: They are implicitly applied whenever any of the keywords they contain are applied. If I have a hierarchy like the one in Figure 8.23 and I apply the keyword *dog* to an image, I don't have to apply *mammal* or *animal*. Since they are the containing keywords for *dog,* they are implicitly applied. If I search for images with the keyword *animal,* that image will be in those results.

You can create hierarchies the same way you create keywords on the fly, by typing them in the Keywording panel. There are two different ways to enter a hierarchy. One may seem more logical than the other, depending on how you normally read a hierarchy. Let's go back to our dog. If you read the hierarchy from top to bottom, *animal* contains *mammal* contains *dog,* then type your hierarchy using the pipe character (|) *animal| mammal|dog.* That will instantly create the hierarchy and apply *dog* to the image. Remember, *animal* and *mammal* are applied implicitly.

However, if you read the hierarchy from bottom to top, *dog* is part of *mammal* is part of *animal,* then you would type that using the right angle bracket, or greater than symbol (>) *dog>mammal>animal.* The result is the same: The hierarchy is created, *dog* is applied, and *animal* and *mammal* are applied implicitly.

Remember that the Keyword Tags section of the Keywording panel (Figure 8.24) has three different view options available from the drop-down menu:

> **Enter Keywords:** Only applied keywords will appear. Additionally, you can enter keywords in the large box where all the keywords are visible.
>
> **Keywords & Containing Keywords:** This adds all of the containing keywords that are applied implicitly. Keyword entry is restricted to the Click Here to Add Keywords field below the box.
>
> **Will Export:** This view shows you what keywords will be included when you export this image. Keyword entry is restricted to the Click Here to Add Keywords field below the box in this view as well.

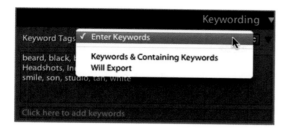

Figure 8.24

Viewing options for the Keyword Tags section of the Keywording panel.

CAUTION

Deleting a keyword that contains other keywords has a cascading effect. The keyword you are deleting and all keywords it contains will be deleted. Lightroom will warn you about this (Figure 8.25).

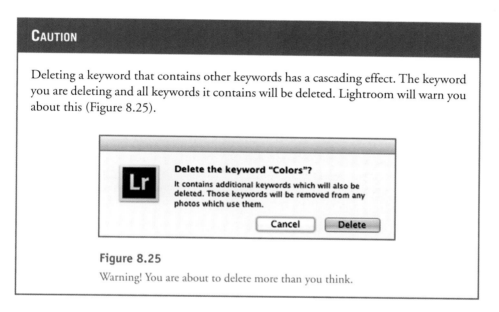

Figure 8.25

Warning! You are about to delete more than you think.

CAUTION

If you want to retain those keywords, drag them out of their containing keyword before you delete it.

While creating a hierarchical list, you may want to add several keywords to a particular keyword or category. Of course, you could enter the keywords and then drag them onto the containing keyword you want to use. Or you could right-click on the containing keyword and choose Put New Keywords Inside This Keyword. Then as you add new keywords they will all automatically be entered under the chosen containing keyword. Lightroom marks the containing keyword with a small dot (Figure 8.26).

To turn this feature off and restore normal behavior, right-click the keyword and uncheck Put New Keywords Inside This Keyword.

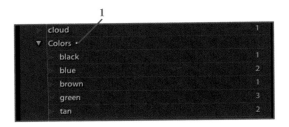

Figure 8.26

All new keywords will be added to the containing keyword marked with a small dot.

Synonyms

We touched briefly on synonyms earlier. Synonyms are an often overlooked feature in Lightroom's keyword system, but they are very useful. There are many times when you don't necessarily need or want to apply every possible descriptive word to an image. However, you want to be able to find something whether or not you can remember the exact keyword applied. That's where synonyms are useful.

You can add synonyms when creating a keyword using the Create Keyword Tag dialog (refer to Figure 8.18). But you can also add them by editing any existing keyword. To edit an existing keyword, right-click on it and choose Edit Keyword Tag or double-click on the keyword to bring up the Edit Keyword Tag dialog (Figure 8.27).

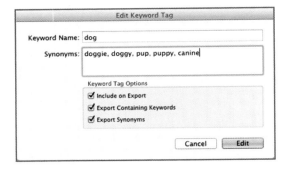

Figure 8.27

The Edit Keyword Tag dialog.

This dialog is very much like the Create Keyword Tag dialog. Enter any synonyms for the chosen keyword. If you want the list of synonyms to be included as additional keywords when you export, be sure to check the box next to Export Synonyms before you click the Edit button.

> **NOTE**
>
> None of the synonyms you enter will appear in the Keyword List panel. Neither does Lightroom give you any indication of which keywords have synonyms and which don't.

It never hurts to throw a few synonyms in when creating keywords. Even if you later use a synonym as a full-fledged keyword, it will still exist as a synonym for other keywords. That helps fill in any gaps by making sure you can find related images whether keyworded or "synonymed."

The State of the Art

Lightroom's treatment of keywords is somewhat cutting edge. It maintains hierarchical structure and all associated synonyms within its Catalog. It will also write most of this out to your image file or to a sidecar XMP file when it can't write to the image file directly. While Lightroom will write keywords and hierarchies out to the file, synonyms exist only in the Catalog. If you chose to include synonyms on export, Lightroom can write those synonyms to the file. However, at that point they are no longer synonyms as far as that exported file is concerned. They become regular keywords.

All of this is because the current standard does not address synonyms or hierarchical keyword structures. You need to be aware of this if you are going to share image files or work with them in other applications and you want to retain access to your keywording data.

I suggest you make full use of hierarchies and synonyms. Lightroom is fully capable of supporting these features and provides options to include them in exported files. Standards evolve and will eventually catch up to Lightroom.

Keyword Exchange

You've worked diligently on your list of keywords. Multilevel hierarchies have been lovingly handcrafted. Synonyms have been cultivated in abundance. Now you decide to create another Catalog (hopefully for a very good reason), and you would like all of that keyword goodness included.

The easiest way is to export your keyword list from the current Catalog and import it into the new Catalog. Start in the Catalog that contains your keywording magnum opus. Select Metadata > Export Keywords. You will be asked to name the file and choose a location (Figure 8.28).

Your keywords will be stored in a text file. By default Lightroom names this file Lightroom Keywords.txt, but you can change that if you like. Press the Save button when you are ready.

When we create our new Catalog, it's pretty empty over in the Keyword List panel (Figure 8.29). But that's only temporary. Select Metadata > Import Keywords and find the file you just exported. Click the Choose button. Voilà. All your keywords, hierarchies, and synonyms are now in the new Catalog (Figure 8.30).

Figure 8.28
Exporting your keyword list.

Figure 8.29
It's pretty empty here in the new Catalog.

Figure 8.30
Ah! That's better. Everything is back where it belongs.

TIP

You may find yourself with some keywords that just don't get used. Perhaps you got a keyword export file from a friend or you created keywords with the intention of using them but never did. To get rid of all that unused keyword clutter without having to delete them one at a time, use Metadata > Purge Unused Keywords. Be careful, though. This command does not stop to warn you or ask if you are sure.

Containing keywords that are otherwise unused will not be purged if they contain a keyword that is being used.

The Controlled Vocabulary Approach

The idea of a controlled vocabulary is not new. Fundamentally, a controlled vocabulary is a set of indexing terms or, you guessed it, keywords. One of the problems a controlled vocabulary solves is coming up with keywords. After the obvious passes for Who, What, When, Where, Why, and How, it becomes increasingly difficult (at least for me) to come up with descriptive and useful keywords.

Since Lightroom has the ability to import keyword structures, it's a natural fit with a controlled vocabulary. An extensive list of keywords is essential to the stock photographer, and there are many others who would benefit from a full vocabulary or a small subset.

Two of the most extensive controlled vocabularies you can purchase for use with Lightroom can be found at David Riecks' The Controlled Vocabulary (www.controlledvocabulary.com/products/lightroom.html) and Shangara Singh's Keyword Catalog (www.keyword-Catalog.com/index.html). In addition to an extensive list of keywords, these vocabularies are organized in logical hierarchies to assist you in finding and applying all the keywords that apply to your images.

TIP

Whether you are using a controlled vocabulary or your own list has grown to epic proportions, you can find keywords in the list quickly using the Filter Keywords field at the top of the Keyword List panel (Figure 8.31).

Figure 8.31

Find keywords quickly.

Enter a keyword or part of a keyword in the field (1), and the keyword list will show only those keywords that match. If the matching keyword is part of a hierarchy, Lightroom will expand the hierarchy and show you the path to the matching keyword (2).

A full-blown controlled vocabulary may be more than you need. Search the Internet. The Lightroom community is a very active and generous group. Many of them have developed more focused controlled vocabularies that you can download for free. For example, if your interest is birds, you can download some extensive bird keyword lists from Mark Wilson at Rusticolus Images (www.rusticolus.co.uk/keywords-for-adobe-lightroom/). Mark is a photographer in the UK who developed several keyword lists for his own work and gladly shares them with the community. He's even taken the time to include the scientific name for each species as a synonym. That way you can find the keyword if you know the scientific name, and when you export it will be included.

Metadata

Look up "metadata" in the dictionary, and you may find a definition such as "a set of data that describes and gives information about other data." Keywords are one kind of metadata, but there are many more datapoints that Lightroom can keep track of. Some are like keywords and require you to supply the data. Others come to you already filled in. All of it can be used to organize and find images in your Catalog.

Data About Your Data

The process of adding metadata to your images should be approached sensibly. While I feel very strongly that all images need keywords, I am less enthusiastic when it comes to other forms of metadata. Metadata in Lightroom is a very broad topic. If you have an extensive Catalog to start with, it could take you a very long time if you try to add metadata to every image. Even when you are importing new images it can be a daunting task. If you have a card with 300 images to import, you may not have the time or the inclination to add metadata to every one of those 300 images. But don't despair. There's already a lot of metadata there.

Don't let this dissuade you from adding metadata—just be discriminating. Not every shot rises to portfolio level. Direct your attention first to those that do.

Why This Is Important

Metadata is important. It tells you many things about your image. There are technical details such as the aperture, shutter speed, and ISO the image was captured with. What lens and camera were used. It includes contact data—who shot the image, is it copyrighted, how can someone contact the photographer. It contains location information—where the shot was taken.

All of this is important if you intend to share, sell, give, or otherwise let one of your images out into the wild. The more metadata you attach to an image, the easier it is to find the image in your Catalog. So don't overlook this important tool.

I suggest you spend time with your best images. The Lightroom workflow is not a straight line. You can move freely from module to module and panel to panel. Often, after you've worked on an image, its real potential surfaces, and it becomes a candidate for extra metadata treatment.

A good method to use with your better shots is to put the image in Loupe view and hide the Filmstrip and left panels (Figure 8.32). This lets you see your image in all its glory. The Metadata panel has different views you can use according to what metadata you are working on. Here I've chosen the Quick Describe view (1), which lets me see some basic info. There are some fields that are filled in by my camera (2), such as dimensions and what camera I used. This view also shows me some metadata I applied during import with a preset.

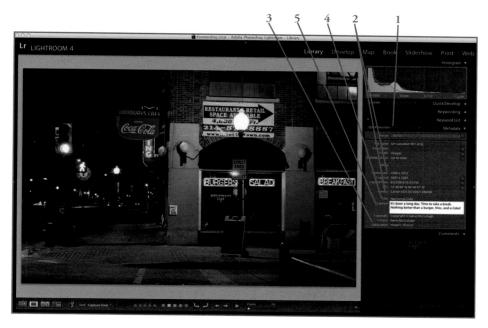

Figure 8.32

Add metadata to your better images.

Now I can spend some time with the image and come up with a title (4) and a caption (5). These two metadata items are especially useful. As we will see later, having this information means we can pull it into books, websites, slideshows, prints, and so on. Very nice!

This is the kind of care you should take with your good images. I realize I just told you that you shouldn't take the time to apply additional metadata to every image. That's not entirely true. When you import your images, you already know you can apply some general keywords on the way in. You can do the same with metadata using presets. That way every image can get some automated metadata, and you don't have to spend additional time adding it image by image.

Metadata Presets

I recommend that you create at least one metadata preset with basic information applicable to all of your images. This should be your go-to metadata preset when you import images. It can also be applied to all of your existing images if they lack this information.

To create a metadata preset, select Metadata > Edit Metadata Presets or choose Edit Presets from the Preset drop-down in the first section of the Metadata panel. This drop-down menu is the first section in every Metadata panel view.

This will bring up the Edit Metadata Presets dialog (Figure 8.33). There will be data from whatever image is selected. If no image is selected, all the fields will be blank. It is important to understand how this dialog works so you don't inadvertently save data from one image that doesn't apply to other images.

Figure 8.33

Creating a new metadata preset.

All metadata fields are listed, but only those with a checkmark next to them (1) will be included in your preset. Any section with a checkmark (2) means that all fields in that section will be included. If you see a – instead of a checkmark, that tells you only some of the fields have been checked for inclusion.

The two most important and universal sections are IPTC Copyright (3) and IPTC Creator (4). I recommend that you create your basic preset using these two section with all fields completed.

Before you create the preset, scan through and make sure none of the image-specific data is being included. For example, if the Title field (5) was checked, then all of my images would get that title. Not good.

TIP

If you suddenly start seeing keywords appearing on your images and you don't know where they are coming from, check the metadata preset you are using. Many times those mystery keywords were mistakenly included when the preset was created. Clear them out and resave your metadata preset.

When you're ready, go to the top of the dialog and from the Preset pull-down menu choose Save Current Settings as New Preset. You will then be able to name the preset in the New Preset dialog (Figure 8.34).

Figure 8.34

Name your new preset.

Give it a name such as Basic Metadata or Copyright & Contact or, better yet, INCLUDE THIS ON ALL IMAGES. Whatever works for you. Click the Create button, and your new metadata preset is ready for you to apply on import or anywhere else you want in Lightroom.

TIP

If you include the year in your Copyright field, set up a reminder in your calendar to edit this every January. This way you won't be tagging images taken in 2012 with Copyright © 2010.

A Wealth of Information

Keywording and adding metadata can be a seemingly insurmountable task at first. But I encourage you to start small. Add keywords during import. Create a basic metadata preset and use that when you bring images into your Catalog. Before you know it you will have a wealth of information at your fingertips. Lightroom will faithfully store and retrieve it whenever you like. Combine that treasure trove of data with the filtering tools we will soon meet, and you have a perfect storm. If you need that image of the white puppy on the red pillow in the wicker basket next to the flowers in the crystal vase, you will be able to pull that puppy up (yes—pun intended) in a few quick keystrokes. No matter where you put it on your drive and no matter how long ago you shot that image, Lightroom will find it in an instant. But only if you start creating that data now.

9

Map

There be dragons here.

Perhaps the second most fundamental question after "Who am I?" is "Where am I?" We humans are fascinated by location. As a child you probably looked at a map or a globe to find out where you were on the planet. I know that I spent a lot of time wandering around a map of the world looking at the different continents and countries. I wondered what it must be like here or there. It seems important to us to know where we are.

It's also important to know where we were. "Where were you when (insert event) happened?" You look through your Catalog of images and remember where you were when you captured that sunset or that mountain or that smile. Until recently you had to rely on memory or written notes to pinpoint the place. Now, however, with GPS technology becoming more and more ubiquitous, our gear can record that for us. We can revive our childhood fascination with maps and see our images, our adventures, displayed geographically.

The New "Where"

The Map module is new in Lightroom 4. It provides an easy way for you to tap into that geolocation data and see your images geographically. Whether your images are geolocated automatically by your camera or you place them manually, the Map module provides an interface for you.

NOTE

Unlike other modules in Lightroom, the Map module requires that you have an Internet connection. Maps are not stored locally, so they must be pulled down from Google as needed.

I think the Map module is a great addition to Lightroom 4. At first you might think "Maps? Yawn." But there are some great benefits here. Prior to the Map module, Lightroom's "Where" dealt with folders, collections, Catalogs, and stacks. Now we can branch out. Maps are the new "Where" in Lightroom.

Personally, I think the Map module should have been another view in the Library module and not a module on its own. That's one of the reasons I'm introducing it here even though it appears after the Develop module in the Module Picker. But I'm sure the Lightroom team has its reasons, and I'm interested to see where Adobe takes this module in the future.

The Toolbar

There aren't many new interface components in the Map module. Our old friends the Filmstrip, the Metadata panel, and the Collections panel make an appearance. The rest of the interface remains pretty much the same, with a few small variations. The toolbar in the Map module has some new tools (Figure 9.1).

Figure 9.1
The Map toolbar.

The Map Style menu (1) lets you choose from the following:

- Hybrid—A satellite view with street and landmark names superimposed.
- Road Map—A standard road map view.
- Satellite—This view shows features but no street names or other guides.
- Terrain—A topographical map showing natural features and elevations.
- Light—A low-contrast light version of the road map.
- Dark—A low-contrast dark version of the road map.

These styles are also available via keyboard shortcuts. Command+1 for Hybrid, Command+2 for Road Map, and so on. Figures 9.2 through 9.7 show examples of these map styles.

Figure 9.2

The hybrid map style.

Figure 9.3

The road map style.

Figure 9.4

The satellite map style.

Figure 9.5

The terrain map style.

Figure 9.6

The light map style.

Figure 9.7

The dark map style.

The Zoom slider [refer to Figure 9.1 (2)] zooms in and out of the Map view. You can click the – to zoom out and the + to zoom in. Grab the slider itself and move it to the left to zoom out and to the right to zoom in. You can also zoom in by double-clicking on the map. Pressing the – will zoom out, and pressing the = key will zoom in.

Still another way to zoom in is to hold down the Option key. When you do, Lightroom displays a small banner saying Drag to Zoom [Figure 9.8 (1)]. While holding down the Option key, drag a box over the area of the map you want to zoom into (2). When you release the mouse button, Lightroom zooms in to the area you defined.

Figure 9.8

You can also drag to zoom in.

When you place photos on the map, their locations are marked with a pin or marker. The lock icon in the toolbar [refer to Figure 9.1 (3)] will lock the pins in place so you don't accidentally move them while navigating the map. It's a good idea to keep your pins locked because moving a pin will also change the GPS data for your image. Command+K will also lock and unlock the pins.

The icon that looks like a small curvy line is the GPS Tracklog control (4). When you click this, you get a menu with the following options:

- Load Tracklog
- Previous Track
- Next Track
- Select Photos on Tracklog
- Set Time Zone Offset
- Auto-Tag Photos
- Turn Off Tracklog

A GPS Tracklog is a file that contains time stamps and GPS coordinates. We'll go into greater detail about these logs later on in the chapter.

The last item in the toolbar is the Option menu (5). This lets you hide or show the controls we've just covered.

Working with the Map View

Getting images onto the map is relatively easy. Lightroom provides several ways to do this in the Map module. Some of your images may already have GPS coordinates in their metadata. For others you might know the general location and need to place GPS coordinates in the file. If you have a running GPS Tracklog from your shoot, Lightroom can use that data to help.

Embedded Data

A few cameras have GPS capability built in. There are GPS tracking add-ons for other cameras that will embed this data as well. But the most common example is your smart phone. Nearly every smart phone has a camera and GPS capability. When you take a shot with your smart phone, it already knows where you are and embeds that information into the image file. (Unless, of course, you have disabled that feature.)

Lightroom will automatically use this embedded GPS data when you import the image and map it for you.

Figure 9.9 shows a simple image shot with my iPhone. Since the iPhone will embed GPS data into images taken with its camera, the image comes into the Catalog with a map icon (1) and GPS coordinates (2) already there.

Figure 9.9

An image with GP data embedded.

Switching to the Map module, you can see that the images have been automatically added because of their embedded GPS data (Figure 9.10). Selected images will show on the map with yellow markers (1), and unselected images have orange markers (2). A location tag is provided in the upper-right corner of the map (3). You can toggle this on and off using the I key or View > Show/Hide Map Info.

There is a map key in the lower-right corner of the map. You can turn this off by clicking the X corner of the key or with View > Show/Hide Map Key. I recommend you leave this on at first. Once you recognize the different markers, you can turn it off to see more of the map.

The Navigator panel in the Map module shows an expanded map with the current zoom level indicated by a small rectangle (5).

There are some nice extras in the Map module. For example, when you move your mouse over an image in the Filmstrip, the marker for that image will bounce on the map if it is visible. We've already seen that selecting an image will change the color of its marker on the map. If you select a marker, the corresponding image will be selected in the Filmstrip. Selecting a group or cluster on the map will highlight all of the images in that group or cluster.

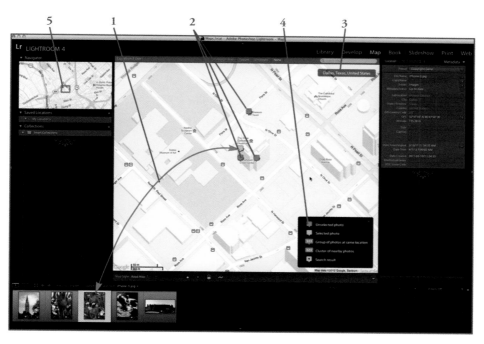

Figure 9.10

Images with embedded GPS coordinates are automatically added to the map.

> **NOTE**
>
> As you zoom out on the map, individual markers will merge into a cluster. As shown in the map key, this is indicated by a rectangle with a number indicating how many images are in the cluster. If several images have the same GPS coordinates, they form a group. Groups are represented by rectangles with a small pin at the bottom and the number of images indicated the same way as for a cluster.
>
> As you zoom in, clusters will eventually break apart into their individual image markers. Groups remain together.

Hover your cursor over a marker [Figure 9.11 (1)]. A small preview window appears and shows you the image represented by that marker (2). If you are hovering over a group or cluster you can use the navigation arrows (3) to move between the different images in that group or cluster. The preview header gives you some data about the image shown, including its place in the group or cluster when applicable.

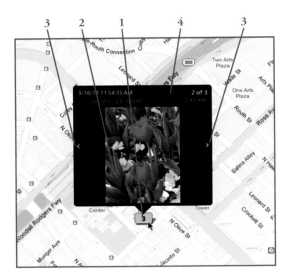

Figure 9.11

Image previews on the map.

Searching

What do you do if you have images that don't have embedded GPS data? You can still place them on the map manually. Start by searching the map for the location you want.

At the top of the main viewing area is the Location Filter bar. At the far right you will find the search box [Figure 9.12 (1)]. Type the search criteria here and press Enter. If there are multiple results, you will get a drop-down with the available choices (2). Choose the one you want.

Figure 9.12

Search for the location you want.

Once you select the location, the map will show it to you (Figure 9.13). The marker with a black dot indicates a search result (1).

Figure 9.13
You found it.

Manual

One method to place your images is to drag and drop them onto the map (Figure 9.14). After searching for your location, you can zoom in until you have the right level of detail to place the images.

When you let go of the mouse button and drop the image, a pin is placed on the map [Figure 9.15 (1)]. This adds the location badge to the image's thumbnail (2) and puts the GPS coordinates in the GPS metadata field. This method can be used on a single image or a group of selected images shot at the same location.

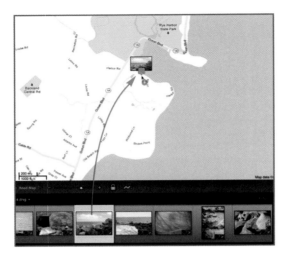

Figure 9.14

Drag and drop images on the map.

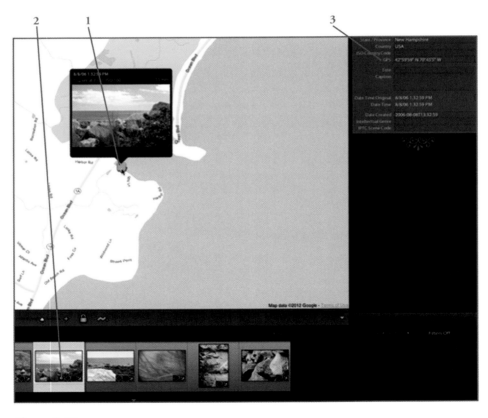

Figure 9.15

Once you drop the image, the pin is placed on the map.

If you prefer to work from the map, select the images to be placed and then right-click at the location on the map where you want them to be pinned (Figure 9.16). Select the only option in the contextual menu—Add GPS Coordinates to Selected Photos. The result is the same. The marker is placed on the map, the thumbnail gets a location badge, and the GPS coordinates are added to the image.

Figure 9.16

You can also work from the map.

> **TIP**
>
> You can use the camera in your smart phone to do reference geotagging. Every time you change locations to shoot more images, remember to take one image with your smart phone. Smart phones embed GPS data into their images. Import the smart phone images into Lightroom, and they will be mapped automatically. Now you can drag the images from your regular camera and drop them on the map where the matching reference image from your smart phone is. When you're done, delete the smart phone images from your Catalog.

The Location Filter Bar

At the top of the map you will find the Location filter bar (Figure 9.17). We've already seen how the search field works, but there are four other filter options:

- Visible On Map
- Tagged
- Untagged
- None

Figure 9.17

The Location filter bar.

Choosing Visible On Map (Figure 9.18) will show only images in the Filmstrip that are currently located on the map.

Figure 9.18
The Visible On Map filter applied.

The Tagged filter darkens any untagged images in the Filmstrip (Figure 9.19).

1

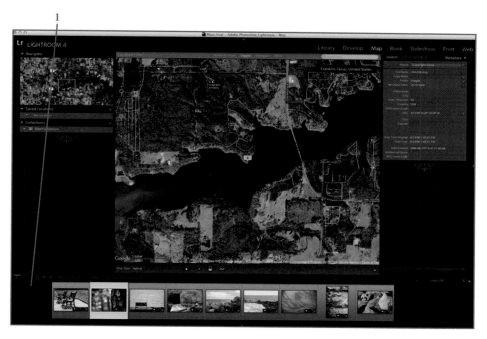

Figure 9.19

The Tagged filter.

The Untagged filter, as you'd expect, does the opposite of the Tagged filter and darkens all tagged images in the filmstrip (Figure 9.20). This makes it very clear which images still need to be tagged.

None, of course, removes all filters.

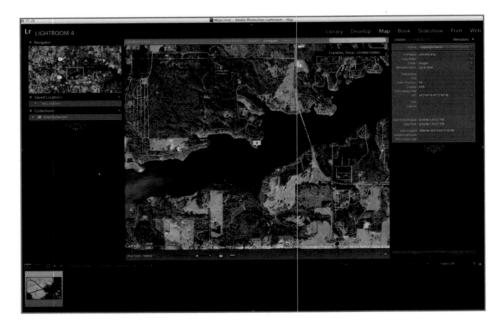

Figure 9.20
The Untagged filter.

Reverse Geocoding

This is the real excitement surrounding the Map module. Reverse geocoding will save you hours of metadata entry. When your image has GPS coordinates embedded in the metadata, Lightroom uses reverse geocoding to populate these location fields for you:

- Sublocation
- City
- State/Province
- Country
- ISO Country Code

If you allow it, Lightroom will pass the GPS coordinates to Google, and Google will return the information it has for those coordinates.

The first time Lightroom tries to get this data, you will be asked for your permission (Figure 9.21).

Whether you choose to enable or disable reverse geocoding, you can always change your mind later (Figure 9.22).

Figure 9.22

You can always change your mind later.

Figure 9.21

Enable reverse geocoding?

By simply dragging images onto the map, you reap all of this new metadata (Figure 9.23).

Figure 9.23

Reverse geocoding in action.

If you have been diligently entering this location information, let Lightroom do it for you now. Time saved. If, on the other hand, you haven't been filling in these fields because it was just too time-consuming, this is your lucky day. I think this really is the sleeper feature in the Map module.

Saved Locations

We all have places we return to again and again to shoot. Wouldn't it be convenient to be able to save those favorite locations in Lightroom? Yes, it would be, and yes, you can.

The only new panel in the Map module is the Saved Locations panel (Figure 9.24).

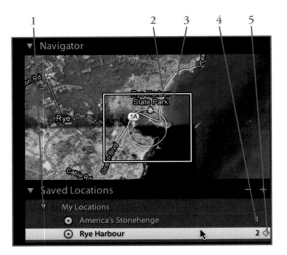

Figure 9.24

The Saved Locations panel.

Before you save any locations, the Saved Locations panel contains one default folder (1) called My Locations. But you can create other folders if you like to help organize your saved locations any way you like.

If you recall, the rectangle (2) you see in the Navigator panel represents the zoom level of the map in the main viewing area. When you hover over a saved location that is within the visible map, a circle (3) appears in the Navigator panel to indicate the saved location's boundaries.

In the Saved Locations panel, each location has a number to the right (4). This tells you how many images are within the boundaries of that location. When your mouse is hovering over a location, a small arrow appears next to the number (5). If you click this arrow, Lightroom will take you to that location on the map.

Public

By default all saved locations are public. By that I mean the location data will be embedded in the file and any exported versions unless you actively elect to remove it. To create a saved location, click the + in the header of the Saved Locations panel.

Several things happen when you do this. First, a large shaded circle appears on the map [Figure 9.25 (1)]. This circle represents the saved location you are about to create. It is always centered on the map and will extend almost to the edges of the map regardless of the zoom level you are currently at. But don't worry. You will be able to adjust this at any time.

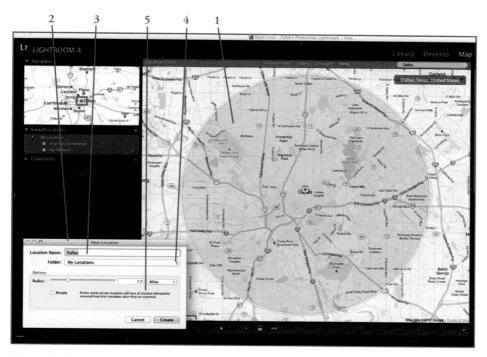

Figure 9.25

Creating a saved location.

The second thing that happens is the New Location dialog appears (2). Here you can name your location (3). If you've used the search field in the Location filter bar to find it, that will be the name you see to start. Change it to whatever you prefer. Just below the Location Name field is the Folder drop-down (4). All of your existing folders are listed as well as the option to create a New Folder.

In the Options section, you can set the radius of the circle using the slider or by typing the number directly in the box after the slider. That radius is expressed in either kilometers, meters, miles, or feet. You choose which in the drop-down following the slider.

The last option is whether to make the location private or not. Checking the box will make this location private. Leaving it unchecked makes it public.

The new saved location falls alphabetically in the assigned folder [Figure 9.26 (1)]. Now that the location has been saved, notice there are two small dots—one at the center of the circle (2) and one on the edge of the circle (3). You can use these to adjust the saved location. Dragging the center dot will move the location of the circle. Dragging the dot on the edge will let you change the radius of the circle.

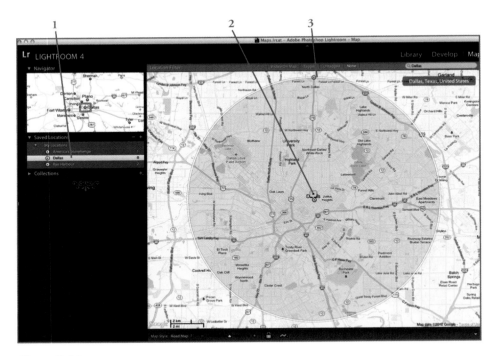

Figure 9.26

The new saved location.

If you right-click on the center dot, a contextual menu appears with options to delete the location or change its options. You can also delete a location by selecting it in the Saved Locations panel and clicking the – in the panel header.

As mentioned earlier, you can assign images to a location by dragging them and dropping them within the location's circle. You can also select images and then hover over the list of saved locations in the Saved Locations panel (Figure 9.27). A small checkbox will appear to the left of the location under the cursor (1). Click to place a checkmark. All selected images will be added to the location at the center point. Unchecking this box will remove the location metadata from all images within the saved location area and remove them from the map.

Figure 9.27

Assigning location with the Saved Locations panel.

Private

Having the capability to save frequently used locations is extremely useful. However, some of the locations we use often may not be places you want the world to find. Those paparazzi can be quite annoying, you know. You can mark saved locations as private (Figure 9.28).

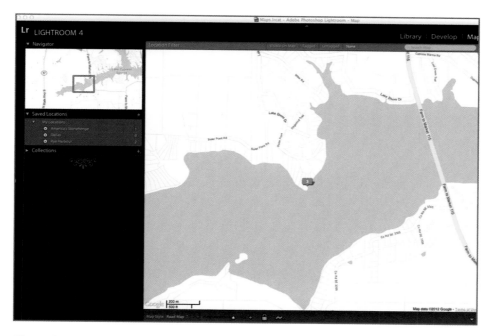

Figure 9.28

Our private lake getaway. Shhh. Don't tell anyone.

To create a private saved location, follow the same process. Click the + in the Saved Locations panel header.

The New Location dialog appears as before (1). This time, however, check the Private option (3). I also like to keep my private locations in a different folder (Figure 9.29), so under the Folder drop-down, choose New Folder and the New Folder dialog will pop up for a folder name (3). Enter the folder name and click Create, then click Create in the New Location dialog.

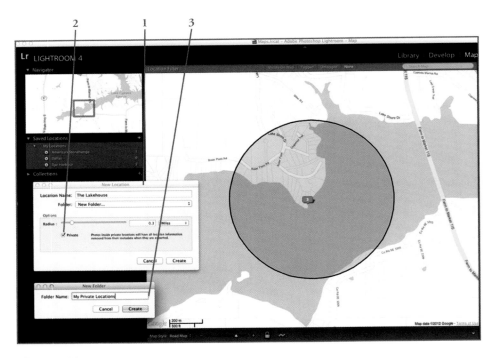

Figure 9.29

This time we'll create a folder to keep the private locations separate.

Figure 9.30 shows the new private location for the lake house. There is a new folder in the Saved Locations panel (1) and the new location in that folder (2). Private locations have a small lock icon on top of the dot icon. On the map you can distinguish a private location by its black border (3), darker shading (4), and lock icon on the center dot (5).

Why bother making locations private? When anything is inside a private location, you can still see all of the same GPS and location data. But now you don't have to remember to strip out this data when you export these images or upload them to your favorite image-sharing site. Lightroom does this automatically for any image inside a private location.

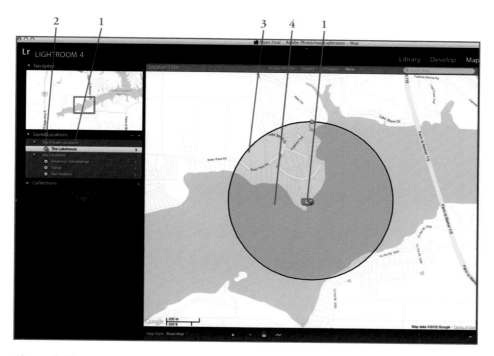

Figure 9.30

The new Private Saved Location.

Other Options

The Saved Locations panel has a few other options available by right-clicking any location. You'll get a contextual menu with the following choices:

New Folder—You can create a new folder at any time without having to create new locations. You can then drag and drop locations into your folders to organize them.

Location Options—This brings up the Edit Location dialog.

Rename—Use this to rename your location.

Update with Current Settings—Suppose you mistakenly create a location for Rome, New York, but you meant it to be Rome, Italy. Use the search field in the Location filter bar to find Rome, Italy. Then right-click on your misplaced Rome location and choose this option. You location will be updated with the coordinates for Rome, Italy.

Show in Finder—Locations are stored in files on your drive. This will open the folder where a particular location file is stored.

Delete—Deletes a location.

Export—Lets you export locations for backup or sharing locations.

Import—Brings locations that others have shared with you into your Catalog.

Pretty good for a module that most people yawned at when it was announced. It may seem like a lot of work to geotag your images, but it adds a wealth of information you can search with for years to come. In the last section, we'll walk through how to create and use a GPS Tracklog to make this process easier and more automatic.

GPS Tracklogs

To make the process of adding GPS data to your images easier and fairly automatic, the Map module supports the use of GPS Tracklogs. Lightroom can import GPS Tracklogs saved in the GPX format. GPX is an XML-based format that is becoming more prevalent, and many devices and applications now use it. However, a quick trip to Wikipedia will tell you there are quite a few formats that GPS data can be saved in. Fortunately, there are applications available to convert these formats to GPX.

> **NOTE**
>
> If you would like to learn more about the GPX format, visit www.topografix.com/gpx.asp.

Before you can import your GPS Tracklog into Lightroom, you need to create it. To do that you can use either a dedicated GPS logger or your smart phone. Dedicated GPS loggers are small devices you can attach to your camera, clip on your belt, or just carry in your pocket. Turn one on, and it will start logging your position and the time. When you get back from your shoot, you can plug these devices into your computer and download the logs. If your logger uses GPX format, you're all set. If not, you will need to convert it to GPX using the manufacturer's software or a third-party application. A good GPS logger will cost around $50 or $60.

If you have a smart phone that can run apps (such as an iPhone or Android-based phone), there are a number of applications available that turn your phone into a GPS logger. These are available at very reasonable prices. In fact, many have a free lite version you can use. If you want more features, the pro version is usually available at a reasonable price. My favorite, and the one I'll use for this example, is called Geotag Photos Pro from TappyTaps. It is available for iOS and Android. They have a free lite version, and the pro version costs $3.99.

When you are ready to start logging your GPS coordinates, you first need to synchronize your camera with the app. In the settings for Geotag Photos Pro, select the Setup Time on Camera option (Figure 9.31).

This will show you the time and date used by the app. Set your camera's time and date to match (Figure 9.32).

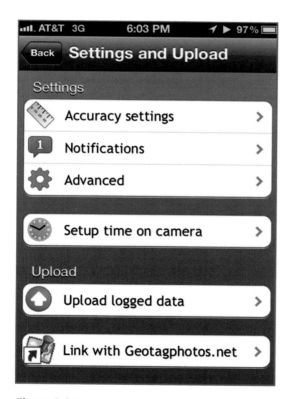

Figure 9.31

The Geotag Photos Pro settings screen.

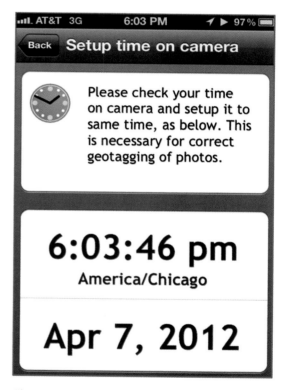

Figure 9.32

Synchronize your camera and app.

On the main screen, tap the Record button. When you are done shooting, tap the Stop button (Figure 9.33).

Geotag Photos Pro has a few ways to get your GPX file off your phone. You can upload the file to their website and then access it from your browser. I prefer to email the file to myself. GPX files are not large at all. I just tap on the Export to Email button, and within seconds I have my file attached to an email (Figure 9.34).

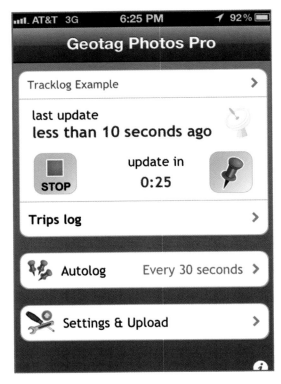

Figure 9.33

Tap the Stop button when you are done shooting.

Figure 9.34

Email the GPX file to yourself from within the app.

You're back from your shoot and ready to put this all together in Lightroom. Import your images. Save the GPX file to your drive. Select the images and open the Map module. Load the Tracklog by selecting Map > Tracklog > Load Tracklog or click the Tracklog tool in the toolbar [Figure 9.35 (1)] and choose Load Tracklog.

Find your Tracklog in the Import Track File dialog and click Choose (Figure 9.36). Lightroom will load the file and display the map with the Tracklog in place (Figure 9.37).

Figure 9.35

Load the Tracklog into Lightroom.

Figure 9.36

The Import Track File dialog.

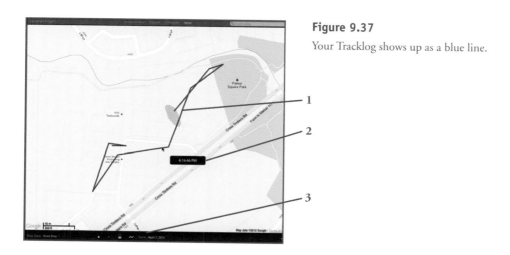

Figure 9.37

Your Tracklog shows up as a blue line.

The path you took as recorded in the Tracklog will show up on the map as a blue line (1). If you hover your cursor over any part of the Tracklog line, Lightroom displays the time at that point (2). You can store several "tracks" in a Tracklog. You might do this if you are going to a few different locations and don't need to track the route between those locations. In Geotag Photos Pro you'd simply stop the recording at one location and then start it when you arrive at another. When you have multiple tracks, you can access them from the track drop-down that appears next to the Tracklog tool in the tool-bar (3). You could also use the keyboard shortcuts Option+Command+T for the next track and Shift+Option+Command+T for the previous track.

If you forgot to synchronize your camera or if you captured your Tracklog in another time zone, you can match them up later. From the Tracklog tool menu choose Set Time Zone Offset to get the Offset Time Zone dialog (Figure 9.38). The time range for your selected photos appears on the first line, and the time range for the track appears on the second line. When they are out of sync, the Tracklog times will be red. Adjust the offset slider until the Tracklog turns black and then click OK.

Figure 9.38

Compensate for time differences with the Offset Time Zone option.

To apply the track to your images, select Map > Tracklog > Auto-Tag X Selected Photos or choose Auto-Tag X Selected Photos from the Tracklog tool menu.

Lightroom goes to work and matches up the time stamps in your image files with the time stamps in the Tracklog, and before you know it, all the images are pinned to the map, and the corresponding GPS coordinates are entered into the metadata. If you've enabled it, reverse geocoding kicks in and fills out the IPTC location data as well. Brilliant.

Once your images are placed you can turn off the Tracklog. Select Map > Tracklog > Turn Off Tracklog or select Turn Off Tracklog from the Tracklog tool menu. Turn Off Tracklog is also available from the contextual menu when you right-click on the Tracklog in the map.

To select the images on the Tracklog, right-click on the Tracklog and choose Select Photos on Tracklog. The same option is available from the Tracklog tool menu.

If you haven't tried geotagging your images until now, give the Map module a try. Aside from all the useful data you will record, it can be a lot of fun to see where your images are on the map. The addition of the Map module to Lightroom makes it easy. And don't worry about those dragons. You'll be fine.

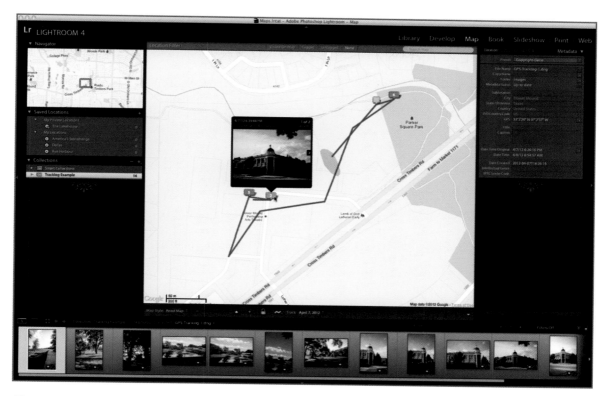

Figure 9.39

Images tracked and tagged.

10

The Good, the Bad, and the Ugly

Up to this point, we have dealt mainly with objective data. Keywords are the most subjective data we've encountered. But even then, keywords bear some rational relationship to the content of the image. All that data is extremely useful and deserving of your efforts to capture it. But there comes a point at which you must look at your shots and judge them. You must discern the finer points of each image to pull out the best shots from the worst.

In this chapter, I'm going to show you the tools for comparing, filtering, and rating your images. From time to time I will point out some other uses for some of these tools. As you get used to working with them, I encourage you to come up with additional and creative uses.

I know that every one of your shots is portfolio quality right out of the camera. But bear with the rest of us as we explore how Lightroom can aid us in separating the good from the bad from the ugly.

Reviewing Your Shoot

You know you have to do it. Sometimes it's easy and obvious—that out of focus accidental shot of the floor. That can go and good riddance. But the rest are all like your children. You don't want to play favorites or reject one and not the other. That's the artist's conundrum. You just need to deal with it and forge ahead. Lightroom will help you in many ways, but the review ultimately falls on your shoulders. Let's dive in and clean up that catalog.

Grid and Loupe

As you know, the Library module has four views you can use to examine your images. The first two, Grid and Loupe, work hand in hand when reviewing images. Later in this chapter you will learn about stars, labels, and flags. All of these can be used while viewing images in the Grid and Loupe views. For now we'll look at a basic flow through a set of images using those two views.

CAUTION

Although there are numerous ways to do just about anything in Lightroom, I urge you to learn as many keyboard shortcuts as you can. Keyboard shortcuts are faster. Moving from the keyboard to the mouse to the keyboard can add up to a lot of time.

You can always access the main keyboard shortcuts for any module by pressing Command+/. This will show you a window like the one in Figure 10.1.

Library Shortcuts

View Shortcuts	
Esc	Return to previous view
Return	Enter Loupe or 1:1 view
G	Enter Grid Mode
E	Enter Loupe view
C	Enter Compare mode
N	Enter Survey mode
Command + Return	Enter Impromptu Slideshow mode
F	Cycle to next Screen Mode
Command + Option + F	Return to Normal Screen Mode
L	Cycle through Lights Out modes
Command + J	Grid View Options
J	Cycle Grid Views
\	Hide/Show the Filter Bar

Rating Shortcuts	
1-5	Set ratings
Shift + 1-5	Set ratings and move to next photo
6-9	Set color labels
Shift + 6-9	Set color labels and move to next photo
0	Reset ratings to none
[Decrease the rating
]	Increase the rating

Flagging Shortcuts	
	Toggle Flagged Status
Command + Up Arrow	Increase Flag Status
Command + Down Arrow	Decrease Flag Status
X	Set Reject Flag
P	Set Pick Flag

Target Collection Shortcuts	
B	Add to Target Collection
Command + B	Show Target Collection
Command + Shift + B	Clear Quick Collection

Photo Shortcuts	
Command + Shift + I	Import photos and videos
Command + Shift + E	Export
Command + [Rotate left
Command +]	Rotate right
Command + E	Edit in Photoshop
Command + S	Save Metadata to File
Command + -	Zoom out
Command + =	Zoom in
Z	Zoom to 100%
Command + G	Stack photos
Command + Shift + G	Unstack photos
Command + R	Reveal in Finder
Delete	Remove from Library
F2	Rename File
Command + Shift + C	Copy Develop Settings
Command + Shift + V	Paste Develop Settings
Command + Left Arrow	Previous selected photo
Command + Right Arrow	Next selected photo
Command + L	Enable/Disable Library Filters
Command + Shift + M	Mail selected photos

Panel Shortcuts	
Tab	Hide/Show the side panels
Shift + Tab	Hide/Show all the panels
T	Hide/Show the toolbar
Command + F	Activate the search field
Command + K	Activate the keyword entry field
Command + Option + Up Arrow	Return to the previous module

Figure 10.1

Shortcuts for the Library module.

These are the most common shortcuts. You can also look at the menus. Whenever there is a shortcut for a menu command, it will be listed to the right of that command in the menu itself. Get yourself in the habit, and you will find your work in Lightroom going faster and faster. Then you can get back to shooting sooner.

The Grid view shows an array of thumbnails so you can visually scan many images at once. The number of thumbnails you see will depend on how large they are, how large your monitor is, what thumbnail view you've chosen, and which panels are visible. When reviewing a group of images, I suggest you maximize Lightroom on your screen and hide all the panels. This will present you with the greatest number of thumbnails at once. Adjust the size of the thumbnails so you are able to see what each image is without straining.

Use the F key to cycle through three different screen modes: normal (Figure 10.2), full screen with menus (Figure 10.3), and full screen (Figure 10.4). Option+Command+F will immediately return you to normal screen mode.

Figure 10.2

Normal screen mode.

Figure 10.3

Full screen with menus screen mode.

Figure 10.4

Full screen mode.

Here are two ways to use Grid and Loupe views together to review—one for a single monitor setup and one for a dual monitor setup. Start by choosing a screen mode. I suggest one of the full screen modes so you can concentrate on your workflow. Then press Shift+Tab to hide all four panel groups (Figure 10.5).

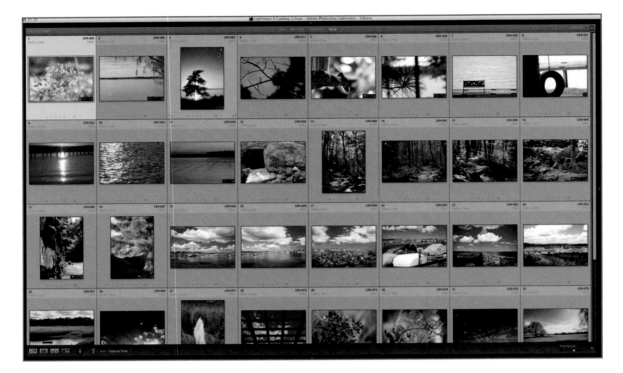

Figure 10.5

Maximizing the grid.

You can navigate around the grid using your arrow keys. To examine an image more closely, press the spacebar or E to switch to Loupe view (Figure 10.6).

Press the spacebar to zoom in and again to zoom back out (Figure 10.7). Holding down the spacebar will temporarily zoom in until you release it.

Your arrow keys will continue to move you around the grid even when you are in Loupe view. You can move from image to image while staying there, or you can press G to return to the image in Grid view.

An alternative key method is the Z key. Start in Grid view. When you see an image you want to examine, press Z, and you will switch to the Loupe view already zoomed in. Z will return you to the grid even if you've changed to another image via the arrow keys.

The idea behind this workflow is to allow you to move fluidly through your images, examine some more closely, and while doing that apply one or more of the rating tools we'll see in a moment.

Figure 10.6

Loupe view for a closer look.

Figure 10.7

Spacebar for an even closer look.

If you are using two monitors, you can keep your main monitor in Loupe view while having the grid on your second monitor (Figure 10.8).

Now you can move around the grid and see a full screen Loupe view at the same time.

Monitor 1 in
Loupe view.

Monitor 2 in
Grid view.

Figure 10.8

Dual monitors—the best of both worlds.

Survey View

Survey view lets you see a selected group of images and whittle down the group. Once you have the selection you want, you can apply ratings directly in this view. You start by selecting a group of images. In Figure 10.9, I'm starting with six shots of a building.

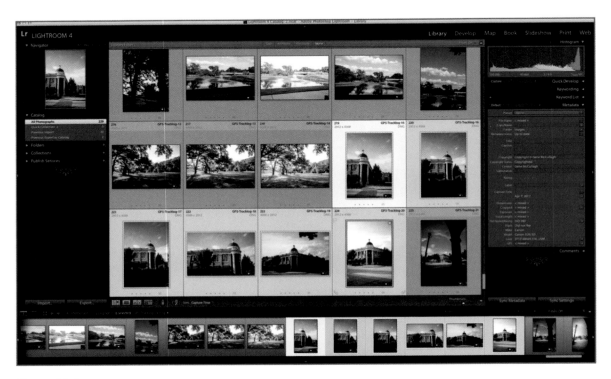

Figure 10.9

Start by selecting the images to survey.

This also works well if you hide the panel groups with Shift+Tab. With your images selected, enter Survey view by clicking the icon on the toolbar or pressing N. This displays larger versions of the images selected (Figure 10.10).

Now you're focusing on your selection. When your cursor is over an image, an X appears in the lower-right corner (1). Click this to remove the image from the survey. Also notice that one image has a white border (2) around it. This is the target image. You can use your arrow keys to change which image is the target image. Remember those keyboard shortcuts from Grid and Loupe? They work just as well here. Z goes to Loupe view zoomed in and returns you to Survey view. Spacebar also goes to Loupe view and toggles the zoom. Use N to get back to Survey view.

Figure 10.10

The selected images in Survey view.

TIP

I had the pleasure to attend one of Scott Kelby's seminars recently. He talked about Survey view and summarized it in a way that made perfect sense. He said it's easier to deselect the images you don't like than it is to select the ones you do. That's what Survey view is about. Click the X and away goes that image. Then, as Scott pointed out, you get rewarded because Lightroom makes the remaining images bigger. Approach Survey view with this mindset, and I think you'll find it an easier process.

Right away I eliminate four of the images by clicking the X. The rest get bigger (Figure 10.11). The remaining two are what I want, so I will apply one or more of the rating tools and then move on to the next set of images.

Figure 10.11

These are the images I want.

Compare

Compare view is used to limit your choice to two images at a time—the Select on the left and the Candidate on the right. Your Select remains constant while you compare it to the Candidate, which changes as you move through your images. If the Candidate looks better to you, you can make it the Select and continue the process. It's very much like having an eye exam. The doctor shows you two different corrections, and you choose one or the other. Then you move to another correction to compare it to the one you said was better.

Make your selection and switch to Compare view by clicking the icon in the toolbar or pressing C (Figure 10.12). If you have the Filmstrip open, you can see that the Select is marked with a white diamond (1) and the Candidate with a black diamond (2). You can use the left and right arrow keys to move through the images one by one. Press the spacebar to zoom in and out of both the Select and Candidate images simultaneously. If the Candidate looks better, press the up arrow key to promote it to the Select.

Figure 10.12

Make a selection. Your target image becomes the Select.

Marking Your Selections

All of this gridding, louping, surveying, and comparing is fine, but there's more to reviewing your images than just looking through them and making comparisons. That's where the rating tools come in. Lightroom has three different and independent rating systems you can use separately or in concert with each other. These tools aren't just for rating an image, though. If used cleverly, they can be workflow aids as well.

Flags

The most basic of the rating tools are the flags. There are two flags in Lightroom.

- The *pick* flag is white.
- The *reject* flag is black with an X on it.

Your images can exist in one of three states—picked (flagged), unflagged, or rejected. It's that simple.

> **CAUTION**
>
> Any discussion of flags in Lightroom 4 must come with a warning. If you've never used Lightroom before and version 4 is your introduction, you can skip this warning. If you are a veteran Lightroom user, read on.
>
> Starting with Lightroom 4, flags are global. Quite frankly, I think this was a very poor decision on Adobe's part. Until now flags were locally applied, and they were, in fact, the only local rating in Lightroom. Having this local quality meant you could flag an image in one collection and reject it or leave it unflagged in another.

You can use flags as a separate rating method or as part of a rating workflow. For example, before giving an image a star rating, you might first use flags to create a subset of images—those worth reviewing for a star rating.

Here are some additional keyboard shortcuts you may find useful when using flags:

- Command+up arrow increases the flag status (pick being highest, and reject being lowest).
- Command+down arrow decreases the flag status.
- The grave accent (`) toggles between picked and unflagged.

There are two methods I suggest for flags. The first I call PUXing. The second is the Refine Photos command.

Do You PUX?

Wait. Wait. I'm not being rude. Really. PUXing is a way to work through your images after a shoot.

Whether you come back with 300 images from a landscape shoot or 3,000 from a wedding, you still have the inevitable task of going through the images and deciding what stays and what goes. There are many ways to approach this. PUXing is quick and easy.

There are ultimately three basic images:

- Keepers.
- Losers.
- Hmmm...I don't know yet.

Lightroom provides an excellent system in the form of the pick and reject flags. Here's what I do when I'm ready to start my review process.

After I've imported my images into Lightroom, I go down to the Quick Filter bar at the top of the Filmstrip (Figure 10.13). There are three flag filters:

- Picked or flagged
- Unflagged
- Rejected

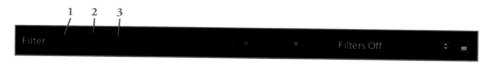

Figure 10.13

The Quick Filter bar is where PUXing begins.

I click on the middle filter, unflagged images. (If your filters are off, you will need to click a second time.) Then I close all of the panels with Shift+Tab, which leaves me with a screen full of thumbnails. For this process you can make your thumbnails larger so you can see some detail. (You could also switch to Loupe view.)

Now I'm ready. Looking at the first image, I press either the P key or the X key. P is for pick and X is for reject. (We'll get to U in a minute.) When I do that the image disappears from my screen. It's not gone; it's just that the image is no longer unflagged, so the filter removes it from view.

If I'm undecided, I move on to the next image and leave the previous one alone. As I progress through my shoot, the only thumbnails I can see are the unrated ones. When all the images are gone, I know I've made a decision on all of them.

I can now change the filter to show me rejected images only (Figure 10.14).

Lightroom presents rejected images in a sort of faded view (2). Whichever one is active, however, is clearly visible and not faded. This is nice when you have a screen full of images. It makes the rejected ones less apparent but not totally out of sight.

I take a quick run through these, and if I've changed my mind, I press the U key to unflag the image and remove it from the rejects. It's a simple matter at this point to create a folder and drag the rejects to it for holding. I like to keep the rejects around but sequestered just in case. You never know. Lightroom 10 might have a new tool that can save them.

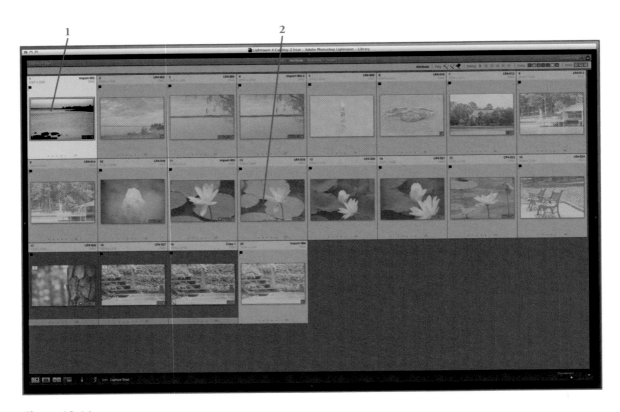

Figure 10.14

Review the rejects.

Turn off the filter, and your picks and unflagged images are there (Figure 10.15).

This can be a real timesaver. No longer will you hover over every single image, stuck in the unanswerable quandary, "Is this a 3-star or a 4-star image? 4...no, wait, it's not tack sharp so 3...but the composition is stunning so 4," and so on and so on. If you haven't PUXed your images before, give it a try. You'll like it.

Figure 10.15

Filter's off, and everyone is back.

Refine Photos

The Refine Photos command is another way to use flags to weed out images. Start by marking images with a pick flag (Figure 10.16).

To refine your photos, select Library > Refine Photos or press Option+Command+R. You will be presented with a dialog (Figure 10.17).

Picked Images

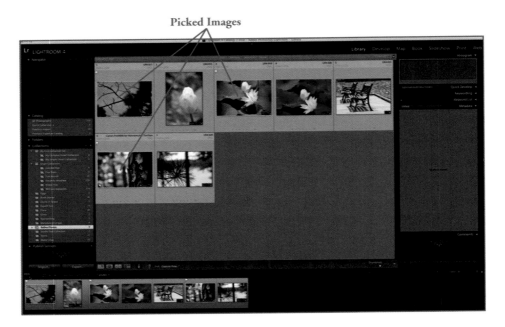

Figure 10.16

Three images picked.

Figure 10.17

The Refine Photos dialog.

Once you get used to what this command does, you can check the Don't Show Again option to skip the dialog in the future. Click the Refine button. Now the previously picked images are unflagged (1), and the previously unflagged images are rejected (2) (Figure 10.18).

Now if you pick the first image in each row and then select Refine Photos a second time, you get a smaller set of images (Figure 10.19).

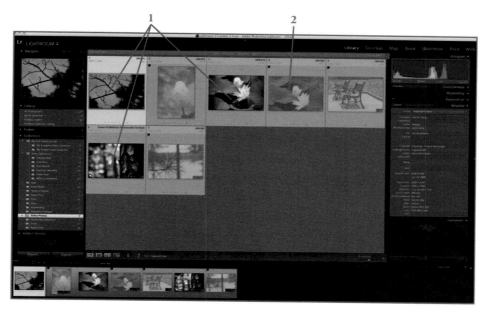

Figure 10.18

The results of the Refine Photos command.

Figure 10.19

Further refinement.

Delete Rejected Photos

When you get down to a group of images that you want to keep, you could put them in a collection or use other tools to mark them.

Also available is the Delete Rejected Photos command. You get there by selecting Photos > Delete Rejected Photos or pressing Command+Delete Before. This will show only the rejected photos and a dialog to confirm your decision to delete (Figure 10.20).

Figure 10.20

The Delete Rejected Photos warning while in a collection.

If you do this while in a collection, the command will remove the images only from that collection. However, if you are in a folder or the catalog, then the dialog and the choices will be different (Figure 10.21).

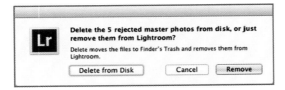

Figure 10.21

The Delete Rejected Photos warning while in a folder.

Now you have two choices. Remove will remove them from the catalog but leave the files on your drive. Delete from Disk will remove them from the catalog and delete the files from your drive. So be careful here. I am not a big fan of this command. I find it a bit too harsh.

> ## CAUTION
>
> If any of the images you are about to delete are part of a publish service, you will first get an additional warning (Figure 10.22).
>
>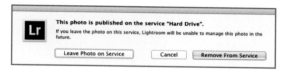
>
> **Figure 10.22**
>
> Be careful. This is part of a publish service.
>
> If you choose Leave Photo on Service, Lightroom won't be able to do anything with that image in the future. Depending on which publish service you are using, that could present a problem, so be careful.

Stars

Stars are probably the most universally understandable rating system. Three stars are better than one. Five stars are better than three. Easy. Or is it?

With flags you have only two choices—pick or reject. With stars you can get yourself into a mental trap. What makes one image two stars and another one three stars? Who knows? This kind of rating system can get you into trouble if you overthink it. Don't get too caught up in the granularity of star ratings. You've been fairly warned, so let's do some stargazing.

I think you already have an understanding of how star ratings work, so our time is better spent looking at how to add a star rating to images.

Lightroom has several ways to add a star rating. The first is simply to type a number from one to five. When you have an image targeted, press 2 to add two stars or 4 to add four stars. To remove all stars press 0 (that's zero).

You can also use the Star tool in the toolbar (Figure 10.23). Click on the star you want (1), and that will be applied to the image. To remove a star rating using the tool, double-click on the first star.

If you have ratings set to appear in the footer of your image cells, you will see dots as star placeholders. (If the image already has a rating, you'll see a combination of stars and dots, as in Figure 10.24.) Click the dot that corresponds to the star rating you want (1).

Figure 10.23
Use the Star tool in the toolbar.

Figure 10.24
Click the dot and win a star.

If you prefer to wander the menus, select Photo > Set Rating and choose a rating from the submenu. The same submenu is available when you right-click an image.

You don't have to do one image at a time. If you select multiple images and apply a star rating to one, all images in the selection get that rating.

There are two other keyboard shortcuts you may find useful when star rating images.

- Command+[will decrease the star rating.
- Command+] will increase the star rating.

Color Labels

Of all the rating tools Lightroom provides, I get the most questions about color labels. Perhaps it's because of poor lonely purple, the only color without a key. Or maybe it's because this tool is actually two tools in one—Colors and Labels. Whatever the reason, color labels seem to confuse many photographers. I'll try to shed some light on this tool and hopefully clear up some of the confusion.

TIP

Stars can be used for workflow purposes instead of ratings. For example, you could set up a workflow system using stars to indicate where an image is in the workflow.

- **1 star**—Image reviewed
- **2 stars**—White balanced/color corrected
- **3 stars**—Cropped
- **4 stars**—Edits applied
- **5 stars**—Ready for use

Whatever five steps or milestones you have in your workflow could be marked by stars. It's another way to use the tool.

Out of the box you get five color labels:

- Red
- Yellow
- Green
- Blue
- Purple

And, boringly, the default labels are the names of the colors.

Applying a color label to an image is done in the same ways we applied stars. You can use 1 through 5 to apply that many stars. Continue down the number keys for color labels—6 for red, 7 for yellow, 8 for green, 9 for blue, 0 for...wait. 0 means "remove the star rating." What about purple? I told you—poor lonely purple, the keyless color. You can't apply purple with a keyboard shortcut.

You can use the Color Label tool in the toolbar (Figure 10.25) to apply a color. Click the color, and it is applied to the image (1). Notice that the tool tip says Set Label to "Blue" and not Set Color to "Blue." We'll see the significance of that in a minute.

As with stars, you can set color labels from the menu—Photo > Set Color Label—or right-click and choose Set Color Label from the contextual menu. Then from the submenu, pick a color or None to remove the color.

If you have the color label showing in your cell footer, you can click that (Figure 10.26). and choose a color.

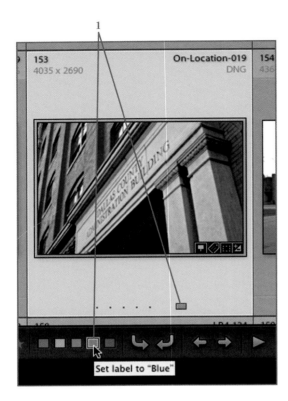

Figure 10.25
Use the Color Label tool to apply a color.

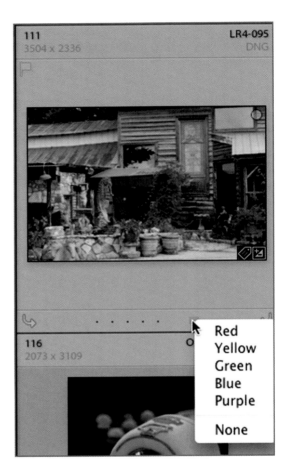

Figure 10.26
Click the color label indicator in the cell footer.

Here is where the confusion starts. If you are thinking about this tool as Colors and not Color Labels, you are missing out. Lightroom lets you define any number of color sets. That doesn't mean you can change the colors. Sorry. You are stuck with red, yellow, green, blue, and purple. But you can change the labels.

Select Metadata > Color Label Set > Edit to bring up the Edit Color Label Set dialog (Figure 10.27).

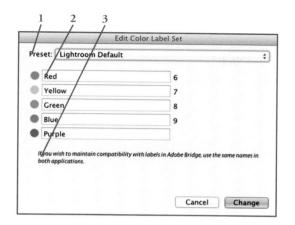

Figure 10.27

The Edit Color Label Set dialog.

At the top of the dialog is the Preset drop-down (1). Here you can choose which color label set to edit. Other options in this drop-down are these:

- Save Current Settings as New Preset
- Restore Default Presets
- Delete Preset *<preset name>*
- Rename Preset *<preset name>*

Enter new labels for each color in the field to the right of the color (2). If you are also an Adobe Bridge user, Lightroom reminds you that the labels must match those used in Bridge to maintain compatibility (3). When you've finished your changes, click the Change button.

By default three color label sets are installed:

- Bridge Defaults
- Lightroom Defaults
- Review Status

Let's switch to the Review Status color label set to see what happens when we use different sets. You activate a different set by selecting Metadata > Color Label Set > Review Status. Now our colors are mapped to these labels:

- **Red:** To Delete
- **Yellow:** Color Correction Needed
- **Green:** Good to Use
- **Blue:** Retouching Needed
- **Purple:** To Print

Clicking the Color Label tool still applies the color to the image [Figure 10.28 (1)]. But remember that tool tip? Now it says Set Label to "Retouching Needed" (2). Retouching Needed is the label assigned to the color blue in the Review Status color label set. That makes sense. What happened to the previous blue label? It is now white (3) and indicates that a color label has been assigned but from another color label set. This is also called a *custom label*. The label itself is what gets written to the file or its XMP sidecar.

There is no direct way to find out which set the custom label belongs to, because it still retains its label. These labels are accessible via search and are therefore still useful without their colors. In Figure 10.29 I've changed the header information in the cells to show the label.

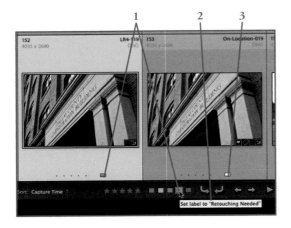

Figure 10.28

The Review Status color label set is active.

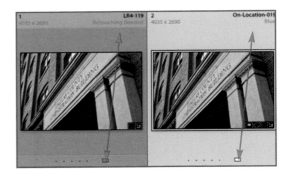

Figure 10.29

The label is retained even when the color label set is different.

The image on the left shows the color blue and the label "Retouching Needed," which matches the currently active color label set, Review Status. The image on the right had its label assigned when the Lightroom Defaults color label set was active. Its color shows as white (indication of a custom label), but the label "Blue" is retained even though the color label set is no longer active.

This separation of labels and colors is the source of confusion for most users. Just remember that the labels and the colors are independent from each other. The color serves as a visual reminder. When you reactivate a color label set, all of its previously "colored" images get their colors back, and the other images turn to custom labels. Get your mind around this, and you'll begin to see some intriguing organizational and workflow possibilities.

CAUTION

Editing a color label set that has already been applied to some images does not update the labels on those images. As soon as you save the changes those images become "orphans." Their labels remain, but they are no longer attached to a color label set. Keep this in mind when all your red images turn white all of a sudden.

If you aren't convinced that colors and labels are indeed independent of each other, take a look in the Metadata panel and notice the Label field. You can assign any label you like to an image or group of images. No color is involved unless the label you enter exactly matches a label assigned to a color.

Select, Add, Subtract, and Intersect

Flags, stars, and color labels all work with each other. As your catalog grows and you apply many of these markers, you will have new ways of making selections across the entire catalog. The Edit menu in the Library module has a great set of selection tools available (Figure 10.30).

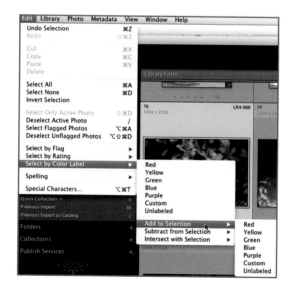

Figure 10.30

Selection tools in the Edit menu.

Most are pretty self-explanatory (Select All, Select None, etc.), but there are three selection submenus that need a little more detail. Flags, stars, and color labels each get their own Select By menu. They all follow the same pattern, so I'll explain the Select by Color Label menu, and you can apply that to the other two.

When you choose Edit > Select by Color Label, you see a submenu listing the labels in the currently active color label set along with custom and unlabeled. Choose any of these, and you get a selection of all images in your current view that match that choice. If you are in a collection, it looks in that collection, and if you're in All Photographs it uses the entire catalog.

Suppose you already have images selected but you want to adjust that selection based on color labels. The next three submenus each have the same color label choices. Here's how they work:

> **Add to Selection**—This will add all images with the selected color label to your current selection.
>
> **Subtract from Selection**—This will remove any image with the selected color labels from your selection.
>
> **Intersect with Selection**—Remember Venn Diagrams? One circle is your selection. The other circle is all images with the selected color label. This returns what's in the space where the circles overlap. In other words, if you have 10 images selected and four of them have a Blue label, and your current view has 15 images with a Blue label, you get a selection that consists of all previously selected images with a Blue label.

This is powerful stuff and well worth the investment up front. When your catalog gets to 150,000 images, you'll be glad you've been doing this over time.

Filtering

Any database worth its salt provides some way to filter data. Lightroom is no exception. All of the work you've done adding keywords, GPS coordinates, stars, flags, color labels, and other forms of metadata pays off now.

The Filter Bar

Sleeping at the top of the main viewing area in the Library module is the filter bar (Figure 10.31). If it isn't visible, press \ to make it appear. That same key will also hide it.

At first glance it doesn't look like much. In the middle of the bar there are only three search methods—Text, Attribute, and Metadata. But this little bar is a magic carpet to finding the images you are looking for in your catalog. Let's take these in order.

Figure 10.31

The filter bar.

Text

When you click on the word Text, the filter bar gets a little taller (Figure 10.32). Still rather unimpressive. Text Search has a simple interface. It consists of a drop-down of places to search (1), an operator or search rule (2), and a field for you to type the text you want to search for (3). Nearly all fields that contain text are searchable.

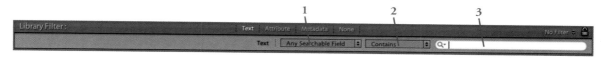

Figure 10.32

The Text Search method.

There are six search rules (eight for keywords):

Contains—This looks for any match of the entry in the search field. Partial words will be included. If you enter *jo* in the search field, it will match John and mojo. If there are multiple entries in the search field separated by a space, *jo dog*, for example, it will return images that have either.

Contains All—Using the *jo dog* example, this will match images that contain all of the entries. An image with only *John* won't match, but one that contains both *John* and *dog* will match.

Contains Words—This will match only whole words. If *dog* is entered it will match images that contain *dog*. It will not match *dogs*, *doggy*, *dogged*, etc.

Doesn't Contain—The opposite of Contains. This will match images that don't contain the entry in the search field.

Starts With—This looks for all images that start with the entry in the search field. Enter *jo* and it will match *John* but not *mojo*.

Ends With—This time you'll match images that end with the search field entry. Enter *jo* and it will match *mojo* but not *John*.

Are Empty—This is available only when Keywords is selected. All images without keywords are matched.

Aren't Empty—This is also available only when Keywords is selected and returns all images that have at least one keyword.

> **TIP**
>
> Common search shortcuts work in the search field. Add a period (.) before a word to exclude it. Add + before a word to make it start with a pattern, and + after a word makes it end with a pattern. Also, you can enter any combination. For example *jo+ +do .oh* using Contains would match an image with *mojo, dog* but not one with *mojo, dog, John*.

Remember that synonyms don't appear in the Keyword List panel, but they are searchable.

Figure 10.33 is an example of searching for *puppy*, which I added as a synonym for *dog*. Images with the keyword *dog* are returned even though *puppy* isn't in the Keyword List panel. I told you those synonyms were useful.

Keyword "dog" applied

"puppy" is synonym for "dog"

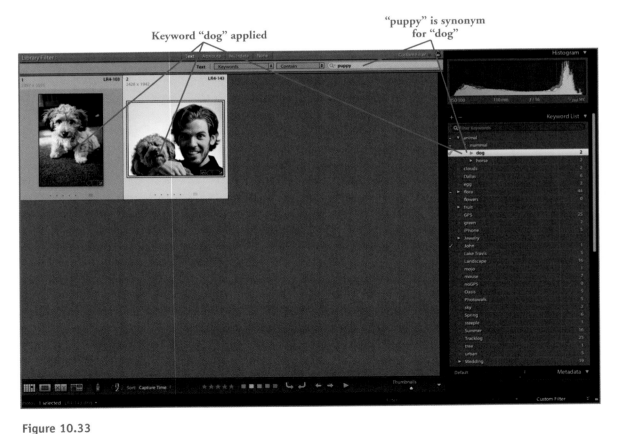

Figure 10.33

Synonyms are searchable.

> **TIP**
>
> You can access everything in this filter from the search field. Click on the magnifying glass, and the drop-down menu will contain all choices for all fields and search rules.

Attributes

Moving right along, we come to the Attribute filter. Click this and get a different set of filters (Figure 10.34). With this set of filters we can search based on flags, stars, color labels, and kind. This is a pick-and-click toolbar. Just click on the attributes you want, and Lightroom returns any images that match.

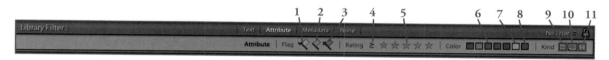

Figure 10.34

The Attribute filter.

The flags are first: pick or flagged (1), unflagged (2), and rejected (3).

Stars are next. First you decide how to compare the images to the star level you choose. Right after the Rating label you will see one of three math symbols [4: greater than or equal to (>=), less than or equal to (<=), or equals (=)]. Click the symbol to choose the comparison:

- Rating is greater than or equal to
- Rating is less than or equal to
- Rating is equal to

Then click on the number of stars you want (5).

In the Color section, the first five squares (6) are the standard colors. The next square (7) is for custom labels. Last in line is a square for unlabeled images (8).

The last section, Kind, has three choices: master images (9), virtual copies (10), and videos (11). I'll get into the differences when we get to the Develop module.

These attribute switches are not mutually exclusive. You can click any combination you like to find what you're looking for. As you click, Lightroom instantly filters and briefly displays a message telling you the full filter you've built so far (Figure 10.35).

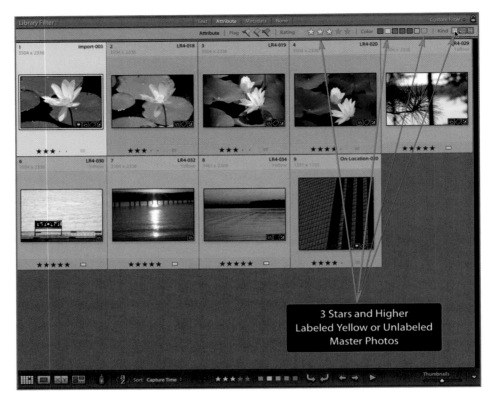

Figure 10.35
Attribute filters can be combined.

Metadata

Now we're talkin'. The Metadata filter (Figure 10.36) has a lot to choose from.

Figure 10.36
The Metadata filter.

Don't be overwhelmed by all of this, though. It's really a simple (yet powerful) filter. The default columns—Date, Camera, Lens, and Label—are shown. These can be changed to other metadata fields.

In addition, you aren't limited to four columns. Lightroom allows up to eight columns in this filter. To change the field for a column just click anywhere on the column header except the far-right end. A list of the fields will pop up, and you can choose the one you want assigned to that column.

Certain fields, like Date and Keyword, are hierarchical and will have a small icon in the header that looks like an outline (Figure 10.37) (1). Non-hierarchical fields, like Camera, will have no icon in the column header (2). When you put your cursor over a column header, a small list icon appears on the right side (3). Click this to access options for the column.

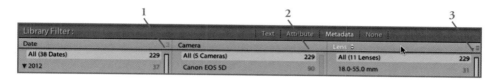

Figure 10.37

Column headers can tell you the type of field.

All columns have the first section shown in Figure 10.38 (1). Columns that have a hierarchy will have the second section, View (2). You can show those values in a hierarchy complete with disclosure triangles to drill down into the hierarchy. Or you can select Flat to show them in a list. Some columns, like Date, have the Sort section (3). Choose Ascending or Descending.

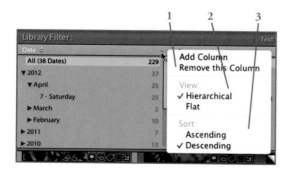

Figure 10.38

Column options.

Metadata searches are flexible. Figure 10.39 shows a somewhat extreme search, but it illustrates a few things about this filter. This search is using all of the eight available columns. The filter is a cascading search. In other words, as you make selections in one column the remaining columns adjust to the maximum number of images found by the previous column. Look at the Camera column. I've chosen the Canon EOS 5D, which results in 57 images. Those 57 images become the starting point for the next column, Lens. In that column I chose the EF17-40mm f/4L lens, which yields 32 images, and that 37 becomes the starting point for the Label column. As I make choices from left to right, the results cascade down until I reach my final group. In this extreme example, it's one image.

Figure 10.39

Metadata searches are cascading.

You may have noticed that some of the columns have multiple values selected. The usual selection methods apply here—use Shift to select contiguous items and Command for non-contiguous items.

What if eight columns aren't enough? Don't despair. You can use these filters together.

Figure 10.40 has both the Attribute and Metadata filters turned on. When you do this, Lightroom filters from the top down, passing the results to the next filter.

Figure 10.40

You can use more than one filter at a time.

Filter Presets (Saved Searches)

Perhaps it took me a long time to perfect that fantastic search in Figure 10.40. What if I want to re-create it at another time? No need to write it down somewhere because Lightroom lets you save your searches. At the right side of the filter bar you will see a drop-down menu (just before the lock icon). If you haven't started creating a filter it will say No Filter. But if you have already created a filter it will say Custom Filter. Click on this to open the menu (Figure 10.41).

Figure 10.41

You can save and recall searches.

All of your saved searches appear in a list (1). The searches shown are the default searches that install with Lightroom. When you're done creating your ultimate search, click Save Current Settings as New Preset (2). Restore Default Presets will bring you back to the list shown here (3). To save changes to an existing preset, choose Update Preset *<preset name>* (3). Right now I want to save this great search I created, so I will click Save Current Settings as New Preset.

I'll name my preset My Great Search and click Create to save it (Figure 10.42). From now on I can recall that search whenever I need it.

Figure 10.42

Save your search with the New Preset dialog.

> **TIP**
>
> When you're done searching you can turn off the filters by pressing Command+L. If filters are already off, pressing Command+L will recall the last filter you used.

Locking Filters

Filters don't stay active if you change collections or folders. If you would prefer that your filter remain in place while you change folders or collections, click the lock icon at the right end of the filter bar. Click again to unlock it.

If you are a long-time Lightroom user you may remember how filters behaved back in Lightroom 1 and 2. Filters used to be "sticky" and would attach themselves to individual collections and folders. It was possible to have one filter active for Collection A and a different filter for Collection B. Switching between the two collections would activate their respective filters. You can re-create that behavior in Lightroom 4.

First lock filters by clicking the lock icon or selecting File > Library Filters > Lock Filters. Then select File > Library Filters > Remember Each Source's Filter Separately. Now your filters will be "sticky" like they were back in the pre-Lightroom 3 days.

Quick Filter

The filter bar is available to you only while in the Library module. But you will have the need to search while you are in other modules. Lightroom's got you covered here as well. Rather than make you bounce back to the Library module every time you need to search, you can use the Quick Filter.

Filter Bar Redux?

You may remember when we discussed the Filmstrip that it is one of the panels that follows you from module to module, always there, always available. The Quick Filter lives at the top of the Filmstrip (Figure 10.43).

Figure 10.43
The Quick Filter lives at the top of the Filmstrip.

The Quick Filter doesn't have all of the elements of the filter bar, but there is some depth here. You have immediate access to what looks like the Attribute filter. You can click and pick flags, stars, and color labels. That's useful. The real secret here, though, is the drop-down that follows the attribute options. This gives you access to all of your saved searches from the filter bar. So even though you can't directly access the Text filter or the Metadata filter, you can call them into action via saved searches.

Figure 10.44 is an example of the Quick Filter in action. I'm in the Print module, and I want to get to that image I found with the filter bar last week. Luckily I saved that as My Great Search, so I choose that from the Quick Filter drop-down (1), and it instantly returns the expected result (2). No need to jump back to the Library module.

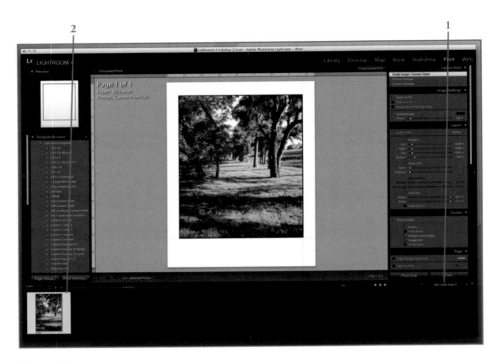

Figure 10.44

Using the Quick Filter in the Print module.

Sources

In addition to the Quick Filter, you can find the Sources menu at the top of the Filmstrip (Figure 10.45).

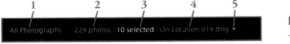

Figure 10.45

The Sources menu.

One function the Sources menu serves is like the little "You Are Here" markers on a map. Just looking at the Sources menu tells you the following:

- Where the current images are from. Here you'll also see the type of location—folder, collection, or smart collection—followed by the name of the folder or collection. Here we see one of Lightroom's default groups, All Photographs.
- The number of images in this group.

- The number of images selected in the group.
- The filename of the target image.

And at the very end is our clue that this is also a menu—a disclosure triangle (5). Click anywhere on the Sources menu to open it (Figure 10.46).

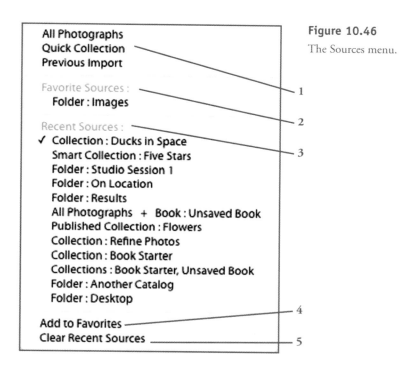

Figure 10.46

The Sources menu.

The first section (1) always shows the three Lightroom default groups:

- All Photographs
- Quick Collection
- Previous Import

You're not limited to these, however.

Favorite Sources

If you have particular folders or collections you go to frequently, you can save these as favorite sources. These will be listed in the Sources menu for easy access (2). To save a source as a favorite, click Add to Favorites when the source is active. When you have a favorite source active, this will change to Remove from Favorites so you can delete it from the list.

NOTE
You can't make any of the three default groups a favorite because they are always available when you open the Sources menu.

Recent Sources

The Sources menu also keeps track of where you've been recently (3). This gives you a quick way to return to a group you recently left without having to clutter your favorite sources. If you find yourself returning to a group frequently, it's a simple matter to make it a favorite.

As this list grows it can get out of hand. You can clear the Recent Sources list by selecting Clear Recent Sources (5) at the bottom of the Sources menu.

Time to Check the Map

Your road trip's going well. We have only one more stop before we leave Lightroom's left brain and venture into its creative right brain modules. That's how to make Lightroom work the way you want and how to tap into many of its timesaving presets.

So spend a little time at the rest stop, grab a snack, and we'll get back on the road whenever you're ready.

11

What's Your Preference?

A s you spend more time working in Lightroom, you discover that there are many ways to make the application your own. You can turn panel groups on and off and even change their size. But there's a whole lot more you can fiddle with under the hood to make Lightroom more of a "custom fit" for you.

I have already talked about a few of the customization options in the previous chapters. In this chapter, we'll look at the major preference options. While we won't cover every single place Lightroom allows customization, you will find that there is a pattern to these dialogs. Once you've been introduced to one kind of dialog and see how it works, you will be able to apply that knowledge to similar preference dialogs you meet.

We'll start with the big two—Preferences and Catalog Settings—and continue from there.

Preferences

You will find Preferences in the Lightroom menu (Windows keeps it in the Edit menu). The Preferences dialog has five tabs at the top [Figure 11.1 (1)].

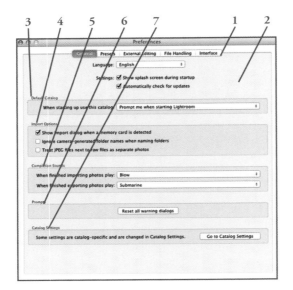

Figure 11.1

The Preferences dialog.

On the General tab, the first section (2) is where you can set the language you'd like Lightroom to display, whether it should show you the splash screen when starting, and if it should check for updates automatically. I recommend you always keep the Automatically Check for Updates option checked so you don't miss any fixes and new features as they come out.

In the Default catalog section (3), you can decide what catalog Lightroom opens when starting up. You can decide to have Lightroom ask you each time. Choosing that will present you with a dialog listing the most recent catalogs to choose from. You can also have Lightroom start with whatever catalog it had open the last time it closed. Choose Load Most Recent Catalog for that option. Or you can pick a catalog from a list and always open that when Lightroom starts.

If you want Lightroom to open the Import dialog whenever a new card is detected, check the Show Import dialog when New Memory Card Is Detected option in the Import Options section (4). The other significant setting here deals with JPEG files when you set your camera to shoot RAW+JPEG. Selecting the Treat JPEG Files Next to Raw Files as Separate Photos will import both versions into the catalog and let you work on them independently. Unchecked brings the JPEG files in as sidecar files but does not show them in the catalog as separate files.

Completion Sounds (5) is where you can set different sounds to alert you when import and export operations are complete.

Many of Lightroom's warning have a Do Not Show Again option. If you want to see the warnings you've turned off, press the Reset All Warning Dialogs button in the Prompts section (6).

To go directly to Catalog Settings, press the button in the last section (7). Don't go there just yet. We'll look at catalog settings when we're done with Preferences.

There are many places in Lightroom where you can create presets or templates. The Presets tab has a few options concerning these (Figure 11.2).

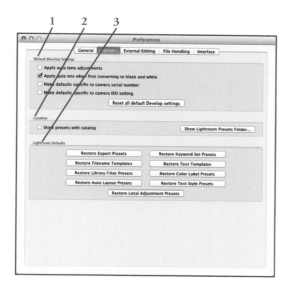

Figure 11.2

The Presets tab.

Default Develop Settings (1) has five options. Apply Auto Tone Adjustments will use the default tonal adjustments on an image when it is imported into the catalog. Apply Auto Grayscale Mix when First Converting to Black and White can be a useful starting point for your black and white conversions.

Since Lightroom captures all of the metadata from your images, it knows the serial number of the camera that took the shot. This is extremely useful when you have several cameras of the same make and model and want to tell which one the image was taken with. Make Defaults Specific to Camera Serial Number allows you to set up different defaults for each camera. Similarly, Make Defaults Specific to Camera ISO Setting lets you set up different defaults for each ISO value.

If you want to start over, you can press Reset All Default Develop Settings and return to the original Lightroom settings.

> **TIP**
>
> Sometimes when you are having problems with Lightroom it can be useful to just throw out the existing preference file. This often clears up a problem and is also a way to put Lightroom back to its out-of-the-box state if you want a fresh start.
>
> Make sure Lightroom isn't running. If you installed to the default location, on a Mac go to your user level library and find the Lightroom plist file (~/Library/Preferences/com.adobe.Lightroom4.plist) and delete it. Windows users should look for C:\Users\username\AppData\Roaming\Adobe\Lightroom\Lightroom 4 Preferences.agprefs. These are usually hidden files, so consult your OS help to see how to view and delete hidden files.
>
> The next time Lightroom starts it will see that this file is missing and create a new copy in the default state.

If you are a multiple catalog user you can store the presets you create with the catalog you have open in the Location section (2). If you do this, however, be aware that those Develop presets will not be available in other catalogs. By leaving the Store Presets with Catalog Box unchecked, your presets are available in every catalog. If you want to see where the presets are stored, press the Show Lightroom Presets Folder button, and Lightroom will open up Finder on the Mac or Explorer in Windows.

The Lightroom Defaults section (3) allows you to reset any of the main presets or templates that come with Lightroom. This is very useful if you have inadvertently deleted some of them or just want to clear out one of the preset areas.

The Edit in Adobe Photoshop section [Figure 11.3 (1)] allows you to set the options for editing images in Photoshop. Lightroom will show the most current version of Photoshop that is installed on your computer as the main editor. Three file formats are available: TIFF, PSD, and JPEG. Of the three, I recommend using TIFF, as this format provides the most flexibility, preserves the most image data, and causes fewer problems for you.

Three color spaces are available in the Color Space drop-down: ProPhoto RGB, AdobeRGB (1998), and sRGB. ProPhoto RGB is a larger color space than AdobeRGB (1998). sRGB is even smaller. Depending on what your final destination is for the image, you should choose a color space that will preserve the image's color quality. I believe it's best to preserve as much data as possible until you are ready for your final output.

Which brings us to bit depth. Here your choices are 16-bit and 8-bit. Again, 16-bit preserves more data than 8-bit. Weigh this against the fact that not all tools and filters are available for 16-bit images. Still, I recommend you work in 16-bit until you need a tool or filter that is only available for 8-bit images.

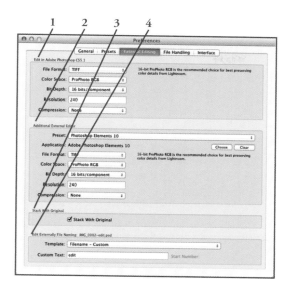

Figure 11.3

The External Editing tab.

Finally, in the Resolution field, you can set the resolution of the file that is opened in Photoshop for editing.

You have the capability to set more than one Additional External editor (2). This is done via the Preset drop-down menu. The example shown in Figure 11.4 presents Adobe Photoshop Elements 10 as an external editor. If any changes are made to the other fields, including which application to open, you can choose from several options.

Figure 11.4

External editor options.

Save Current Settings as New Preset in the Preset drop-down menu will let you to save and name your new preset so it appears in the list of presets. Delete and Rename allow you to delete the current preset or rename it. This opens up a world of possibilities in Lightroom because you can set up all your external editors and specialty programs as presets. This then lets you bring the image out to that program and back into Lightroom when you're done. It's a great productivity booster.

File Format (refer to Figure 11.3) lets you choose between TIFF, PSD, and JPEG. Color Space, Bit Depth, and Resolution offer the same choices as before.

When returning to Lightroom from the external editor, you can have the edited field stacked with the original by checking the Stack with Original checkbox (3).

The last section, Edit Externally File Naming (4) (a grammatically difficult choice of words, don't you think?), is where you can set up the filename defaults for externally edited files. When you edit a file externally, a new file is created and returned to Lightroom, so a new name is needed to distinguish it from the original file. All of the file naming templates are available here.

Shooting raw is definitely the way to go because you don't lose any of the information captured by your camera's sensor. With a raw file you can adjust many of the settings after the fact and not degrade the image significantly. The problem is that every manufacturer defines its own proprietary raw format. In some cases, they come up with a new format for each camera. While developers like Adobe do their best to keep up with this, there is usually a delay between the release of a new raw format and the capability of programs such as Lightroom or Photoshop to read those new formats. Another problem could arise as time goes by. If the manufacturer goes out of business or abandons support for that particular raw format, you may not be able to open your images later. Adobe has promulgated an open raw standard called Digital Negative (DNG) that all Adobe software will be able to read. Several camera manufacturers have started to capture their raw information directly to DNG format. You can read more about DNG on Adobe's website (www.adobe.com/products/photoshop/extend.displayTab2.html).

The Import DNG Creation section [Figure 11.5 (1)] allows you to set up some parameters for converting raw files to DNG on import. File Extension offers the choice of dng or DNG. Whether you like lowercase or uppercase file extensions is a personal preference. JPEG Preview allows you to set the embedded preview size to Full, Medium, or None.

Figure 11.5

The File Handling tab.

Two other options are offered in this section. Embed Fast Load Data will significantly reduce the time it takes your image to load up in the Develop module. Converting to DNG will usually result in a smaller file size than the original proprietary raw format, so you will give back some of this savings by choosing this option. But I recommend you do because the time saved is well worth it. You can also choose Embed Original Raw File in case you don't want to part with the camera manufacturer's RAW formatted information. This will effectively double the size of your files, so use this with caution. My suggestion is to archive the original files elsewhere if you really feel the need to maintain the proprietary raw formats.

The Reading Metadata section (2) deals with keyword separators. Normally, hierarchical keyword patterns are separated by a vertical bar (|). These two options allow you to add a backward slash (\) as a hierarchical separator.

Filenames come from many sources and operating systems. Sometimes they include characters that can cause problems in your operating system when used in a filename. Perhaps you will be sending files to someone on a different OS than yours, and those characters will be a problem. The File Name Generation section (3) gives you some control here.

Treat the Following Characters as Illegal lets you choose between two sets of characters that will be considered invalid in a filename. The following option, Replace Illegal File Name Characters With, will substitute an underscore (_), a dash (-), or a similar (but legal) character for the illegal one.

Some operating systems do not handle spaces in a filename very well. Or perhaps you just don't like spaces in your filenames. The When a File Name Has a Space option lets you substitute an underscore (_), a dash (-), or Leave As-Is and leave the space there.

Every time you open an image for editing in Lightroom, the entire image is cached. This allows a quicker response time on reopening. In Camera Raw Cache Settings (4) you can choose where the cache is stored and what size it is. If you have ample disk space, increase the cache size for better performance.

The Purge Cache button will clear out the cache. However, if you have the space and aren't having any problems, I recommend you don't purge the cache.

The cache for video files is handled separately. The video cache can quickly grow quite large. If you do a lot of video work in Lightroom and have the room, this may not be a problem. You can limit the size of the video cache in the Video Cache Settings section (5).

The Interface tab (Figure 11.6) is where you can tweak aspects of the Lightroom interface with panel end marks, what badges to show, or how spaces are treated in keywords. Play with these settings until Lightroom looks the way you like.

Figure 11.6

The Interface tab.

Catalog Settings

Preferences control aspects of Lightroom independent from what catalog is open. Catalog settings, however, are catalog-specific.

The Catalog Settings dialog has three tabs (Figure 11.7). The first is the General tab. Most of this tab is informational. You can see some important statistics about your catalog—location, name, creation date, size, etc. If you need to find the catalog on your drive, simply click the Show button.

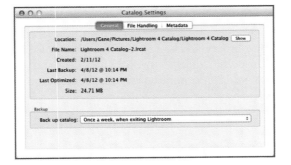

Figure 11.7

Catalog settings.

The Backup section is important and offers the following choices:

- Never (as in *never choose this option!*)
- Once a month, when exiting Lightroom
- Once a week, when exiting Lightroom
- Once a day, when exiting Lightroom
- Every time Lightroom exits
- When Lightroom next exits

The option you pick will depend on how frequently you work on your catalog. *Never ever choose Never!* It is absolutely critical that you back up your data. Letting Lightroom do it for you is painless and automatic, and I don't see any reason not to take Lightroom up on its offer.

CAUTION

This backup option does not back up your image files. It only backs up the catalog. While this is extremely important, please do not rely on this as your only backup. When the worst happens, you will be glad you had a regular and complete backup program in place.

By default Lightroom wants to store your backup in the same folder as your catalog. Don't do this. If your drive fails and you lose your catalog, you also lose your backup. Pick the Choose button (Figure 11.8) and pick another drive to store your backups. You can also elect to optimize and test the integrity of your catalog. I recommend this occasionally because all database files get a bit of cruft over time.

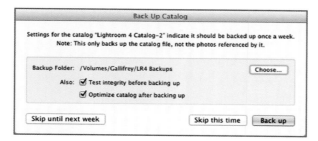

Figure 11.8

Backing up your catalog.

The File Handling tab deals with previews and sequence numbers (Figure 11.9). Pick a preview size that best approximates your monitor's resolution. If you are pressed for disk space you can have Lightroom discard your 1:1 previews at set intervals. If you have the room, I suggest setting this to Never.

Figure 11.9

The File Handling tab.

The sequence numbers add some flexibility to file naming. Lightroom offers three different sequence numbers for tracking images.

Sequence Number—This is the number you see in the Import dialog. It remains at whatever number you last started with.

Import Number—Lightroom will count the number of times you import and keep track here.

Photos Imported—Keeps a running count of the number of photos imported.

You can set these and override Lightroom's count.

The more you use Lightroom, the more it learns. In many fields, Lightroom will offer suggested values based on what you have entered in the past. You can turn off this behavior by unchecking the Offer Suggestions from Recently Entered Values option or just clear out the lists with the Clear All Suggestion Lists button (Figure 11.10).

JPEG, TIFF, and PSD files can hold Develop settings, and you can opt to write these into the files themselves by checking the Include Develop Settings in Metadata inside JPEG, TIFF, and PSD Files option. I use this because it affords me yet another record outside my catalog of what I've done.

Figure 11.10

The Metadata tab.

The next option has been a source of much discussion over the years. Automatically Write Changes into XMP is both angel and devil, depending on who you talk to. I suggest you choose this option. This will make sure you never forget to write this data to your files. If you find that your setup runs slower than you like, you can turn this off to help speed things up. If you do, however, please remember to write the metadata out to your files regularly.

You can also change your reverse geocoding options on this tab.

Identity Plate Setup

You can personalize or brand your copy of Lightroom. Select Lightroom > Identity Plate Setup (Windows users will find this in the Edit menu) to open the Identity Plate editor (Figure 11.11).

You can create two different kinds of identity plates: styled text and graphical. Figure 11.11 shows a styled text Identity Plate. You can change the font, face, size, and color. To change those for individual words, first highlight the word. The module picker can be styled to match using the right window. If you don't see the Module Picker window, click the Show Details button. In this example the button reads Hide Details because the Module Picker window is already visible.

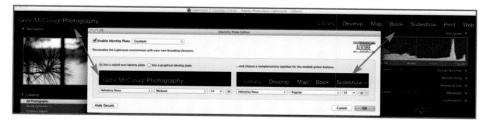

Figure 11.11

The Identity Plate editor.

To save your Identity Plate, pull down the menu next to Enable Identity Plate. Your other saved plates are there as well.

When using a graphical Identity Plate (Figure 11.12), you can drag the image onto the window or use the Locate File button.

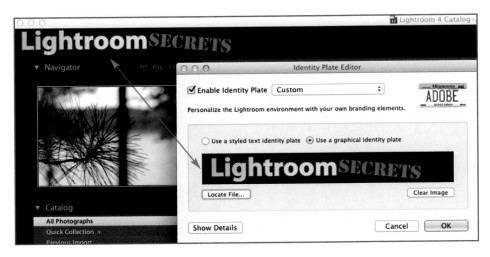

Figure 11.12

Using a graphical Identity Plate.

TIP

When designing graphics to be used as an Identity Plate for Lightroom's top panel, the maximum height is 60 pixels. PNG files work best and can have transparent areas. While transparency isn't as important against Lightroom's dark background, it can become important if you use the Identity Plate elsewhere.

Identity Plates aren't just for branding the interface. If you save them, they can be used in other modules to add content to your images. Similar to watermarks, Identity Plates can be overlaid onto images and slides. When creating graphical Identity Plates for that purpose, you aren't restricted to a 60-pixel height. You cannot alter the aspect ratio, however, so plan your graphics accordingly.

Watermarks

Watermarking in Lightroom has come a long way since it was first introduced. You can access the Watermark editor (Figure 11.13) by selecting Lightroom > Edit Watermarks. (Windows users look in the Edit menu for this.)

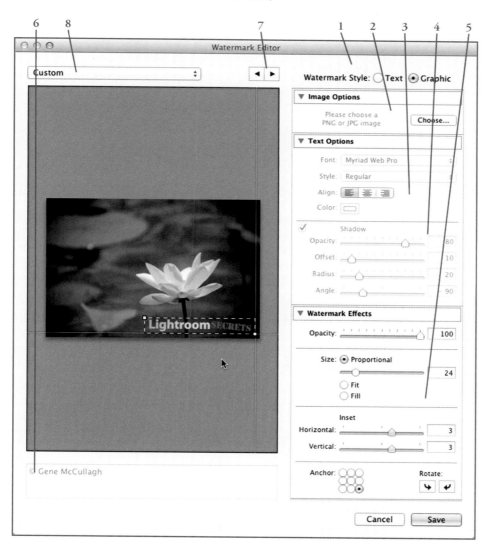

Figure 11.13

The Watermark editor.

Watermarks can be text or graphics based (1). If using a graphic, click the Choose button (2). Graphics cannot have their aspect ratios altered in the editor, but you can change the size and rotation. Again, PNG files work best because you can take advantage of their transparency features to blend in your watermark seamlessly. For text watermarks you can adjust the font, face, alignment, and color (3) as well as add a drop shadow (4). Both kinds of watermarks are controlled by the Watermark Effects section (5). Hover your mouse over the preview to see the inset guides and watermark boundaries.

When creating a text watermark, enter the text below the preview window (6). I recommend you select several images and include both landscape and portrait layouts. Then you can preview how the watermark fits on different images by moving through the selected images using the Next and Previous buttons (7).

You can save several watermarks. Choose Save Current Settings as New Preset from the drop-down (8) or click the Save button in the lower right. You will be prompted for a name.

Layout Overlay

Since we've mentioned using PNG files for Identity Plates and watermarks, I should also mention the Layout Overlay option (Figure 11.14). This neat little feature really comes in handy when shooting tethered, but it can also be useful when reviewing shots for selection.

The Layout Overlay can be set up and activated in the View menu. Select View > Layout Overlay > Choose Image to pick a PNG file as the overlay. You can also use the keyboard shortcut Shift+Option+Command+O. Figure 11.14 demonstrates a typical use for the Layout Overlay—a magazine cover. To turn the Layout Overlay on and off, select View > Layout Overlay > Show Layout Overlay or use the keyboard shortcut Option+Command+O.

When you hold down the Command key, you have access to the three controls for the overlay. Opacity (1) controls the opacity of the overlay itself. Hold down the mouse and move right to increase opacity and left to decrease. Matte (2) controls how dark the matte covering the image outside of the overlay gets. You can scrub that from none (0) to full black (100). Lastly, you can grab any of the corner handles (3) to resize the overlay. As with the other graphical elements we've discussed, you cannot change the aspect ratio, so plan your PNG accordingly.

Figure 11.14

The Layout Overlay.

File Naming

There are several spots where Lightroom lets you use a filename template to change the names of files. The three places you'll likely run into this is during import and export and when you rename files in your catalog.

I've selected eight images and selected Library > Rename Photos. In the resulting dialog, I chose to edit the filename to bring up the Filename Template editor [Figure 11.15 (1)]. The editor shows you an example of how the filename will look (2) when you are done. In the setup window you create a template using a combination of data tokens (3) and static text (4). Tokens can be chosen in the groups below the setup window. Find the field you want and click the Insert button to add it. If you don't want to save the template, click the Done button, and the custom template will be used once. If you click the Preset drop-down, you can save and name it for future use.

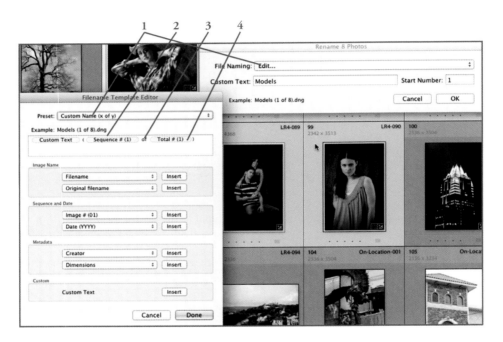

Figure 11.15

The Filename Template editor.

The Filename Template editor in the Import dialog has a slightly different layout (Figure 11.16) but operates in the same way, using tokens and static text.

Figure 11.16

The Import dialog's Filename Template editor.

Other Templates

There are still other places in Lightroom where you can save customized templates for later use: the Print module, the Web module, and the Slideshow module, for example. These all use the same dialog (Figure 11.17).

Figure 11.17

The New Template dialog.

Give your new template a name and then choose (or create) a folder to put it in. You can then rest assured that your work has been preserved.

Develop Presets (Settings)

Without a doubt, Develop presets are one of the most powerful features of Lightroom. Lightroom has presets practically everywhere you look, but Develop presets are unique. Here is where you can capture the essence of a look and use it on other images or share it with your friends and colleagues. We are about to move into the right-brain side of Lightroom where the Develop module lives, so what better preset to end on than the Develop preset.

As with the other presets you are saving aspects of your work for reuse. I want to show you the dialog for creating a Develop preset, even though much of what you will see may be foreign to you. I think having the layout of the Develop preset in mind when we explore the Develop module will give you an awareness of how things fit together. You will start to think in terms of technique groupings and how to distill the essential parts into a preset.

Figure 11.18 shows the New Develop Preset dialog. I'll show you how to get to this when we talk about the Develop module. For now, look at how things are laid out. The top part (Preset Name and Folder) should be very familiar to you by now. These act the same way as in other preset dialogs. Each of the checkboxes controls a different aspect of the develop process. They are grouped with their "develop siblings" and can be turned on or off individually or in groups. You can use the Check All and Check None to fill 'em up or clear 'em out.

Figure 11.18

The New Develop Preset dialog.

To make these presets useful and complementary, you don't want to check all of the boxes on every preset. That will make Preset B cancel out Preset A. It's better to think of Develop presets like layers in Photoshop. If my bottom layer has a blue square on the left, and my top layer has a red square on the right, when I stack the layers, I can see a blue square and a red square. If, however, my bottom layer is completely filled with blue, and I add a layer on top completely filled with red, all I see is red. This is like checking all the boxes in two different presets and applying one after the other. You only see the effects of the second preset.

Just keep this in the back of your mind when thinking about Develop presets—less is more. Just check the boxes you intend to use and leave the rest blank. You'll have a much better chance of creating useful and flexible Develop presets.

OK. Time to give your left brain a rest and drive off into the wild territory of Lightroom's right brain—the Develop module. Get your smocks on and your palettes out. It's art time!

Index